ENTWOOD LIBRARY

JU100 10/02 1024

Digital Photography Handbook

DOUG HARMAN
Photography by David Jones

Quercus

How To Be A Digital Photographer

Digital photography offers many advantages - practically, technically, creatively and even economically - over traditional film photography. Over 95% of cameras sold today are digital, but it is the minority of photographers who make the most of the power at their disposal. With a digital camera, you can shoot and store hundreds of photos at practically no cost; instantly review and re-shoot your images; achieve great picture quality; improve your images on computer, correcting badly lit pictures and even repairing old photos; adjust colours and apply special effects; or set up a photo web site... the possibilities are exhilarating and nearly limitless.

The Digital Photography Handbook will allow you to make the most of all the advantages your camera has. Assuming no prior knowledge, it will help you quickly to become a true digital photographer whether you just want to improve your basic technique to get error-free holiday snaps or to learn professional image manipulation techniques for maximum creativity.

This book will take you step-by-step through the four key areas you'll want to master:

- 1. Going Digital the basics, including choosing a camera and equipment, and getting started
- 2. Using Your Digital Camera how to take great pictures
- 3. The Digital Darkroom improving your images on a computer
- 4. Output getting the best end result, on-line or in print

But although this handbook offers a complete beginner's course in digital photography, you don't have to work through all of its pages to make progress. Each topic makes sense read individually, and you can use the table of contents and comprehensive index to jump to anything you want to know. Cross-references in italics direct you to any other useful topics related to a particular subject.

Wherever you start, this book offers comprehensive advice and is packed with information. But it also draws your attention to the most important things - green and red hint boxes give you instant do's and don'ts to improve your results. Blue highlight boxes focus on the key techniques and knowledge for each topic, speeding the learning process.

Whilst a beginner's guide, The Digital Photography Handbook does not avoid any of the seemingly difficult concepts you'll need to know. It demystifies traditionally complex topics such as pixels, depth of field. F-numbers and cloning, explaining them in simple language and using them in practical situations. Any key technical terms you come across can also be found in the glossary for quick reference. In addition, this book will take you, in illustrated steps, through numerous image editing examples, allowing even the novice computer user, working at their own pace, to produce professional results

Your digital adventure begins here. Enjoy!

Doug Harman

Contents

Going Digital

The basics – getting started

The Digital Camera	
Camera Features Explained 8	3
Types Of Digital Camera 12	2
How Many Megapixels? 14	1
Memory & Memory Cards 16	
A Buyer's Guide 18	
Starting To Use Your Camera 20)
Care, Maintenance & Cleaning 22	2
Lenses	
Zoom Lenses	1
Fixed Lenses	3
Changing Lenses 27	7
The Computer	
Which Computer?)
Computer Accessories	2
Getting Connected	1
Accessories	
Which Software?	3
Which Printer?	3
Which Scanner? 40)
Preventing Camera Shake 42	2
Extra Flash44	1
Extra Storage	
Light Meters	

Batteries & Power 49

Using Your Digital Camera

Taking great pictures

Photo Techniques

Joinposition
ocus
Depth Of Field
Exposure
Vhite Balance62
Creative Flash64
ow Light
Close-Ups
Black & White

Photography Ideas	
Portraits & People	74
Still Life	78
Reportage	82
Travel	84
Architecture	88
Landscapes	91
Sports & Action	95
Weddings	98
Gardens & Flowers	02
Children	06
Pets & Animalsl	10
**	

The Digital Darkroom

Improving your images on a PC

Basic Digital Techniques
Starting To Use Editing Software 120
Saving Your Photos 124
Auto & Quick Fix
Cropping
Straightening132
Resizing
Sharpening
Brightening & Darkening Photos 138
Removing Redeye140
Creating Black & White142
Advanced Digital Techniques
Advanced Digital Techniques
Advanced Digital Techniques Colour Management
Advanced Digital Techniques Colour Management
Advanced Digital TechniquesColour Management144Adjusting Colours146Levels148
Advanced Digital TechniquesColour Management144Adjusting Colours146Levels148Curves150
Advanced Digital TechniquesColour Management144Adjusting Colours146Levels148Curves150Advanced Curves152
Advanced Digital TechniquesColour Management144Adjusting Colours146Levels148Curves150Advanced Curves152Channels154Cloning & Healing156Dodge & Burn158
Advanced Digital TechniquesColour Management144Adjusting Colours146Levels148Curves150Advanced Curves152Channels154Cloning & Healing156
Advanced Digital TechniquesColour Management144Adjusting Colours146Levels148Curves150Advanced Curves152Channels154Cloning & Healing156Dodge & Burn158

Masterclasses

Blurring Backgrounds 1	08
Adding Movement	70
Making Panoramasl	72
Restoring Old Prints	74
Special Effectsl	76
Special Effects Using Filters 1	79
Making Art: Poster Effects 1	82
Making Art: Painted Effects 1	85

Getting the best end result
Backing-Up190
Printing
Scanning Your Photos196
Creating Slide Shows
Emailing Photos 200
Getting Your Photos On-line 202
Making A Portfolio 207
Making Money 209
Copyright
Glossary
Index
Acknowledgements 222
The Authors 224

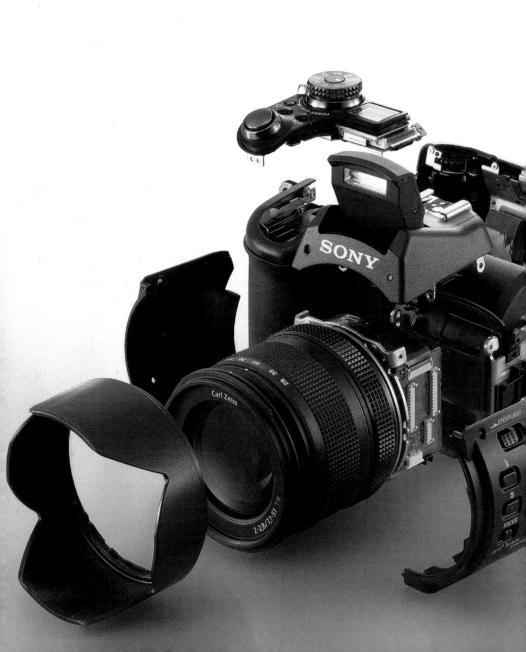

Going Digital

In this section, you'll find all you need to get started, including:

How to choose the right camera for you

The basics – digital camera features and operation, and camera care

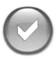

Camera essentials – what you need to know about memory cards, power and lenses

Advice on computers, software, printers and other useful equipment

Explanations of megapixels, focal lengths, zoom ratios, resolution, modes and menus, connection speeds, gigabytes, D-SLRs...

Camera Features Explained

Digital cameras are designed to be familiar to anyone who's ever used a film camera. But they have many extra helpful features too. . .

Most digital cameras have similar basic features. Here we'll introduce you to the typical features of a compact digital camera, and will go on to discuss more specialised

functions later in the book. You should check the manual supplied with your camera to see which additional features your camera has.

The Side

Wrist Strap Lug

You attach the camera's wrist or carrying strap here.

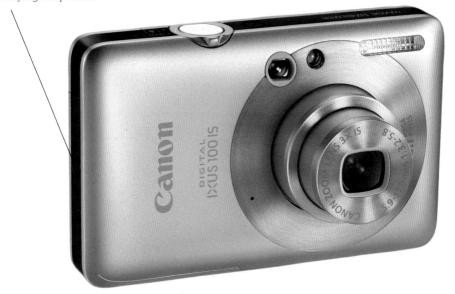

The Front

Viewfinder

This enables you to view the scene to be photographed. There are two types: electronic and optical. Using an optical viewfinder means you can turn the large colour screen off. saving battery power. An electronic viewfinder (EVF) uses a little power, but has the benefit of being able to display camera information.

AF Assist Emitter

This small port has a bright LED that can emit a beam of bright light to help focusing in low light situations and is also used to help reduce the redeve phenomenon.

Built-In Flash

Most digital cameras have a built-in automatic flash unit that can be used to provide extra light if it's dark, or to reduce shadows on heavily shaded subjects in bright sunlight.

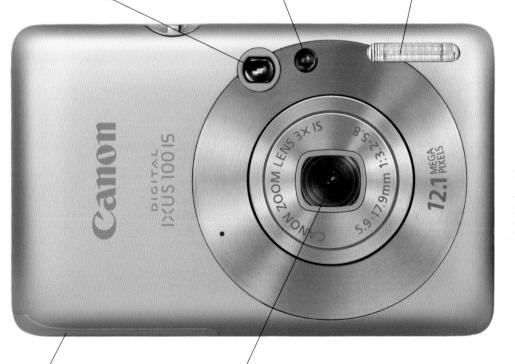

Battery and Memory Card Cover

Safely tucked away under a cover, you'll find a place to insert batteries and a socket for inserting the camera's memory card.

Lens

Most digital cameras come equipped with a zoom lens that enables more or less of a scene to be included by 'zooming' in and out. These changes in focal length are reflected in the viewfinder and on the large display screen on the back of the camera.

The Top

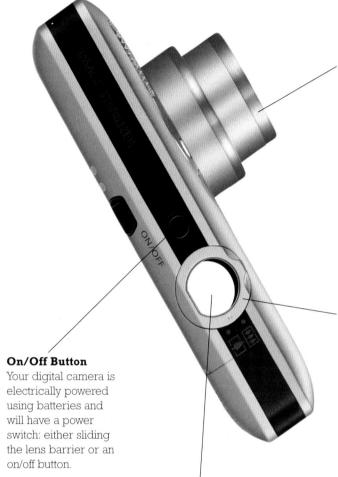

Zoom Lens

When the camera is switched on, the camera's systems are activated. This includes the lens which will extend to its shooting position, ready for action. Zoom lenses are allocated a multiple (or ratio) as a measure of the extent to which they can zoom compared with the lens's focal length. These 'zoom ratios' can be values of up to 10x or more, but a typical digital camera has a 3x zoom lens, which is ideal for most situations (see Zoom Lenses).

Lens Zoom Control

The lever surrounding the shutter release is moved left or right to make the lens zoom in or out. This makes it easy to adjust the view when framing a shot. Some cameras have the zoom button on the back. which needs pressing.

Shutter Release

The most important button on the camera; it takes the pictures. The shutter release will have two pressures. A half press (and hold) activates the focus system and all the electronics that measure the amount of light available (the light metering system). A little beep, or an 'OK' indicator on the colour screen and/or an illuminated green light next to the viewfinder, will indicate that focus has been achieved. Completing the press of the button will fire the shutter and take the photo.

The Back

Viewfinder (Back View)

This is the part of the camera you use to compose a shot. It also has two small indicators that show the focus and flash status. A green light means the focus is okay, red shows that it is not. If the flash indicator flickers, the flash is charging; when it is steady, it means the flash is ready to fire. However, not all cameras will have optical viewfinders.

PC/AV/HDMI Socket

Beneath covers either on the camera's back (as here), or often a camera's side, you will find sockets for mains power, connecting the camera directly to a computer, an AV (audio visual) socket or an HDMI port for connecting the camera to a TV, to display images and videos in high definition.

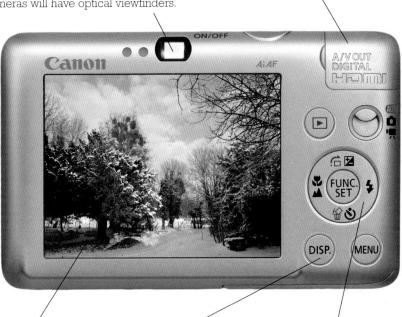

Colour Screen (LCD)

The colour screen on a digital camera is great for instantly reviewing your photos to make sure they're okay or for showing them off to others. It can display your camera's settings, menus and picture information. The screen also gives you a live display of your subject, making correct composition easy.

Other Adjustment **Buttons and Controls**

Depending on your camera model, there will be several other buttons on the camera that will be used to control frequently used functions without having to go through onscreen menus. Such functions could include control of the flash, the focus mode, movie mode activation, focus modes (activating macro focusing for example), image playback, menus and display modes.

Jog Buttons

This type of 'jog' button is common to digital cameras and allows you to scroll through your images on the large screen. It is used to navigate through the camera's on-screen menus and can be used to activate various camera features, such as sensitivity (ISO) settings. The central 'FUNC./SET' button can be used to confirm selection of other options and activates further menus for control of the camera's shooting functions.

Types Of Digital Camera

What kind of camera do you need? Here's a simple quide.

The Basic Digital Camera

A basic digital camera has everything you need to take great photos but in a package that's very simple to use. It will have few - if any - manual photographic controls to play with and most functions will be automatic. These are often called 'point-and-shoot' cameras.

It will include a built-in flash. It will probably have automatic shooting modes you can select such as landscape or portrait setting, and it will have either a fixed focal length lens of around 35mm or it might sport a modest zoom lens.

The resolution is likely to range from eight megapixels (8MP) to as many as 10MP but could be more or less depending on the type you buy (see How Many Megapixels? for more about resolution). It's worth mentioning that a camera with eight megapixels can print images that range in size from normal 6x4-inch prints to well over A3 in size.

The Mid-Range Digital Camera

The most obvious differences between basic and mid-range digital cameras, apart from an inevitably higher price tag, are likely to be in the resolution and the lens. A mid-range camera will probably have a higher resolution of around 12MP to 14MP and almost certainly have a longer built-in zoom lens such as a 5x zoom ratio.

However, some mid-range models come equipped with 'super' and 'ultra' zoom lenses. Hence digital cameras can have lenses that provide anywhere from a fixed focal length to zoom ratios of up to 10x, and even higher (see Zoom Lenses).

There will be manual controls to put you in charge of the photo taking and enhanced features such as automatic scene assessment, a wider variety of scene modes and high definition (HD) movie modes rather than standard resolution movies. 'Build quality' is likely to also be noticeably improved over basic cameras.

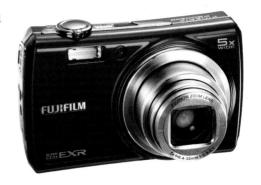

The High-End Digital Camera

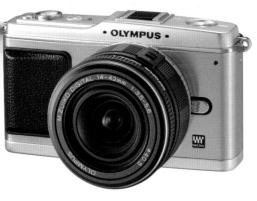

Designed primarily for the advanced snapper, high-end digital cameras (also known as 'Prosumer' or 'Bridge' cameras) are expensive pieces of equipment and feature a multitude of manual controls, backed up by an even more enhanced range of automatic settings.

This camera will have superior internal software that speeds up image capture and processing, making the camera faster and more efficient than mid-range models. The lens may not have a better zoom ratio than cheaper models, but will be crafted from the camera maker's premium optical glass which brings improvements in light-catching ability. Special lens coatings and optical configurations are employed to give improved performance and results.

High-end models will tend to have highresolution sensors, often of between 10MP and 14MP. They are likely to have ruggedised or toughened build, such as waterproofing, and they'll have improved focusing, metering and flash set-ups, the latter enabling the use of external flashguns; for some models professional studio flash equipment can be used. Improved computer connections for faster download and, in some cases, multiple memory card slots will also be in there, depending on the camera you buy.

The Digital, Single Lens Reflex (D-SLR) Camera

D-SLRs are the very top of the digital camera tree. They are expensive, enthusiast and professional-level high-resolution digital cameras.

'SLR' is the name given to a camera (digital or film) which lets you view the scene you're photographing through a single 'taking' lens, via a reflex mirror. The reflex mirror directs light through the viewfinder (usually) through a special prism called a pentaprism which is mounted inside the camera. This provides the photographer with an exact view of the subject - through the viewfinder - as 'seen' by the lens. The mirror flips up out of the way when a shot is taken allowing light to reach the sensor.

D-SLRs can use interchangeable lenses, not available on a compact digital camera, and this flexibility provides unparalleled shooting versatility. You'll also get all the high-tech gadgetry found on high-end digital cameras, only it will be more specialised or enhanced to give even better performance including resolutions from 10MP to 24MP and beyond.

Added to this is a brick-like build quality; anti dust systems and, on some models, Live View that allows you to use the camera's large screen to compose a shot in the same way as you can on a compact digital camera.

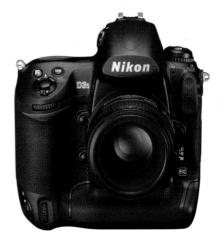

How Many Megapixels?

When looking at the sales blurb for digital cameras, you'll see endless mention of megapixels – and this is indeed a critical feature of your camera. So here we'll explain what they are - and how many you'll need.

A digital camera contains a special device, known as a sensor (sometimes referred to as a CCD or CMOS sensor), to capture light. This replaces the photographic film used in a traditional camera. The sensor is comprised of numerous tiny 'photosites' that collect light, convert it into an electric form and feed it to the camera's on-board computer. Once this digital information is stored in your camera's memory, it can be reassembled on a computer monitor, on your camera's colour screen, or printed to make your photo.

A pixel (from the term 'picture element') is a tiny, discreet location on the sensor that contains the photosite, a micro lens to focus light onto the photosite and other electronics.

The number of megapixels refers to how many millions of pixels the sensor in your camera has. A megapixel is the common term for one million pixels, often abbreviated as '1MP'. A two-million pixel camera will be referred to as 2MP, and so on.

The number of pixels is important because the more a camera has, the more detail it can capture - and the higher its resolution is said to be. Additionally, the more pixels there are, the larger you'll be able to print your pictures. But don't forget, the more megapixels a camera has, the more expensive it will be too.

So how many megapixels should you get when you buy a digital camera? The answer to this depends largely on your budget and what you want to do with your images. You need fewer pixels to post images on the Internet and send them as emails, than to print standard 6x4 inch prints. But you'll need more pixels than that if you want to create enlargements.

For example, you can achieve perfectly good 6x4 inch prints from a camera with as few as 2MP but most digital cameras today have over 8MP, meaning even with a relatively inexpensive camera you can get poster-sized prints quite easily with a suitable printer or printing on the high street. If you buy (or perhaps already own) a camera with more than 4MP then you'll be able to print at sizes up to A3 and even larger. If you want to create larger prints, then a lower resolution camera is not the choice for you.

Happily, all digital cameras can be set up to use less than their full complement of pixels, so you can tailor shots to their end use, such as the lesser number of pixels needed on an image to be emailed. This is even true with a very high-resolution model. (See the topics Printing. Emailing Photos and Creating a Photo Web Site for advice on output resolutions.)

Another thing to remember is that the more pixels your camera has, the more memory the shots will use up - per photo - because each image will then be made up from more pixels and so contain more digital information.

High- and Low-Resolution **Image Comparison**

A single frame of 35mm film contains the equivalent information of around 30MP of data, if it were translated across to a digital camera. But it's not always about the numbers, as the human eye can only perceive a finite amount of detail - around 3MP worth of detail when viewing a print at around arm's length. As has been discussed, the more pixels your camera has on its sensor, the more detail it can capture, allowing you to display or print at a larger size. However, you don't always need all that data.

The following images have each been reproduced to (broadly) demonstrate how more pixels can equate to more detail and so lead to differing output (or print) image sizes.

High-Resolution 14MP Image

This image represents a 14MP image with 3425x3245 pixels and has detail and pixels enough for very large prints; colours and detail are finely reproduced and this image could easily be printed at well over A2 (420mm x 594mm) in size.

Medium-Resolution 6MP Image

In this medium resolution of the same shot, despite having many fewer pixels (around 2000x3000 pixels) it still has bags of detail; indeed this resolution was at the high-end of the scale for digital cameras only a year or two ago. It looks almost indistinguishable from the highresolution 14MP image and can be easily printed at up to A3 in size (297mm x 420mm).

Low-Resolution 2MP Image

This low-resolution image of the - same shot now has only 1400x1400 pixels and is typical of many camera phones or very old basic digital cameras. This would be ideal for email use but could be reduced in size further for use on-line or on screen. However, you will get a good 6x4 inch print from it.

Memory & Memory Cards

Every digital camera uses memory of some sort, sometimes called 'digital film'; it provides storage space for your photos as you take them. Here we'll provide advice on how much and what type you need.

The Memory Card Explained

In simple terms, the memory in a digital camera is a small computer chip called 'flash memory' that retains all the data that makes up the photo. Removable memory cards slot into the camera and can be taken out, allowing you to put in a fresh card. Removing a memory card from a camera does not mean you lose the images; they stay safely ensconced on the memory card for downloading or printing later for example.

Those digital cameras with built-in memory capacity rarely have more than enough for a few photos, really just enough to get you started. Many digital cameras come complete with a removable memory card (probably of low capacity) included in the box when you buy them. Either way, you'll need to purchase extra cards almost immediately. The types of cards your camera can use will be indicated in its manual so check before you buy.

Memory Cards at a Glance

There are various types of removable memory cards and they come in a range of capacities, measured in megabytes and gigabytes (MB or GB for short), from around 1GB up to 32GB and while larger capacities are being developed all the time, some smaller capacity cards (less than 1GB) may be available. One gigabyte is the

equivalent of 1024MB so when comparing cards you should note a 1GB card has more memory space than a 512MB card, for example. The bigger the number of bytes indicated on a card, the more space there is and, of course, the more it is likely to cost. Here's a look at the main types.

CompactFlash (CF) Type I and Type II

One of the most popular memory cards. CF has been around for almost as long as digital

cameras. They are robust and come in capacities of up to 32GB and now are available in higher performance versions with improved write speeds to help deal with the increased data from high-resolution cameras and those that can shoot high definition video. These are often denoted as having '300x' or '600x' write speeds.

SecureDigital (SD) and SecureDigital High Capacity (SDHC)

The SD card format now comes in High Capacity versions (SDHC) too, designed to offer increased

storage for today's high-resolution digital cameras and cater to the fact the newer cameras can shoot high-definition video and so require even higher capacities and better performance. Capacities available are now up to 32GB. Mini and Micro versions of the SD card technology are also available for mobile phone and MP3 players.

Memory Stick (MS)

Memory Stick is Sony's proprietary memory card format that is used across many of their products.

from digital cameras to TVs. Memory Stick Pro and Duo (including 'Magic Gate' cards) are versions of this MS format, but the type needed depends on the digital camera. Capacities range from 2GB to 32GB depending on the format.

xD Picture Cards (xD)

This format is largely used within Fuji and Olympus digital cameras. It's small, and while

theoretically it can achieve very high capacities, currently it is available up to 2GB.

What Capacity Cards Should I Buy?

The number of images you can fit onto a memory card will depend on the card capacity; the level of compression applied to the images in the camera (it varies from manufacturer to manufacturer); any adjustments you make to the image resolution (for different quality shots); and the effective number of pixels the camera has on its sensor.

To give an example of how many images you can shoot on a 1GB memory card in a 10MP camera you can shoot up to 500 basic quality images. Switch to higher quality settings such as uncompressed RAW (also see Saving Your Photos) then that immediately drops to around 45 images.

Whilst having one large memory card for your digital camera might seem attractive and more cost effective than using a number of smaller cards, it's better not to have all your 'photo-eggs' in one basket. Imagine the frustration if you had a once-in-a-lifetime holiday, shot all your photos onto one memory card and then lost it! This is a disaster easily averted if you buy two or three medium-sized cards. Instead of buying a single 32GB card, for example, buy two or three smaller (2GB, 4GB or 8GB) cards. It might cost a little more (though not always, as some of the much higher capacity cards are still very expensive) but you can be sure you'll have the same total capacity without the risk of losing all your photos if something goes wrong.

- Some cameras use more than one type of memory card. But not every camera will use every type of card, so check before you buy. You cannot use a CF card in a camera that only uses xD for example.
- Do buy several smaller memory cards to ensure that all your photos are not stored on one card. If something goes wrong, you won't then lose all the images.
- Remember: the more pixels your camera has, the faster your memory card will fill up.

A Buyer's Guide

Choosing a digital camera can be daunting given the huge number of models on the market and their varied features. Here's a quick guide to help you see what's really important when you buy.

The first thing to do is to narrow down the many possible buying criteria to a few key ones. Top of the list will probably be your budget, and then what you need your digital camera for.

What to Spend?

In terms of cost, the most important factors, in no particular order, are simply these:

- As with most things in life, you get what you pay for, so don't scrimp on your investment.
- Remember to budget for a decent size memory card (see Memory & Memory Cards).
- Generally, always buy as many pixels as you can afford (see the following descriptions of different resolution cameras for more detailed advice on this).
- Buy a digital camera with a display screen, the larger the better. Without this, you'll miss out on some of the key benefits of using digital cameras: being able to see the shot as it looks before taking it and instantly reviewing it afterwards.

What Do You Need from a Digital Camera?

Before you buy, you need to decide what you want from a digital camera. Once that's done it becomes a much easier decision.

The most common things you might use your digital camera images for are:

- · Posting on the Internet
- · Sending by email
- · Viewing on your PC screen
- Printing out as photographs
- Using for professional work or to make money

Some digital cameras can provide images that are good for all these things; some might not give images that are suitable for any of them. Knowing this is the key to buying the right camera.

Essentially, the number of megapixels (1MP or 3MP for example) that the camera has is the key to the 'tasks' it can perform. It's also worth bearing in mind that the more pixels your camera has, the higher its overall specifications are likely to be and the better its build quality. You'll get bigger pictures and more quality for your money.

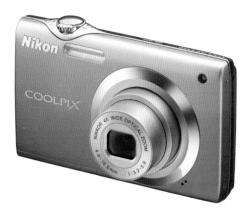

The Nikon COOLPIX S3000, a great all round 12MP digital compact that's ideal to take anywhere and with enough resolution for good-sized prints:

6MP to 8MP Digital Cameras

These digital cameras are more basic, less expensive and have fewer features and (often) plastic build quality compared with some of the higher resolution models. Cameras below 6MP have almost entirely been phased out. These cameras are capable of excellent prints up to and over A3 (297mm x 420mm) in size.

8MP to 12MP Digital Cameras

The most popular and broadest range of cameras fit into this resolution bracket and are widely available. Expect to get enhanced shooting features and high quality video (high definition in many cases) with sound built-in. Very large poster-sized prints can be achieved and the detail these cameras can capture is great for most subjects from detailed landscapes to crisp portraiture. Buy as many pixels as you can afford in this range as often the features and build will lend itself to a more professional-style of imaging work.

12MP and Above Digital Cameras

Some of the latest professional level digital cameras today have resolutions of 24MP. Many consumer oriented digital compacts

have 14MP and the level of detail and quality they afford is superb but comes at a price. However, the more pixels you have to play with the larger the prints can be or the more detailed they can be. Many models can shoot HD video with sound, which means you'll need higher performance cards to boot.

Such cameras are expensive but, you don't necessarily need to buy very highresolution models if you're unlikely to be making large prints.

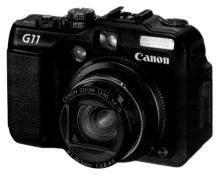

Canon's G11 is an enthusiast's compact model. It has a special 10MP, high-sensitivity sensor (reduced from 15MP in the G10). Fewer larger pixels in the G11 make the most of the camera's high-sensitivity features so helping low-light performance.

MORE PIXELS, MORE DETAIL

In general, it's best to buy a camera with as many pixels as you can afford, as you can always downsize an image if it has more pixels than you need, but you can't upsize an image that doesn't have enough.

For example, if you want to print a lower resolution image shot at, say, 2MP at the size you could print an 8MP photo, you would quickly see the blocky pixels, not detail. You cannot add detail that's not already there in the picture.

Starting To Use Your Camera

Digital cameras are controlled in the same way as a traditional film camera but can also do so much more. Here's a quick quide to the basic operations to help you get started.

Inserting the Batteries

Digital cameras are powered by electricity and so first you'll have to insert the batteries. Over 60% of all digital cameras use specially designed battery packs; some use multiple power sources, for example AA batteries and a battery pack. Cameras that use rechargeable battery packs will come with a charger when you buy them. Charging the battery takes a couple of hours, but they should be fully charged before you begin. (See *Batteries & Power* for more advice on batteries.) Once the batteries are inserted, you can turn the camera on using the on/off switch.

Inserting Memory Cards

Your memory card can only be inserted one way into the special slot on the camera. Once the memory card is inserted, you're ready to start shooting.

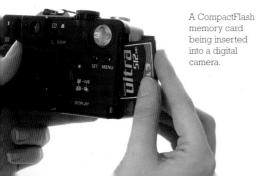

Shooting Controls

The controls that actually allow you to take a photo are the shutter button, and the 'mode' dial. The former is the most important button on the camera as it allows you to focus and fires the shutter, taking the picture. The latter is used to access different shooting functions, to change between playback and picture taking, and to set scene modes (see below).

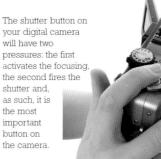

Using Scene Modes

Scene modes automatically set the camera up for specific shooting situations and are indicated by small icons on the mode dial or in the on-screen menus, or sometimes both, depending on the camera. Expect to find portrait, landscape, sports and night settings, although some digital cameras have many more. When you select the mode that matches your shot (portrait mode for a portrait and so on), the camera does almost all the work for you.

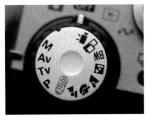

A typical mode dial will include icons such as those shown here, providing fast activation of the camera's various shooting options simply by turning it to the required

Other Controls

Other buttons provide control over various functions of your digital camera including the menus (see below), activating the flash, turning the screen on and off, and activating the self-timer.

Using Menus

The menus which appear on your camera screen might look daunting at first, but they provide you with a step-by-step series of options for setting the camera up. From changing the date, choosing a resolution or adjusting the brightness of the screen, menus are the heart of your digital camera's settings.

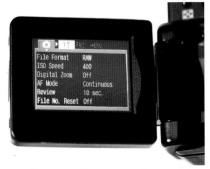

Menus are displayed on the camera's colour screen and provide fast, easy access to the camera settings.

Built-In Flash

The flash lets you add extra, artificial light to a scene that would otherwise be too dark to take a good photo. It can be set automatically or you can manually select it to flash for a particular shot. Additionally, you can use the flash to lift, or fill-in, shadows (see Creative Flash) and it also helps prevent

unwanted silhouettes if the background is very bright.

The built-in flash provides extra light when shooting indoors or when it's dark.

Movies and Audio Functions

Most digital cameras have a movie mode (with sound) varying from low resolution movies for use on the Internet, for example YouTube, while many can now also shoot high quality HD movies. Movie mode allows you to shoot clips from a few minutes, or until the memory card is full. Audio capture can be used to add a short commentary to your photos.

Connecting to a PC or TV

Digital cameras are supplied with the cables needed to connect them to a PC or TV. Connected to a television, you'll be able to display your photos on a TV screen directly from the camera. Connected to a PC, you can save your images to the PC's hard disc to print them, burn them to a CD or make a slide show as will all be explained later.

Whichever digital camera you own, you'll be able to plug it into a PC using the supplied leads.

Care, Maintenance & Cleaning

If you've invested your hard earned cash in a digital camera, you'll want to look after it. Here are a few simple pointers to help protect your camera and maintain its performance.

A digital camera is a precision piece of electrical equipment and contains many delicate elements, particularly the optics in the lens, the electrical circuitry and the sensor. Each can be damaged quite easily unless you take care.

Camera bags such as this one are an inexpensive and easy way to look after vour camera.

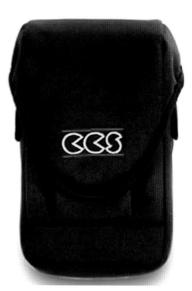

Camera Bags

The simplest way to protect your digital camera is to keep it in a proper camera bag. Get a case that's waterproof with decent cushioning and an opening that fastens twice: velcro and a zipper for example. Ensure there's enough room for spare memory cards and a lens cloth.

Protecting Against Dirt and Water

Water and dirt, especially sand, are the digital camera's mortal enemies. If you take your camera to the beach or into the wilds, use a special waterproof 'housing'. This will also keep out sand and dirt. Check with your camera's manufacturer for suitable housings. If you don't have a housing, put the camera back in its bag immediately after use.

- Don't get sand in your digital camera
- Don't get a digital camera wet. Use a protective housing.
- Don't store a digital camera with the batteries still inside.

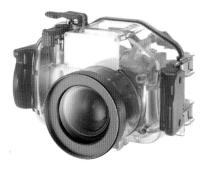

Protect your digital camera from water and sand with a waterproof housing such as this one. You'll then be able to take your digital camera underwater too.

- Do use rechargeable batteries it will save you a fortune.
- Do buy high-mAh-figure rechargeable batteries.
- Do use silica gel if storing a digital camera for any length of time.

Inserting Leads

Many digital cameras come with their own leads made specially for connecting to a PC or TV. So never force a lead into a socket or use the wrong lead. If you damage the socket, the camera will need potentially expensive repairs.

Cleaning

Digital cameras aren't hard to clean simply wipe them down with a lint-free cloth. Never use solvents or water. If you have a D-SLR and can see dust on the CCD sensor, never, ever clean it yourself. The CCD is very fragile and, despite the fact that you can buy CCD cleaners, if you touch the sensor, it will break. Only get a CCD cleaned by a servicing agent certified for your make of camera.

Storage

If you're not going to use a digital camera for a while, store it in its camera bag with a silica gel pack (it will come with one in its packaging when you buy it). These are small packs containing a gel that absorbs moisture very well. Also remove its batteries or you will risk corroding the contacts inside the camera.

Memory Card Care

Memory cards are NOT affected by airport X-ray machines, but...

- They are affected by magnetic fields. Keep them away from magnets, TV screens and audio speakers.
- Keep cards cool and dry, away from direct sunlight and humidity.
- Keep them away from dust, as this can block the small holes or electrical contacts used to communicate with your digital camera.
- Always keep cards in the protective cases in which you bought them.

You can protect your memory cards too. A case such as this one for xD cards is ideal.

Zoom Lenses

A zoom lens is a key feature on a digital camera as it adds tremendous flexibility to your photography. Here's what you need to know about them.

Most compact digital cameras have optical zoom lenses; that's a lens that can vary its field of view in order to magnify ('zoom in') or broaden ('zoom out') a scene. These are ideal for when you cannot get close to your subject or want to include more of it in the shot, making the camera very versatile.

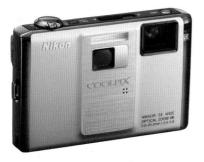

Remember

Buying a digital camera with an optical zoom lens will give you great flexibility in your shot-taking, and the larger the zoom range, the greater the flexibility you will have.

Focal Lengths

Zoom digital cameras have their focal lengths (the range through which the optics in a lens can move) specified by comparison with the focal length of the familiar ('35mm') film camera. They are indicated on the camera lens in millimetres.

Whilst this may sound confusingly technical, helpfully all you need to know is simplified in the descriptions of digital cameras by using terms such as 'two times' (abbreviated to '2x') or four times ('4x') and so on. The wider the focal range, the greater the 'x' factor (or 'times' factor) becomes and the greater the apparent magnification.

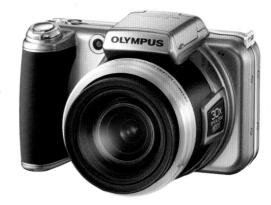

Digital cameras such as this Olympus have long zoom lenses; this camera has an amazing 30x zoom of 28mm to 840mm.

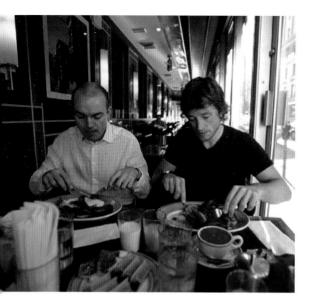

These two images show how you can use a zoom lens to improve a shot. By 'zooming out' you can fit everything into a shot, even in confined conditions, as with these men eating at the table. The shot of the balcony, however, was 'zoomed into' to improve detail and the composition with the shadows.

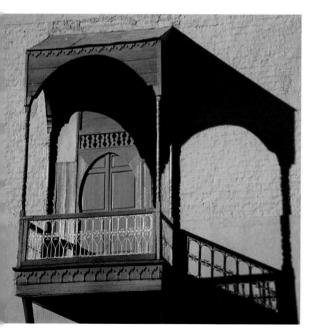

Here's an example to make all this clear. A digital camera with a zoom lens which has a 35-105mm focal range is said to be a '3x' optical zoom lens, because the highest focal length figure is three times the lowest focal length, i.e. $35 \times 3 = 105$. A 28-112mm lens would be a '4x', for example, and so on.

The optical zoom range available to digital cameras is growing as lens technology improves and there are now many digital cameras with so-called ultra-zoom' ranges with up to 30x optical zooms, offering a focal range as wide as 24mm in some cases to as long as 840mm in the camera shown at left. The most common digital cameras have 3x to 5x zoom lenses and while they cannot zoom as much as an 'ultra', they are less expensive and just as much fun to use.

Optical Zoom or Digital Zoom?

Digital cameras, almost without exception and including those that already have an optical zoom lens, have a feature called digital zoom. This can electronically enlarge a portion of the sensor's image to produce a zooming effect.

Optical zoom works by using the lens to magnify the scene and it utilises the entire sensor area for the image, retaining full image quality and resolution.

Digital zoom enlarges a small, central portion of the sensor instead. So it will produce blocky, grainy images and should be avoided if top quality prints are required.

Fixed Lenses

Most cameras come with a zoom lens as standard. But you might want to consider the alternative to these – the fixed lens camera.

Here we'll explain which is best for you.

We've seen the flexibility a zoom lens has to offer, but there are a couple of benefits offered by a fixed lens digital camera which are not available to most zoom optics. These are a higher optical quality and a compact size.

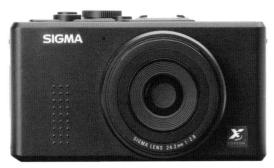

Sigma's DP2 is one of the few remaining fixed or non-zoom digital compacts on the market; robust and at the premium end of the market, it's quite pricey but has a high quality 28mm prime lens.

Advantages

Better optical quality results from the lens not being the optical equivalent of a Jack-of-all-trades. A zoom must do a multitude of optical tasks and, in order to achieve them, compromises are made in the lens designs which affect optical quality.

No such compromises are made in a fixed lens. Having one focal length, usually a wide view between 28mm and 35mm, means that the lens is made specifically for that length, making it sharper (for more detail) and

brighter (to let in more light) than the zoom lens equivalent. They often have a wider field of view too.

Compact sizes are possible because the design doesn't cater to the mechanisms needed to zoom the optical train back and

forth. Battery power lasts longer too for the same reason.

Disadvantages

Fixed lens digital cameras can seem expensive, largely due to the cost of their optics and the fact that fixed lens digital cameras are often premium models. Another consideration is that there are fewer fixed lens digital cameras on the

market. Also, as already discussed, a fixed lens camera doesn't have the convenient flexibility of a zoom. Because of this, most people are willing to live with the compromises involved in a zoom camera.

The Cheaper Option

There are many very cheap non-zoom digital cameras on the market. They tend to use digital zoom to make up for the lack of an optical zoom. We've discussed the problems with digital zoom already, and with very cheap fixed lens digital cameras you actually get worse optics, poor image processing and even poorer results. These are best avoided.

Changing Lenses

You're not always restricted to the lens your camera came with.

If you're after more shooting flexibility on a compact, you can use an adapter lens. D-SLRs can use any lens made for them, but there are pitfalls. Here's what you need to know to make the right lens choice.

A digital camera with the ability to use any lens offers the photographer two things: unparalleled versatility and access to superb quality lenses.

This photo was taken using a wide-angle lens without which you couldn't fit everything into the shot.

Despite the fact that compact digital cameras come with a predetermined focal length range – or just a single focal length for a fixed lens camera – you can still buy specialist lenses and adapters that enable you to stretch your compact's abilities,

including wide or telephoto lens adapters. Unlike on D-SLRs, adapter lenses don't replace the original lens – they fit over it.

The interchangeable lenses on D-SLRs are really their raison d'être, allowing you easily to remove a lens and replace it with another of a different focal length. Let's look at how best to adapt or change the lens on each of these types of camera.

Lens Adapters for Compact Digital Cameras

The only way to expand the abilities of a compact's lens when it is an integral part of the camera is to attach something over the front of that lens. Happily, many compact digital cameras come with a screw thread round the front of the lens barrel that provides the means to do just that.

Other types of adapter lenses clip over the front of the camera's entire lens barrel, there are some that strap on, while yet others have special magnetic strips that are used to mount them on the front of cameras. However, the screw-in variety is best as there's less chance of them getting out of alignment and they're less fiddly to use. The other types are, however, cheaper if you're on a tight budget.

Such specialist lens adapters might not offer the same optical quality as a lens made for a D-SLR, but they do provide a way to extend your shooting flexibility quickly and (relatively) cheaply.

Adapter optics are available that provide extra-wide-angle shooting abilities or extend the telephoto end of the lens (the longer focal lengths), providing an increase in optical performance without the drawbacks associated with, say, a digital zoom.

Having said that, optical quality can drop with an attachment, so always buy the lens adapters designed for your camera and, if you can afford it, the ones made by the same camera manufacturer, since they'll be matched to the lens already built into your compact.

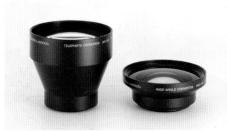

Telephoto and wide-angle converters such as these screw onto the front of your digital camera's lens, providing increased focal range for specific tasks such as zooming closer to your subject or squeezing all of a wide subject into the shot.

LENS FILTERS

Another type of adapter you can attach over an existing lens is a filter. They're not really regarded as a lens, but do provide optical 'special' effects. They include UV filters and polarisers which boost colours, and filters that will change the colour of a scene. They're fun to use but you'll first need to check if you need a special mount to use them on your camera.

Avoiding Adapter Problems

Because adapter lenses are basically a set of new, separate optics that 'bolt' onto the front of an existing lens, there are a few things worth considering before buying.

The adapter lens should be made from high-quality glass of at least as good a quality as that within the camera's lens. If not, expect image degradation.

A wide-angle adapter lens attached to a compact digital camera.

This could include 'vignetting', where the corners of shots taken with the adapter will go dark, or an overall softness that's apparent on all shots. It could even make your photos suffer from barrel or 'pin cushion' distortion. The former makes the image bulge in a circular fashion around the middle and the latter pinches the image in at its corners.

- Do buy the adapter lens made specifically for your camera's lens (a 'matched' adapter). This way you'll be able to ensure all the optics are optimised so reducing possible distortion.
- Do buy screw-mounted adapters. They're very secure and offer a light-tight, seamless join with the camera.

Specialist Lenses for D-SLRs

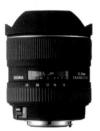

D-SI₂Rs use interchangeable lenses and each make of D-SLR will accept only those lenses specifically made for it; Canon use one type of lens and mount. Nikon another for example. Some independent lens manufacturers such as

Sigma or Tamron make lenses that can be used across different D-SLR makes and models, each fitted with the correct mount for the camera to which it will be married.

These lenses are designed to provide a solution to specific shooting tasks from the relatively mundane, such as portraiture where a lens is built to provide the optimal focal length (usually around 135mm) and a flattering blurred background, to extreme close-up (macro) shooting or the ability to take very-wide-angle shots. In each case, the lens is optimised for its job, to a greater or lesser degree.

The Digital Rangefinder and **Mirror-less Compact**

The digital rangefinder is a compact digital camera able to use interchangeable lenses. However they're now rare with few models left

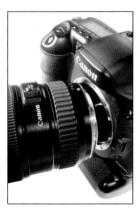

Above: This is Sigma's 12-24mm wide-zoom lens, ideal for squeezing in everyone in a large group at a wedding for example.

Left: Interchangeable lenses are mounted onto a D-SLR camera using a special mount as shown here. Each manufacturer has its own mount type.

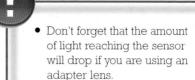

 Don't buy cheap adapters. Image quality will be impaired, distortion will be apparent and you could get horrible pixel fringing too.

on the market. Epson's RD-1 was one of the first with Leica's M9 one of the most recent new but expensive additions. However. Olympus and Panasonic have an entirely new mirror-less compact system digital camera that boasts the features of a D-SLR, including interchangeable lenses, but without the bulk associated with them.

Olympus' PEN cameras are based on its PEN series of 1959 compact film cameras boasting high-resolution sensors, a Micro FourThirds lens mount, a FourThirds Standard sensor with a range of interchangeable system lenses and accessories but remain compact and as versatile as a D-SLR.

While typically more expensive than 'normal' compacts - with equivalent resolution - the PEN and Panasonic's G-series models offer performance and image quality.

Olympus' new digital camera is inspired by its range of 1959 PEN film cameras. The Pen E-PL1 shown here is an interchangeable lens mirror-les compact system digital camera, with the Micro FourThirds lens mount,

Which Computer?

If you want to create slide shows of your images or edit and print your own photos at home, a computer is essential. So what should you look for when selecting a PC to use for digital photography?

A personal computer (PC) ideal for digital photography can be thought of as a digital darkroom. What used to be done in an actual 'dark room' full of noxious fumes and poisonous chemicals can now be done in daylight, sipping coffee, listening to music and with relative ease.

Anyone keen on getting hands-on with their pictures, particularly when it comes to playing around with printing, creating enlargements or making slide shows with music and special effects, will need a PC.

What Type of PC?

There are two main types of PC on the market: portable laptop PCs and desktop PCs. Whether you buy a laptop or a desktop is down to the tasks you want to do and whether or not you'll want to do them 'on location' and need portability, or work from a fixed location such as your home. Whatever your need, remember that laptops tend to have slower processors, or will be more expensive than a desktop with equivalent processing power, their hard disc space will have less storage and the screens will (often) be smaller but they will have built in wireless connectivity (see Getting Connected).

Mac or Windows

Whether you buy a desktop or laptop, it will use a specific operating system (OS). This is simply a computer program used to make a computer run.

The most common is the Windows operating system. Around 95% of people who own a PC use a Windows PC. They're made by a variety of manufacturers, Dell, IBM and HP are good examples; and today, most PC makers have PC systems optimised (say with faster graphics processors) for specific tasks such as digital imaging or movie playback, as well as PCs for more general tasks; so check before you buy.

main type of operating system is the Mac OS (although there are other less common

The second

OSs, such as Linux and Unix) used in Apple Macintosh (Mac) computers. Originally designed to be simple enough for children to grasp quickly, Macs do essentially the same job as Windows PCs. Both these types of computer come in laptop and desktop form.

A Mac tends to be more expensive 'off the shelf' but comes loaded with proprietary software - and the right hardware - for imaging and all multimedia tasks from making movies to sorting digital photos and storing your digitised music. It contains everything you'll need to get started including CD, DVD and Blu Ray disc creation, image manipulation, music and slide show software.

Windows PCs can look cheaper to buy at first but the cheaper models will probably not have powerful enough graphics abilities to handle the large image files created by today's high-resolution digital cameras. This means you could end up spending just as much on your Windows PC upgrading it, or installing extra software in order to make it perform fast enough to cope, so check before you buy that it is capable of dealing with what you intend to throw at it.

Compatibility

Mac or Windows software can only be used on the type of operating system it's been created for and is not transferable. However, new 'Intel' Macs can run both Mac and PC software.

Which Features to Look For

You need to ensure that the computer you buy has a large hard disc as this is where all the programs and files are stored. Images rapidly fill up storage space, so buy a PC with the biggest hard disc you can afford but ideally a minimum of around 250GB, or more.

Another item to ensure you have in a PC is a 'fast' processor; the processor does all the computing for you. Intel is a well-known manufacturer while another is AMD. Either way it is worth buying a PC with a recognisable brand name such as these. Yes, you'll pay a little more but it will be reliable and fast. Get the fastest available within your budget.

Computers today are sold with LCD screens, they're thin, save desk space and if possible buy a PC or laptop with a 1080P High Definition screen to get the most out of your images and other multimedia content.

Ensure you get a PC with a built in CD/DVD/Blu Ray drive; one that can both play and create such discs. Check the spec carefully; there are many variations. It's

worth noting, the very small 'Netbook' style laptops are undoubtedly compact, but will lack processing power, screen resolution and a CD, DVD or Blu Ray drive. Without such features you won't be able to author your own slide shows for example.

Maximise the RAM

There's one simple thing you can do to make your digital imaging experience faster on your PC – maximise the amount of RAM.

Random Access Memory (RAM) is different from 'storage memory' (the hard disc) as your PC uses it to carry out the tasks you give it. All of your commands and the resulting data are processed here. So the more your PC is doing at once, say processing changes to one image while you try to print another, the more quickly the RAM gets used up, and the slower your PC becomes – no matter how 'fast' your PC processor, or how large its hard disc.

Avoid this by ensuring you have as much RAM installed as you can afford. It's also much cheaper to get extra RAM fitted (if needed of course - check when you buy as your PC may already be 'fully loaded') when you buy a PC.

Adding more RAM when you buy is a modest extra cost and not as expensive as adding it later on. And anyway, the extra expense will be money well spent.

Computer Accessories

You've got your PC and camera. Now let's see if there are any accessories that will help improve your productivity and make digital work even easier.

Your PC will come with a standard mouse and keyboard enabling you to input instructions and activate some of your system's many features. But there are other devices available that can help make the imaging process even simpler.

Graphics Pads

Using your mouse to carry out image editing tasks is okay, but a graphics pad makes things even easier and more precise. You use a digital pen to 'draw' your changes onto the screen. Working this way is more intuitive and ideal for fine adjustments and intricate image editing work. A mouse is also supplied, as an alternative to the pen, for less precise, general use.

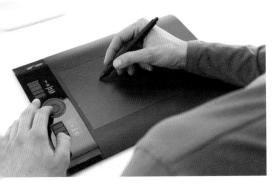

Memory Card Reader

A memory card reader is a small device that usually plugs into the computer's USB port and accepts memory cards. This avoids connecting the camera directly to the PC, therefore speeding up image download to the PC and saving the battery power on your digital camera.

Memory card readers range from those which accept only one memory card to those which allow multiple formats to be used.

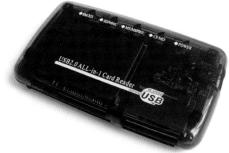

External Hard Drives

External hard drives (or 'discs') are an ideal way to extend the storage capacity of your PC. With capacities from 20GB for more portable discs to over four terabytes (one

terabyte (1TB) is equal to one thousand gigabytes (GB)), such drives mean you don't need to clutter your PC precious hard drive with loads of images and other digital data such as MP3 music files or your digital camera movies. Buy the largest capacity drive you can afford; you'll be amazed how quickly they fill up.

Pen or USB Drives

Pen drives, which have either built-in memory or accept memory cards (as in the Olympus model shown below), are another useful accessory. These are great for quickly swapping data (they save burning a CD for example) and for transferring images from your camera's memory card to your computer, be it a laptop as shown here or a desktop PC.

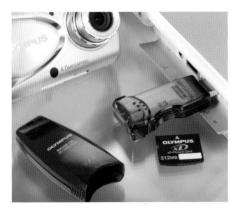

External CD, DVD or Blu Ray Burner

If you have an older PC or a Netbook style laptop, both of which might lack a built-in optical disc burner, then this item is invaluable. A DVD burner is recommended (it'll burn both CDs and DVDs) but if you can afford it, buy a Blu Ray burner as it will deal with everything you throw at it; check your OS can handle it though. Storing files on CDs, DVDs and/or Blu Ray discs also offers a way to back-up huge volumes of image data (see <code>Backing-Up</code>) without using up space on your PC's hard disc. Burners are not too expensive either.

Portable CD or DVD Burner

A portable CD or DVD burner is a useful accessory. They're great for burning images from a memory card when out and about, freeing up space, and can be used as a 'normal' CD or DVD burner when back at home or the office. Battery or mains powered, they are a very versatile tool.

Getting Connected

It's all very well having a digital camera, PC and other kit, but now you need to get them to communicate with each other. Here's a guide on how best to get everything connected.

IISB Connections

The most common form of connection for a digital camera to a modern PC is a USB (Universal Serial Bus) connection. This has recently been improved with the introduction of USB 2.0 which provides increased data flow speeds. Your keyboard, mouse, printer and scanner probably use USB. All digital cameras have a USB port for connection to a PC, and your camera should come with a USB lead as standard. This makes it very easy just to plug in and connect your PC to your camera, so you can download images for editing and printing. USB also enables 'hot swapping', which simply means you can plug or unplug the cables without needing to restart your computer or the device.

USB 2.0 connectivity makes connection of your camera to your PC or, as shown here, directly to a printer, very easy. It provides fast communication between devices, ideal for printing or transferring images.

Your camera will also probably come with a video lead which will allow you to connect your camera direct to your TV to show pictures on screen.

There are other forms of interface, the name given to connecting various digital devices to a PC, and some systems will have one, two or all of them usually depending on the price of the system.

FireWire and HDMI

FireWire is technically called IEEE 1394. It is a fast data cable connection common to higher-end digital cameras such as D-SLRs and most modern PC systems. FireWire is faster than 'normal' USB connections but not as fast as USB 2.0 and also hot swappable. You'll also find FireWire on digital camcorders and on some high-end printers and scanners. Higher-end models may also have an HDMI port (High-Definition Multimedia Interface) that connects the camera directly to HDMI compatible TVs or projectors for HD playback.

Wireless Connections

You'll rapidly see that wires abound with all these interfaces, so if you can afford it, consider wireless networking or WiFi

Some digital cameras can connect directly to a printer or PC via a docking station as with this Olympus digital camera, which means no more fiddling with wires each time you want to connect devices.

(Wireless Fidelity) connectivity. WiFi devices transmit data in a waveform and can connect together multiple devices, such as a printer, PC or camera, without any cables. Often used for notebooks and laptop PCs, WiFi also means you can work anywhere in the home, not just sat at a desk. Any hardware bought that displays the WiFi logo should interconnect seamlessly with any other WiFi enabled device.

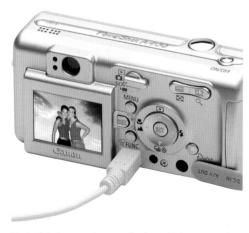

Each digital camera has a socket into which you can plug its connecting wire, be it USB or FireWire depending on the camera you own.

CONNECTION SPEEDS

It's no surprise that the faster the rate at which data is transferred the faster you can work and each of the main connection options has different connection speeds. We don't have to worry about the exact rate they work at, but it's useful to know which is fastest.

- Bluetooth: Bluetooth is very slow when compared to cable and to WiFi connections.
- USB 1.0: Slow and now almost universally replaced with USB 2.0 (see below).
- WiFi: WiFi is getting faster all the time but relatively slow compared with a direct USB 2.0 or FireWire connection. Also, WiFi speed is affected by the number of obstacles in the way (number of walls and the size of the room for example). The latest type (802.11n) is faster than previous versions such as 802.11a, 802.11b and 802.11g, and offers greater range.
- USB 2.0: This is faster than FireWire 400 but slower than FireWire 800 (see below).
- FireWire 400 and 800/IEEE 1394:
 FireWire is common and fast and has two versions, FireWire 400 and 800: the latter is faster but both are okay for large data transfers.

Bluetooth is another example of wireless networking, and can also be found on many modern mobile camera phones. It is a common wireless interface for up to eight devices over a range of about 30 feet (10m). If you have a Bluetooth-enabled printer you could print images directly from a Bluetooth camera without needing a physical wire for example. Not as flexible or fast as WiFi, it still saves on wires.

Which Software?

Your digital camera will come with a CD-ROM of assorted software, and there are numerous imaging programs you can buy or, in some instances, download for free from the Internet. So what software do you really need?

The Software With Your Camera

The 'proprietary' software that comes with a digital camera is very important as it provides the necessary programs to get your PC and camera talking properly (though depending on the model you buy it may not need - or even have - this software). It will come on a CD-ROM and will be very easy to install by following the instructions in the camera's manual or shown on screen once you insert the disc in your computer's CD drive.

The exact features of the software supplied will depend on your camera model but it usually includes tools to save images onto your PC which then make it easy to sort and search through them. It may also allow basic image editing, although there are additional software packages you can buy or download for free that provide more advanced digital imaging tools.

What Image Editing Software Can Do

Why edit your images? Simply, it's an easy way to improve them. For example, you can:

- · Resize images for printing or use on a web page
- Improve colour
- Correct exposure problems
- Remove redeye from a portrait
- · Crop an image to improve composition
- Make a blurred photo sharp
- · Add special effects
- · Remove unwanted elements of a scene

How to use image manipulation software to achieve these effects, and many more, is the subject of Section 3 of this book.

What Software to Buy or Download

The following are some of the best software packages you can load onto your computer to enhance your image editing.

Adobe Photoshop CS

The defacto professional level image editing program is very expensive but comes loaded with everything you might need in order to manipulate photos on your computer. For print, on-line or any use it really is the package to beat.

•Platform: Mac and Windows

Adobe Photoshop Elements

Elements is just like a cut-down version of Photoshop CS with only the digital photography 'elements' left in, hence the name. It is inexpensive but very powerful, and as it is tailored for digital photography it's one of the best to use.

Platform: Mac and Windows

Corel PaintShop Photo Pro

Similar to Photoshop CS in many ways, it plays host to a full set of powerful, professional editing features but at a fraction of the cost. It's full of neat 'how to' tutorials, 'smart' editing features, and HD video editing and image organising tools.

· Platform: Windows only

ULEAD Photo Impact XL

Another affordable package replete with excellent features including a web graphics feature and media management.

· Platform: Windows only

ArcSoft DVD SlideShow

With this package you can quickly create professional looking DVD movies featuring your photos and movies, then burn them to disc to share with friends and family.

· Platform: Windows only

ArcSoft PhotoStudio

This package contains powerful editing tools married to an enhanced browser interface with a Photoshop-like feel. Auto editing functions such as redeye removal are included. This is very affordable and worth trying.

· Platform: Windows only

Picasa

Picasa is a free image editing package produced by the Internet search giant Google. Here you can edit and improve images then share them online in web albums with friends and family by emailing web links to galleries vou upload.

Platform: Mac and Windows

Roxio Creator

Roxio's Creator software allows you to do almost every imaging and video task all from one package. Edit movies, burn DVDs, create photo slide shows, cards and panoramas plus share and organise your images for iPod, YouTube or mobile phones.

Platform: Windows only

Roxio Toast Titanium

Extremely powerful CD and DVD burner with sophisticated tools for video, slide show, and also music, creation. Toast comes complete with automatic back-up software, it allows streaming across TiVo and for TV on-the-go and lets you sync up folders across multiple computers, folders or external drives.

• Platform: Mac only

Which Printer?

It's really easy to turn your digital images into photographic prints. But you'll need a printer for this and there are hundreds to choose from. Here's a buyer's quide to what you need.

Most digital cameras can print directly from a compatible printer or via a computer, and printing the images yourself provides great flexibility in terms of the size of the print you can make. We deal with the practicalities of printing images in the topic Printing, but first here are some tips on making sure you have the right printer.

Inkjet Printers

Inkjet printers are the most common type of printer, designed for general home and office use. They come in many varieties, some being more suitable for printing photographs than others.

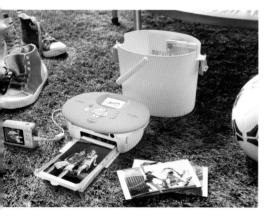

Some modern portable printers let you print almost anywhere; battery operated or powered by a car charger, they are self contained units that allow you to connect your camera and print images as you shoot. Some such as the one shown here even come in their own carry case.

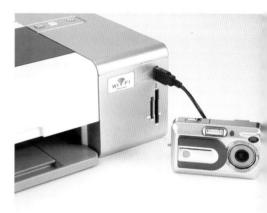

Printers don't always need to be connected to a computer to print images; you can connect cameras directly to the printer (usually with a USB cable supplied with the camera) or insert memory cards into slots built into the printer for easier, fuss free printing.

Standard inkjets use a combination of four coloured inks - cyan, magenta, yellow and black - that combine to form the colours we see on a print. But inkiets designed to do high quality photo printing use these four colours of ink plus special photo inks. All such extra inks are designed to improve the colour rendition on the prints and create finer gradations between light and dark areas.

Inkjet printers come in various sizes: A4, A3 and even A2. Some can print on rolls of paper and/or CDs and DVDs so you can customise discs as you go. A4 printers accept 'normal' letter-sized media, and can therefore be used to print both general work and photos. They are very affordable.

Many of the latest inkjet printers combine a scanner, copier and a printer; some even boast a fax too as does this model. The so called 'all-in-one' combined printer, copier and fax saves on desk space and allows you to print high quality photos and cover-off photo or document scanning/copying/ faxing as well, depending on the model you buy.

A3 printers offer larger print sizes and (sometimes) better colour and print resolution, providing superb print quality, but are expensive. A2 printers tend to be the preserve of the professional and are aimed primarily at studio work; they're very expensive but will produce stunning quality.

Dye Sublimation Printers

Dye sublimation or 'dye sub' printers are designed specifically for printing photos, and offer excellent quality. They come in a range of sizes from 'normal' print sizes (6x4 inches) up to A4. They use a special film coated in cyan, magenta and yellow dyes plus a special fixing layer dye. These are transferred to a special paper which is designed to receive the dyes (or 'sublimated'), using heat.

The downside is that dye sub printers cannot be used for general print jobs such as letters, but if you just want 6x4 inch photo prints a dye sub might be the printer for you.

Printing Without a PC

Most photo printers now have direct printing capability. This allows you to connect the camera to the printer via the supplied connecting lead and produce prints without needing a computer. So if you don't have a PC, you should check you are buying a printer with such capabilities.

Many of the latest printers are also WiFi enabled, thus allowing you to print images without cable clutter and this allows you to have one, centralised printer with more than one computer printing to it, for example an office PC upstairs and a laptop in the living room.

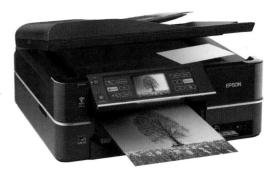

Other printers have built-in memory card slots into which you can insert your camera's memory card and print from it directly that way. This type of printer can also act as a card reader, allowing you to download images from your memory cards to a PC, if it's connected. Some digital cameras even have printer-docking stations, allowing for direct printing once they are 'docked'.

- Look for a printer which is a 'true' photo printer (it'll say on the box) and which uses the extra photo inks.
- Inkjet printers with separate ink tanks can be more economical to use.
- Dye sub printers cannot be used for anything other than photos.
- Always buy a 'photo-quality' inkjet printer if photos are the main task your inkjet will be used for.

Which Scanner?

Scanners allow you to bring all your old film photos into the digital domain. Here's a look at what the modern scanner has to offer and which types are available.

Digitising all your old prints, negatives and slides by scanning them onto your PC means you can not only print copies of old photos but you can enhance and restore damaged photos too.

Scanners are easy to operate and allow you to scan images directly to your hard disc, to an email program or even to a printer, at the press of a button. We'll explain how to get the most from your scanner in the topic Scanning.

Most scanners come supplied with the software needed to link to your PC and some come with image 'cleaning' software that can be applied to the scan as it is made. removing dirt marks, fingerprints, dust and scratches, which saves a lot of time editing on the PC later.

Scanners come in three main types and what you'll need depends on what you want to scan. We'll explain each in turn.

Flatbed Scanners

Flatbed scanners are sometimes called reflective scanners as they capture light reflected off the original document or photo to create an image and are ideal for scanning flat paper and prints. They have an A4 glass platform (called a platen) onto which you place the original photo, document or pages from a book - anything flat really. Some come with a transparency scanning unit (or TPU for short) that additionally allows you to scan slides or negatives. Flatbed scanners are relatively inexpensive and can scan at quite high resolutions, allowing you to put your scans into slide shows for example or make new prints.

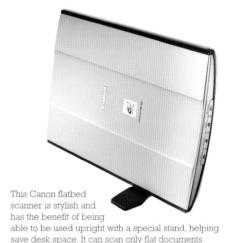

Film Scanners

and photos, not film.

Film scanners are dedicated to their task and are designed to scan just film (as opposed to paper prints) of a particular size, 35mm for example. Some, however, have adapters to take other sizes of film. They are 'transmissive' scanners (in that they capture light transmitted through the negative or slide) and can cope with both black and white or colour negatives and slides. Film scanners use special mounts to hold the film while it's being scanned.

Film scanners also have cleaning software. They are able to use much higher resolutions than flatbed scanners, primarily because the original is typically much smaller. A 35mm frame of film for instance is a lot smaller than a normal sized, 6x4 inch paper photograph.

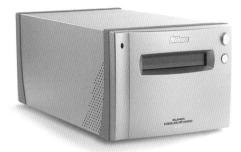

This professional level Nikon scanner is dedicated to scanning film. It's compact yet very high resolution, capable of producing extremely large scanned image files.

Film scanners are quite expensive, but offer a more professional level of working than flatbed scanners. They provide huge file sizes if needed to make massive prints or for larger scale image use.

'All-In-Ones'

Although we have briefly seen 'all-in-one' devices earlier it's worth going into a little more detail. As the name suggests, 'all-in-ones' are combined scanners, printers and photocopiers, sometimes with even a fax built in. These are primarily used where space is at a premium and you don't have room for lots of separate pieces of equipment.

The printer part of an all-in-one is usually of a good standard but the scanner element tends to be of a lower resolution than standalone scanners. The latter is also the part that is used to 'copy'. All-in-ones are inexpensive, particularly when compared to buying all three or four machines separately, and make a good general-purpose or home office tool.

This is a flatbed scanner from Epson, and has a TPU built into the lid so that you can scan both flat documents and photos, as well as negatives and colour film.

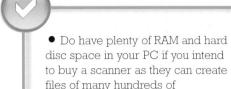

• Do remember that if you want to scan both prints and negatives, it's necessary to get a flatbed scanner with a TPU.

How Scanners Work

megabytes in size.

A scanner can be thought of as a digital camera but one that takes pictures in tiny slices, rather than the whole image at once. The scanner's software rebuilds all the slices back into an image.

A long thin CCD sensor is housed on a motorised arm that moves slowly, in tiny steps, across the original capturing detail as it goes. The resolution (measured in pixels per inch or 'ppi') depends on the number of pixels in the CCD and the number of steps it takes to move across the original document, which the user can adjust depending on the job at hand. The more pixels and steps, the more detail is captured and the higher the resolution and file size.

Preventing Camera Shake

It's very easy for camera shake to blur your photos. But there is a range of solutions and support accessories to prevent this.

What Causes Camera Shake?

Camera shake is caused when the shutter speed your digital camera uses is so slow that it is not fast enough to freeze the human body's natural and slight shaking motion or any other movement for that matter. Such slow shutter speeds come about as a result of using a long focal length which reduces the amount of light reaching the camera's sensor, or just if it is dark.

Preventing Shake by Adjusting **Shutter Speed**

To prevent camera shake in your photos always use a shutter speed that's the reciprocal of the focal length in use. Therefore, if you use a 100mm focal length, you should use a shutter speed of at least 1/100th second. If you use a 150mm focal length then the shutter speed will need to be at least 1/150th second and so on.

If you cannot control the shutter speeds on your digital camera, then to stop camera shake, you will have to support the camera. Very basic point-and-shoot digital cameras don't always offer control over their shutter speeds so a camera support in the form of a tripod or monopod is essential.

Even when you can control the shutter speed on your digital camera, you still need to keep the camera steady in low light. So when taking a portrait shot or photographing city lights at night, or even a sunset when the sun is very low, a support for the camera will ensure you always achieve a sharp image for your troubles.

Here are some of the best support options.

Tripods

A tripod is a three-legged support with telescopic legs that the camera screws onto via the screw lug on the tripod's mount and the threaded tripod bush on the base of the digital camera. Tripods are quite portable and ideal when using very long focal lengths or in low light.

Tripods come in many sizes, from mini, tabletop models to massive and bulky, professional ones built to keep your camera steady in almost any environment, even in strong winds. Tripods are ideal for shooting landscapes where sharp detail is crucial,

long exposures at night or if you

want to include yourself in a

shot. Monopods A monopod - as the name suggests - is similar to a tripod but with only one (mono) telescopic leg designed to help support the camera. The camera mounts on top in the same way as on a tripod, via its tripod bush. It helps to keep the camera steady while still providing a large degree of manoeuvrability. Monopods are not as steady as tripods, you have to hold them and they require a little practice to use properly. They do however offer a lighter, even more portable solution. The monopod shown here

Monopods are not ideal for long exposures at night but are great if you need to shoot a fast moving subject with a longer focal length, such as a running child at a school sports day event for example.

is folded down for easy transport.

Other Supports

It's worth noting that very basic digital cameras or those designed to be small enough to fit in a pocket may not have a way of connecting to a tripod. For these cameras you'll have to use an alternative means of support or use BluTack to 'stick' the camera to the tripod head. This is primitive but it works because such small cameras are very light. Make sure that you take great care that the camera is adequately fixed to avoid it falling.

One good alternative means of support uses a 'bean bag' construction which you can use to help cradle your camera on fence posts, walls or even the ground.

They're waterproof, come in various shapes and sizes and the filling provides a stable cushion into which you can snugly fit the camera. They're extremely versatile, as almost anything in the environment can become your camera's support. But again take care to ensure that the camera is securely supported.

Tripod Heads

The 'head' is the part of the tripod where the camera screws into place. Some use a special quick-release mechanism where the camera screws onto a mount that stays with the camera, enabling it to be quickly taken off without unscrewing it. More important, however, are the movements allowed by the head. Some tilt, some turn and some swivel all the way round, some do all three. The more movement you have, the more the tripod will cost, but the greater the flexibility once the camera is nestled neatly in place.

Using a Remote Release

mechanical release that screws into the shutter button to allow you to take a picture.

Some use a special electrical release that works in a similar fashion but costs more. Other digital cameras come complete with a tiny remote control (as shown) that allows you to trigger the camera from another vantage point, including from within the shot.

Extra Flash

Almost every digital camera has a built-in flash unit designed to give a burst of artificial light, though they're so small that they don't always provide as much illumination as you need. But there are solutions for too little light.

Most digital cameras' flash units are ideal for subjects close to the camera or as a way of filling in shadows in brighter conditions, but not much beyond this. However, depending on the type of digital camera you own, you can increase the amount of light at your disposal by using an accessory or 'off-camera' flashgun. These are much larger and provide a much brighter, controllable burst of light than a camera's built-in flash. Several types are available.

Hotshoe Flash

Many digital cameras have a hotshoe on their top plate which is a secure fitting with

electrical contacts. This provides a way to connect an accessory flashgun to your camera. Such flashguns have their own battery power (usually from four AA batteries) and once connected, an on-board computer 'talks' to your camera to get the flash exposure right each time it fires. This computer operates in the same way as it would for the built-in flash, and is automatically turned off when an accessory flash is mounted on

BUY A DEDICATED FLASH

While some, usually less technically complex, flashquns can be used on any camera they're attached to, they must be controlled manually. However, if you buy a flashoun made by the manufacturer of your camera or one made specifically for your make of digital camera, then they can provide 'dedicated' control.

Dedication is an advantage because the flashgun and camera work together seamlessly; the camera's metering and focus systems combine to help get better flash exposures. And such flashguns can also provide extra functionality such as stroboscopic flash (it freezes fast moving subjects) and finer control over the amount of light being used.

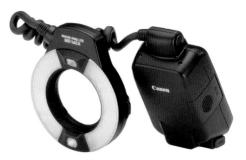

A ring flash such as this is designed for close-up flash work and can also be used effectively for portraits.

the camera. Some

JUDGING FLASH POWER

The amount of light a flash produces, or its 'power', is rated using Guide Numbers (GN) and is measured at a specific ISO (light sensitivity) and at a specific focal length.

The higher the GN, the more powerful the flashgun. A GN of 11 is typical for most digital camera built-in flashes, and will provide enough light to illuminate up to around 11 feet (3.3m) from the camera, at a typical ISO (usually ISO 100) and a focal length of 50mm. A flashoun with a GN of 50 on the other hand will properly illuminate everything up to a maximum area 50 feet (15m) from the flash.

Note that if you alter the focal length or if you change the camera's sensitivity. the range a particular GN can illuminate will also change.

more expensive models offer comprehensive manual control.

Many flashquns also have what's called a 'bounce head' and these are the best types to use as the flash's head can tilt, turn and swivel in order to redirect (or 'bounce') the light at an angle. This allows control over where the light comes

from, for example bounced off nearby walls or a ceiling. This is useful as it helps to increase

A 'typical' accessory flashgun showing the pivoting 'bounce' head on the top of a body that houses the controls and batteries.

SIGMA

creative opportunities (adding neat shadows over a subject for example by bouncing light from one side off a wall) or simply to reduce the harshness of the light hitting the subject if fired 'head on'. The more control and bounce

This flashoun is shown on a small stand for slave flash use. Note the data LCD on the back and many controls that provide all the functions needed to use the flashgun either as a slave or attached to the camera's hotshoe.

movement a flashoun has, however, the more expensive it will be.

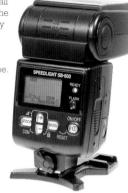

Slave Flash

Slave flash units are another type of

accessory flashgun, which can be triggered by detecting the light emitted by other flash units (or in some cases by using a special radio signal). As such, they are said to be 'slaved' to the main flash doing the triggering. In fact, you can trigger multiple slave flashouns simultaneously.

Some of the more advanced hotshoe flashouns can be used as slaves, but you can purchase 'dumb' standalone units too. Dumb freestanding units are inexpensive and can be placed almost anywhere but in either case, slaves are ideal for getting even more light onto a scene such as a very large room or a large group photo where one flashgun cannot cope on its own.

Studio Flash

Some high-end digital compacts and most D-SLRs have what's called a 'flash synchro' terminal. This is where a studio flash system can be plugged into, and triggered by, the camera.

Studio flash systems comprise large lights often with reflectors attached (they look like big umbrellas) and require mains power. Though they tend to be, as the name suggests, studio-based, some systems are portable and could therefore be used at home.

With such a system, you have ultimate control of the lighting of a subject, ideal for things such as portraiture. But they are very expensive and really only for the very serious photographer.

Extra Storage

Your PC may have a large hard drive seemingly offering plenty of space. But sooner or later you're going to need extra memory, so here's what you should look for.

Today's PCs come with large capacity hard drives, usually over 250GB. However, digital image files can quickly use up this space, as can the applications you use to work on those images. This will slow your PC down too.

External Hard Drives

External hard drives (or discs) are the solution to this. They are relatively inexpensive, simple to use and can provide you with an abundance of extra storage space - they're now available in capacities of over 500GB.

Onto these you can store your photos and any other large media files such as digital music files or videos you've captured on your digital camera. As a rough guide, a 100GB external hard disc can provide enough space for around 50,000 images, depending on their file size.

As with buying a PC, it's important to get as large a capacity disc as you can afford. Although seemingly more expensive at the outset, this actually works out much cheaper than buying several, smaller capacity discs, a situation you may find yourself in as your image library grows.

Once plugged into your computer, the hard disc will appear on your PC's desktop as a small hard disc icon and you'll simply be able to drag and drop onto it in the same way you can with other folders on your PC. They usually don't require any special software to install them and work automatically once plugged in. How to

actually store your data is dealt with in more detail in the topic Backing-Up.

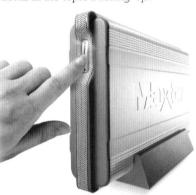

Maxtor's One-Touch II Drive provides a simple to use desktop solution to image storage. As its name suggests, it's easy to use. When connected to your PC, one touch of its button saves images (or any data) across from the PC to its high capacity hard disc without needing any further intervention.

Speed and Connections

Regardless of what capacity disc you buy there are things to look for to help get the most out of your data and working environment. To start with, buy an external hard disc with at least a 7200rpm disc speed. Check the spec on the box before you buy or ask your retailer for advice.

Also buy a disc with either USB 2.0 or FireWire (IEEE 1394) 400 or better still FireWire 800 and preferably with multiple ports, no matter what the connection type.

This way you can be sure you have fast data transfer rates thanks to the connections.

a high speed disc for quick data addressing (that's reading or writing your data) between your PC and the external disc, and you'll be able to 'daisy chain' multiple devices.

An example of the latter is having two external hard discs connected to one another and then to your PC, giving you more total storage. One external disc plugs into the other, and then that last disc is the one actually connected to your PC. Both discs will still appear as separate hard disc icons on vour desktop.

Portable Storage

You don't have to confine extra hard disc. storage to the desk at home or the office. Today there are a range of portable hard discs that provide you with extra storage capacity on the move, ideal for saving images from memory cards to free up space.

Many portable hard discs provide 'dumb' space, they're just a repository for the images and that's it. Others come with screens: some have large colour screens for image playback and browsing while others have black and white LCDs that just provide a simple way to check what's on the disc

The Epson P7000 is a portable with a large 160GB capacity, a 4-inch LCD screen with D-SLR compatible 920k-dot resolution and with built-in card readers for CF and SD/SDHC cards. It also has high quality MPEG-4 video and AAC audio capability so makes a great multimedia device too.

Top Left: This portable image and media player is the very portable Sansa Fuze. It sports a high quality screen with 8GB of internal storage and has iPod-alike controls and styling. The Fuze accepts MicroSD external storage as well and has USB connectivity enabling upload of images, movies and more for playback on the move.

Top Right: The Elio Photo Jukebox is a compact size. high-capacity, portable hard disc and image player with a 20GB hard drive and 2.2-inch colour screen for image viewing and navigation. It can also play your digital music, and has an SD memory card interface for direct image downloading and special 'media management' software to help organise all the data stored on it.

The latest portable hard discs come with software built into them to play slide shows of the images. These can also be played on TV. Some can even play DVD style movies with sound, thanks to built-in speakers.

Portable hard disc capacities tend to be lower than their bigger non-portable counterparts (between 20 and 200GB) but still provide a compact high capacity storage solution on the move.

You can also buy ultra portable external hard discs, which can fit in the palm of your hand or snugly in your camera bag. They are battery powered (usually a couple of AA batteries) with USB 2.0 connectivity so that you can connect to your digital camera or PC. Others have card slots so that you can plug in a memory card and transfer images directly from the card

Light Meters

Still not getting the lighting right on your pictures? If you're suffering from pictures that are overexposed or too dark, using a light meter could be the solution.

A hand-held light meter may not seem to be an essential item given that all digital cameras have a built-in light measuring system of some kind.

However, built-in meters are sometimes not accurate enough, particularly for the demands of the enthusiast or professional photographer.

A camera's meter measures the light reflected from the subject, a person's face for example. A hand-held light meter can be used to measure this light as well, but more importantly it can also measure the light actually falling onto the face.

By holding a light meter alongside the subject, within the same light in which it will be photographed (called an incident light reading), you are able to assess that light more accurately. And that enables a more accurate measurement which can be used to hone your exposure setting on the camera. The reading from the light meter is transposed to the camera and you take your photo as normal.

To be successful, you need a camera with an all-manual mode where you control the aperture and shutter speed for example. Most hand-held meters offer a range of sophisticated settings including a flash sync port (similar to that found on most D-SLRs) so that they can be used in conjunction with studio or off-camera lighting as well as via a cable connecter (see *Extra Flash*).

Hand-held light meters can be expensive but offer a very accurate way to assess exposure and so can improve your creative potential.

Buying Guide

You can spend a lot on a high-spec multifunction light meter, but you don't have to. As long as you get a meter with the following features, it should serve you well.

Buy a meter that offers flash and ambient light readings. This allows increased control in all conditions.

Get a model with a sliding globe – a hemisphere of white plastic that can hide or reveal the meter's light sensor. This covers the sensor during incident readings or can be moved aside for reflected readings. A built-in sliding globe is safer as you won't lose it.

Look for a compact meter. Some meters can be quite bulky, usually larger models designed for studio use. Buy one that will easily slip into a shirt pocket or camera bag.

Consider buying a light meter with a flash sync port. You never know, you may end up using off-camera flash and with this capability built in, you'll be able to finely tune and control flash exposures, ideal in a studio environment for example.

MINELTA

Batteries & Power

There's nothing worse than getting ready to take a photo to find the 'battery low' warning flashing. Here's how to be fully powered up at all times.

The lifeblood of your digital camera, not all batteries are made equal. Here are some tips on getting the most from them and so your digital camera.

- Battery power is measured in mAh or milliamp hours. Only buy high-mAh batteries; 1000mAh is better than 500mAh as they have a higher power density and will last longer.
- If your digital camera uses four AA cells, you can save thousands of pounds over the lifetime of the batteries if you buy good quality rechargeable ones and look after them properly.
- Always charge your batteries properly, for the correct length of time. You can accurately determine the length of charge by multiplying the mAh figure by 1.4 and then divide that figure by the charger's current, indicated by its mA figure, which is usually displayed on the charger. For example, for a 2000mAh power battery, being charged by a 250mA charger, you would make the following simple calculation:

 $2000 \times 1.4 \div 250 = 11.2$

Remember

Always take a spare set of batteries with you when you're mobile with your digital camera. Either charge up a spare set of rechargeable batteries or take new disposable ones along.

So a charge time of 11.2 hours is needed. Failing to do this can reduce the life of the batteries

BATTERY TYPES EXPLAINED

- **Carbon Zinc**: Disposable batteries not suited to digital cameras.
- Alkaline: General all-purpose battery, cheap but not ideal for digital cameras.
- **Lithium**: Disposable and one-third lighter than alkaline batteries. High power, long life and environmentally friendly. Suitable for digital cameras.
- Lithium-ion battery: Some digital cameras come with this special battery 'pack' and charger, designed specifically for them.
- Nickel Zinc: Disposable battery similar to lithium in its good power delivery and low environmental impact.
- NiCad cells: Rechargeable batteries, not good for the environment but can be recharged for over 1000 charge/ discharge cycles. Can suffer from the 'memory effect' which is a capacity loss if they are over- or partly charged, or not fully discharged before recharging. This means they cannot then hold a full charge or that they 'remember' their last, poor charge state.
- NiMH cells: rechargeable batteries that don't have memory effect problems, last a long time but are more expensive.
 Can be recharged over 1000 times.

Using Your Digital Camera

In this section, you'll find all you need to take great photos, including:

Overcoming the common problems of low light, blurred images, poor framing, under and overexposure, washed-out colours and redeye

Inspirational photo ideas to improve your creativity

Practical advice on getting the best results, whatever the subject: portraits, weddings, close-ups, children, travel, flora & fauna, still life, abstracts and black & white

Explanations of depth of field, exposure, white balance, F-numbers, ISO, shutter speed, aperture width, rule of thirds...

Composition

What makes one image more pleasing than another? By following a few simple steps about where to place elements within your pictures, you'll be surprised at how much you can improve your photography.

Composition is the name given to the combination of all the elements within the photo, and their position in the scene. Compositional rules can be thought of as guides to help get better photos. Here are some key techniques to keep up your sleeve.

Framing

Always fill the frame with your subject. If you are photographing a person, then make sure you can see them and that they are not too small within the frame. The benefit of this is that you make the most use of all the pixels you have at your disposal.

Another framing tip is to use frames within frames. When taking a shot, don't be afraid to use elements of your surroundings to frame a more distant part of the scene; shooting through a window including the window frame is a good example.

Portrait or Landscape?

Like any digital camera, yours can be used horizontally in its normal or 'landscape' position or it can be used upright in the vertical or 'portrait' format. While these names suggest the types of image you'd usually use each format on, experiment to see which works best for a given shot.

Rule of Thirds (or Golden Mean)

Using this 'rule', you can add tension and a dynamic 'feel' to your photos by careful

placement of the main elements. First imagine that your digital camera's colour screen is split into a grid of nine equal squares; two lines running vertically and two horizontally across it. Depending on your digital camera, it may have the ability to display such composition lines on your camera's screen for you.

If you place the subject upon any of these lines or, in the case of positioning specific elements within a photo, where the lines intersect (these points are the so-called 'Golden Means'), the image can have more impact. Try placing the horizon across the top (or bottom) horizontal line rather than across the centre of the shot for example. Or place a person at one of the intersections when you want to put them in context with the background in a landscape-style photo.

Bull's Eye Composition

This is when the main subject of the shot is smack in the centre of the frame and should be avoided unless you have a specific reason for doing it. This type of image is less pleasing to the eye and lacks dynamism.

> This shot of potters in Nepal uses the rule of thirds beautifully: both potters' wheels sit on the Golden Mean points. The graphic pattern created by the thrown pots adds interest, and energy comes from the use of a slow shutter speed that has allowed the spinning wheels to blur nicely.

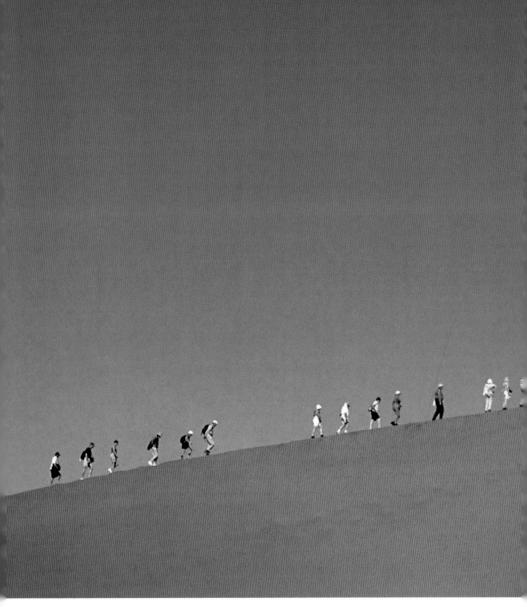

Balance

You can create images with either equal or unequal balance. In the former you have elements within the photo balancing each side of the image, say two buildings of the same size. In the latter, you would have one prominent subject with another element in

the scene placed on the other side of the frame that's either closer or farther away (whichever is best for the composition). Place a big tree on one side, then a small rock or bush or person on the other for example. Although a subjective technique, it is one which can prove very successful when the elements are placed carefully.

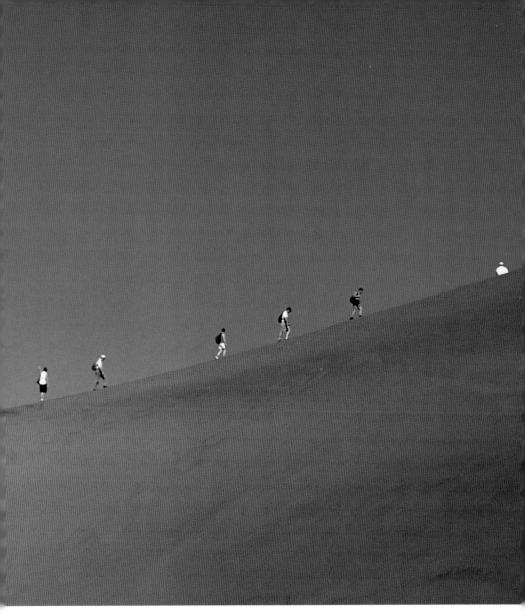

Experiment

The last 'rule' and probably the most important is simply to experiment. Like so many rules, these simple techniques can be broken or bent and by mixing them you'll quickly learn how to get the best from your digital camera.

This image from the Namib Desert has a very dynamic structure thanks to the flowing curve of the sand dune and the sky. Colour is also very important here and the teeth-like effect of people walking on the dune's ridge adds both a sense of scale and energy to the composition.

Focus

Getting your images sharply focused is just a matter of pointing the camera at the subject and pressing the button, isn't it?

Focusing is critical to good photos and today's cameras usually have an auto focus system that quickly gets things sharp. However, not using this properly can ruin an otherwise perfect shot.

Most digital cameras have a central auto focus target indicated by a small square in the colour screen. Many use multiple focus points, which ensure off-centre subjects stay sharp. But, how many times have you taken a picture of family members side by side, with a gap between them and the camera has focused on the wall behind? Read on to find out how to prevent such problems...

Don't Rush the Shutter Button

All digital cameras that use auto focus have a dual pressure shutter button. A first, halfpress-and-hold activates the focusing and other in-camera systems. There's a brief pause and then you'll get some form of focus confirmation: a green LED in the optical viewfinder and/or a green icon displayed in the screen. Only finish pressing the shutter release once you have these 'confirmations'. Trying to take a shot in one big press won't give time for the camera to set itself properly and you'll risk a blurred photo every time.

Portraits

In portraiture, your intention is to take a picture of a person. This usually means a head and shoulders shot or tightly cropped face, so always focus on the subject's eyes. If your camera allows control over which auto focus (AF) points you can use, select the

If you don't let the camera focus by half pressing the shutter button and allowing it to focus properly, you'll get blurry pictures such as this shot of a baby.

central AF point, or the Face Priority AF system where applicable, and use it to focus (half press the shutter button), and then recompose the shot, still holding the shutter button half way to preserve the focus selection. Complete the press to take the shot once you have the composition right.

Landscapes

To get a good landscape you need to ensure sharp focus from the foreground to the far distance. Begin by auto focusing on a prominent object in the distance. Haziness can hamper AF and if your digital camera uses a wide AF system ensure it does not set the focus to something nearby or at the edge of the frame. Then, keep the camera rock steady, using a tripod if necessary.

Use the camera's landscape scene mode – if it has one – as this optimises the camera's settings for landscape work, or select a small aperture if using manual settings.

Macro Shots

Digital cameras offer some of their best results on close-up or 'macro' work. Some digital cameras can focus to within one centimetre of the subject, ensuring frame-filling shots of even tiny details. However, you need to ensure the correct part of the subject is sharp. Use a single AF point and recompose once it's in focus. Also use a tripod, which helps keep things stable if you have slow shutter speeds. Remember, for close-up work you can use the camera's macro mode or select a small aperture if using manual settings.

Small Groups

To prevent the problem of the auto focus locking onto the wall behind a group shot, either move the subjects to reduce any gaps between them, or focus on one person's face and then recompose. This way, you'll ensure that the group, and not the wallpaper, is sharp. Again, try the Face Priority AF system.

By concentrating the focus on the model's eye your interest is directed to her, the main subject of this reportage-style portrait.

Avoiding Auto Focus Problems

Some subjects always cause AF systems problems, so here are ways to avoid them.

- Parallel lines and regular patterns: These can be difficult for the AF to 'key' on. Try tilting the camera (from landscape to portrait for example), refocusing and then recompose for the shot.
- The dark: Unless your digital camera has an 'AF emitter' (it shines a beam of light out to help focusing), darkness or dark subjects provide nothing for the camera to focus upon. The answer is to get more light on the scene; turn on a light or two.
- Low contrast: Fog, haze, a
 predominantly white or black
 subject that doesn't provide the
 AF anything to focus upon can all
 present problems. You cannot
 change the weather; so try
 looking for an alternative but
 prominent element of the scene
 to focus upon. Also, use the
 camera's landscape mode, which
 ensures a small aperture is used.
- The Manual Focus solution:
 Alternatively, to help prevent any of the above problems, try using your camera's manual focus mode if it has one. By taking control of the focusing yourself (check your camera's manual for operating instructions), particularly if you have the time to work on the photo, this will provide fine control and you can check the results on the LCD too.

Depth Of Field

The 'depth of field' is simply how large the focused area in a photo actually is. Let's see how it can be used to help create emphasis in your photos.

Everyone has seen photographs in which everything in the picture is crystal clear, from a foreground flower to the distant mountains. You've also seen pictures where only the main subject is sharply rendered, and everything else is blurry.

These are two examples of the effect which depth of field (DOF) can have. The former is a shot with a deep DOF (more of the scene is crisp) and the latter has a shallow DOF.

What is Depth of Field?

In more accurate technical terms, DOF can be defined as being 'the range of object distances within which objects are imaged with acceptable sharpness'. Thankfully, particularly if using a compact digital camera, you don't need to know the complexities behind the DOF calculations, just how to maximise it to your advantage.

So for simplicity, here are the key practical points about DOF:

- A wide aperture gives a shallow DOF
- A small aperture will give deep DOF
- A telephoto lens (or long zoom, at the 'zoomed' setting) appears to give shallow DOF
- A wide-angle lens appears to give a deep DOF

In points three and four above 'appears to' is used because while the perception in the shot is usually as described, it is not always – technically speaking – accurate. It depends on the subject magnification and scene perspective (or viewpoint) making direct

comparison of focal length and DOF difficult.

However, although this may sound complex, you can now start to play with the DOF effect in your images.

When to use Shallow DOF

The most common use for a shallow depth of field is in portraiture where you want to emphasise the subject. By using either a long focal length on your lens and/or a wide aperture, say, F2.8 (see box opposite for explanation of Fnumbers), you can get the effect of a sharp subject and blurry background. Use this technique on any shot where you want to separate it from its background. A shortcut is to use the portrait mode on your camera if it has one.

away the distracting

background.

When to use Deep DOF

This is slightly more flexible but a good example of when to use deep DOF is for landscape photos. Typically, you'll use the wide-angle end of a zoom lens and a small aperture of, say, F8, which will help to ensure that the sharply rendered area in the shot stretches from near the camera to the far distance. A shortcut here is to use your camera's landscape mode if it has one.

Close-Up and DOF

It's worth pointing out that in close-up shooting, particularly if your camera has a good close-up or macro mode, the DOF will be very shallow indeed; a mere millimetre or two at most. Use a smaller aperture, F8 for example, to help deepen DOF if you want more of the small subject to be sharp.

Throwing the Background Out Of Focus

By selecting a suitable aperture, it is possible to throw the background out of focus by changing the depth of field. In the example below, the same scene was taken three times using different size apertures for each shot.

Firstly, a small, F16 aperture was used, which gives a sharp image from the gargoyle to the distant Montmartre in Paris. For the second shot, an aperture of F5.6 is used and now an element of blur has removed much of the sharp detail visible in the first shot. Finally, an aperture of F2.8 was selected and the background detail is almost completely blurred away.

The effect is to divert the viewers' attention increasingly to the foreground. This is in essence why control of DOF can be so powerful, particularly when there's a cluttered, distracting background.

USING F-NUMBERS

The physics behind the effect that aperture size or F-numbers (also called F-stops) have on photos is quite complex but here are some simplified ways to think about and use them.

The first thing to remember is that a low F-number of, say, F2.8 gives a larger aperture while a high number, such as F8, gives a smaller aperture. A large aperture lets in more light and a small one less light.

Use apertures to:

Let in more light if it gets dark and you don't want to use flash or to get faster shutter speeds in brighter conditions. Here use a small F-number, say F2.8, to make a larger aperture until the exposure is correct in low light or the required shutter speed is achieved in bright conditions.

Control the DOF. Adjust the aperture to a small F-number (F2.8 for example) to get a big aperture and reduce the DOF (which will blur the background) when shooting portraits for example, or any shot where you want to blur backgrounds. Use a high F-number (F8 or F11) which will increase the DOF for close-up work or for landscapes and keep everything sharp in the entire photo.

Exposure

Exposure, the amount of light that reaches your camera's sensor, is the key to great photos. Here's how to control it.

Exposure is controlled by three elements: the camera's shutter speed, the lens aperture and the sensitivity. It is calculated by the camera's metering system for any lighting using a specific combination of these three elements. Alternatively, you can manipulate the exposure either to deliberately darken or lighten a scene, called under or overexposure.

Shutter Speed

The camera's shutter is a small, usually metal curtain that travels across the face of the sensor and helps control the quantity of light hitting the sensor. A fast shutter speed lets through less light, a slow shutter speed more. The faster the shutter speed the greater the 'freezing' effect it has on motion and vice versa.

Aperture and F-Stops

The camera's aperture is a small adjustable circular opening in a diaphragm within the lens through which light must pass to reach

the shutter and then the sensor. The aperture's size can be varied (called the 'iris' control) and each position is called an F-stop. The smaller the F-stop number the larger the aperture. The larger the aperture the more light is admitted. Aperture settings also have an impact on the depth of field (see Depth Of Field for a fuller description of F-stops).

Sensitivity and ISO Equivalence

The digital camera's sensitivity to light can be increased, which is great if it gets dark. Digital camera sensitivity is based on a scale similar to that used for 35mm film sensitivity, called ISO. and is typically 100, 200, 400 and upwards. The higher the ISO number, the more sensitive to light the camera becomes. (See Low Light for more explanation of ISO numbers.)

Increasing the camera's sensitivity (or its 'ISO equivalence') allows you to use higher shutter speeds or smaller apertures than would otherwise be possible at a given light intensity.

CAMERA TYPES AND LEVELS OF CONTROL

Being fully automatic point-and-shoot models, basic digital cameras will not offer any level of manual control.

Some mid-range models offer an aperture priority mode; you set the aperture while the camera sets the shutter speed according to your choice for a correct exposure.

Higher-end models provide control of both (aperture and shutter priority) where you make a selection of one, and the camera automatically sets the other to get a correct exposure. Some, however, do offer full manual control, where both can be independently set by you.

Exposure Compensation

This is the ability to adjust the exposure by one or two F-stops (depending on your camera's sophistication), overriding the camera's automatic exposure control system and therefore lightening or darkening the shot. This allows fine-tuning of the exposure without adjusting any other settings and is ideal if extremes of light are 'tricking' the metering into under or overexposing.

Auto Exposure Bracketing

This is an automatic setting on more advanced digital cameras that carries out exposure compensation for you, automatically, and each time you take a photo. And it does it to a predefined level and on a predefined number of images, usually three.

Exposure bracketing means the camera takes one shot at the metered exposure, then (usually) a single underexposed and another

EXPOSURE EFFECTS

The shutter speed and aperture are interrelated when it comes to setting exposure. By combining the two settings – if your camera offers manual control over them – you can adjust the exposure for specific effects. A fast shutter speed and large aperture can freeze motion. A slow shutter and small aperture can help blur motion.

overexposed shot as well. It takes these three shots (or more depending on the camera) each time you fire the shutter and you can pick the best shot to keep. The amount of under or overexposure can be preset by the photographer by up to one or two F-stops and again depends on the camera.

In this overexposed shot, note how colour has been lost and highlights have been bleached out making for an insipid looking picture.

An underexposed shot such as this one reveals plenty of colour but all the detail has been lost in shadow areas.

White Balance

Unlike the human eye, digital cameras can't automatically adjust to compensate for variations in the colour of light, potentially causing unnaturally coloured pictures. But here we'll show you how to adjust your settings for this – or use the effect creatively.

When shot with a digital camera, a candle produces a nice warm glow, normal household tungsten bulbs create a yellow colour and fluorescent strip lighting produces a cold-looking cast. Artificial light can produce such unnatural-looking colours because digital cameras are primarily designed to 'see' sunlight - that is, light containing all the colours in the spectrum. They need to have their 'white balance' adjusted to take account of occasions when not all of the colours of the spectrum are present.

Most digital cameras are able to set the white balance for a given lighting in two ways. Firstly, there is an automatic white balance (WB)

- Do use the correct WB mode for the lighting you're shooting in.
- Do use the auto WB mode if you're not sure of the light or if it's a mixture of various lighting.

This shot below reveals the difference that using the incorrect white balance will have on your photos. From left to right we have:

- 1 Shade
- 2 Tungsten
- 3 Fluorescent
- 4 Flash (the correct setting for the studio location)

- Don't worry if you get it wrong. change the WB setting and shoot again.
- Don't change the WB setting if you want to capture the mood the ambient lighting has created in the shot.

setting that adjusts the colours for you. Such WB settings can be found in the camera's set-up menus.

You will also find a range of possibly four or five other manually selected settings in the WB set-up menu. These will include 'cloudy' (or 'shade'), 'tungsten' and 'fluorescent'. Some might have a 'mercury' setting and all will have a 'daylight' mode. Each setting alters the way the camera's sensor 'sees' and records the light

according to the conditions.

Experiment with these settings outdoors and you will be able to see how each mode affects the image in the colour screen. Selecting tungsten for example makes daylight images go blue, as this is used to compensate for the warm colour cast attributable to household bulb lighting.

These settings more accurately capture and process the light than the catchall automatic WB mode, which entails extra processing of the image too. In other words, if you know the lighting you're shooting in, then select one of these WB modes so that you can fine-tune your shots. This will help get better quality shots and save time processing on a PC later when you may feel any colour casts are too intrusive to the photo and need removing.

Creative Use of White Balance

There's one caveat to all this. Sometimes you might want to take a picture and keep the colour cast, for example when you want to capture the atmosphere the lighting creates, as shown here in the picture of a candle-lit church. In this case, the auto WB setting proved best, but experiment to see if you can get results that are even more creative.

Creative Flash

Your camera's built-in flash unit has more creative potential than you might imagine, it's not just for use 'in the dark'.

Most cameras automatically apply the flash when it gets dark or whenever more light is needed. Whilst useful in many scenarios, this can limit creative potential. By using flash in bright daylight you can add sparkle to a shot, reduce harsh shadows and boost colour too. so don't always think 'flash equals dark'.

Auto Flash

Most digital cameras' default flash setting fires the flash automatically whenever the camera's meter senses that the ambient light has dropped beyond a level at which a reasonable hand-held exposure can be made.

The flash fires every time in such conditions but the small size of the flash and the resulting flash exposure can leave the shot looking flat and dull, and you'll get unattractive dark backgrounds to each photo (see Flash Fall Off overleaf).

Auto flash is quite limiting, particularly if you want a photo that records both the atmosphere of a party and the people (see Slow Sync Flash opposite). So let's consider some alternative ways to use the flash.

Fill-In Flash

Fill-in flash, as its name suggests, is when the flash is used to fill in parts of the scene with extra light. It's 'forced' to fire each time, ideal for shots of a heavily backlit person or in situations where the camera's meter might be fooled by bright surroundings such as snow or on sunlit beaches.

This technique helps balance the

exposure between the flash and the ambient light. Altering the exposure is not always an option: exposing for the shadows in our portrait example here would have unacceptably overexposed everything else while a nonflash exposure would have left a dark shadow area on the subject's face. A puff of flash has worked a treat. Use this technique to add 'catch lights' in the subject's eyes too; it helps bring portraits to life.

To use fill-in-flash, turn on your camera's fill-in flash mode (if it has one) but if not. switch the flash to its forced flash 'On' mode (it will fire every shot) and the camera's metering system will do the rest. Some cameras will have an auto backlight feature to help out, automatically firing the flash when the background exposure level is much brighter than other parts in a scene.

Slow Sync Flash

Slow sync flash sounds complicated but in essence, it is just a means to synchronise the flash and shutter at a slow speed to help capture ambient lighting in a flash photo. The flash freezes any movement in the main subject while the slow shutter picks up the gloomier background. This is great for those shots where the flavour of an image comes from the ambient lighting - such as a party but the people in the foreground are the main subject of your photo.

Most digital cameras will have a slow sync flash mode but if not, select a slow shutter speed and fire the flash (use the flash 'On' mode) and it will achieve similar results. Slow shutter speeds mean the camera will need supporting to reduce camera shake, although this can be used to creative effect if you want to add a dramatic dynamic to a

Flash Off

Not strictly speaking a flash technique, it's here because there are times when flash is the last thing you want in a photo. These include taking photos through a window, or when taking photos of a flat subject or one with a reflective surface, where the flash would leave a 'hot spot' in the photo where the flash is 'bounced' back into the lens.

REDEYE REDUCTION FLASH

We have all seen photos of people taken with flash in which they appear to have bright red eyes. This is caused when flash light reflects directly back into the camera's lens off the eye's retina. It's red coloured because of the blood vessels in the eve.

Redeye is most common in low light (the eve's pupil enlarges to let in more light), and when using cameras where the lens

and flash are close together - always the case on very small digital cameras!

Depending on the camera, whilst in redeve reduction mode the flash either emits a bright beam of light or a series of fast strobe flashes will fire. Both help reduce the pupil size of your subject, lowering the chance of light being reflected back into the lens.

Flash Fall Off

Flash fall off is caused by the flash illumination dropping off quickly beyond a certain distance. This happens because the intensity of illumination is inversely proportional to the square of the distance between light and subject. Put more simply, if the distance between light and subject is doubled, the light reaching the subject will be only one-quarter of the original intensity.

The result is that light for a correct exposure quickly drops away leaving backgrounds looking very dark, as shown here in our example picture. The man's perfectly exposed. but there's no detail in the background at all, even though this image was shot in a reasonably well-lit but very large room at a wedding.

To avoid this, try using the slow sync flash technique or use an accessory flashgun (if your digital camera has a hotshoe) to provide more light.

Low Light

Shooting in low light or darkness presents real challenges but can be one of the most rewarding photo techniques to get right. Let's look at the best ways to achieve stunning low-light shots.

Typical low-light photo scenarios include shooting cityscapes at night or shooting in a dark interior such as at a party, whilst still capturing the atmosphere created by the available light. Here's how best to shoot different dark scenes whilst avoiding the typical camera shake and image noise problems associated with low light.

Shooting At Night

Night photography, say a night landscape scene with the moon in the shot, presents a couple of key problems: keeping the camera stable is one and another is image noise (see right). A tripod or other such support will keep your camera steady. If you don't have a tripod then find a suitable wall, table or similar support on which to place the camera.

Ensure you set the largest aperture on your camera's lens (if you can control this feature on your camera) and turn off the camera's flash. Then set your camera's 10-second self-timer. This way, even if you jog the camera when you press the shutter button, the vibration this causes is gone when the shutter fires 10 seconds later. Select the camera's landscape scene mode, which ensures correct focus and on many cameras it will automatically deactivate the flash for you too. Also, try selecting the camera's night scene mode if it has one.

LOW LIGHT AND 'NOISE'

A potential Achilles heel that most digital cameras suffer, barring (to an extent) top-end professional models, is image noise in low-light shots. It looks similar to the effect of heavy film grain and is usually characterised by blue or red pixels peppering images shot in low light, particularly those with large areas of even colour. And the darker that 'colour' the more obvious and intrusive it can be.

Noise is created when the signal-tonoise ratio (the difference between the light captured, the 'signal', and the interference or 'noise' created by the camera's electronics, analogous to the hiss you hear if a radio is not tuned properly) is such that there's more noise than signal. Therefore a high signal-tonoise is good (think lots of light) and the reverse is not.

Increasing the camera's sensitivity (its ISO setting) makes the camera more sensitive in low light but has the drawback of adding extra noise. Try to stick with lower ISO settings, such as ISO 100 or ISO 200 and support the camera where possible. Also, ensure you switch on any noise reduction setting – if your camera has it. Noise reduction can extend the processing time between pictures; the worst effects of noise can be processed away.

Low Light and Flash

The night scene mode can also be used in low light. A slow shutter speed with a burst of flash records any ambient light and the flash illuminates the foreground. You still need to support the camera as a very slow shutter is used and the trick with the self-timer is a good idea too. Remember to use the camera's redeye reduction setting if the foreground interest is a person.

This shot was taken using the camera's night scene mode. The burst of flash has frozen the boy, but the background is blurred by camera shake.

Night Portraits

Another common setting on many digital cameras is the night portrait mode. If it has one, select this mode when shooting people in low light. This will select a slow shutter speed combined with the flash - similar to that used in the night scene mode - but crucially, the flash exposure will be less powerful, helping to ensure the subject's skin doesn't bleach out, a problem if the flash light is too harsh.

Party Pictures

A perennial problem taking pictures indoors and particularly at parties is the relatively low available light. The flash will always want to fire and there's a risk of blurry pictures from camera shake if you turn it off because of the slow shutter speed.

Another problem here is that the small flash will not be able to cope with the areas you're trying to illuminate, even relatively small rooms can be too much for a built-in flash. The resulting photo will have a very dark background and this is called 'flash fall off'. The problem is surmountable by switching the flash to its slow synch mode (see Creative Flash for more on this). You risk motion blur, but this can, however, appear to be an intentional effect, as in the night-time shot here.

This shot taken at ISO 200 has no noise problems, the image looks 'clean'.

An otherwise identical shot but this time taken using ISO 3200. You can see image noise is very obvious and seriously undermines its quality, filling the image with blue and red speckles.

CAMERA SENSITIVITY (ISO)

A camera's sensitivity to light is measured in ISO and the higher the number the greater the sensitivity to light. Here's an at-a-glance guide to ISO speeds and what they're good for.

- ISO 100 (or lower): The best all round setting for bright conditions or where low noise is a key requirement.
- ISO 200: Ideal for slightly less bright lighting where low noise is still a requirement but not key.
- ISO 400: Noise might be an issue here on some cameras when printing at larger sizes. Provides faster shutter speeds in overcast conditions or low light.
- ISO 800: Noise will be evident even at 'normal' print sizes so use the camera's noise reduction if it has it. Ideal where fast shutter speeds are needed to freeze fleeting action.
- ISO 1600 (or higher): This setting will only be available on high-end digital cameras and professional D-SLRs; it offers very fast shutter speeds in very low light. Noise issues are as above, but high-end models will have special noise reduction algorithms to reduce this.

Close-Ups

Close-ups are one of the most practical and creative areas of photography and a real strength of digital cameras. Here's how to make the most of your camera's macro abilities.

Close-up or macro (its technical term) photography opens new perspectives on our natural world and most digital cameras are very good at it. Even basic models have macro modes built-in enabling this great technique to be used without needing specialist equipment.

Digital cameras are good at macro because they have a combination of small sensor sizes and short focal length lenses. Together these provide closer focusing distances than would otherwise be available with 35mm film cameras.

Some can even focus as closely as one centimetre – that means the subject can be almost touching the lens. Even if your digital camera doesn't have a macro mode, as long as you can focus the camera sharply on subjects within 20cm of the front of the lens (or closer) you can shoot good close-up shots.

How To Take Close-Ups

Just like a 'normal' photo, when shooting closeups the subject appears in the camera's LCD, which you use to compose and focus your subject properly. If your camera has it, select its macro setting as this helps get focus spot on, and gets metering and depth of field (DOF) to the optimal level for the shot too.

A drawback is that macro results in very shallow DOF so you will find that just a very

IDEAS FOR CLOSE-UPS

The practical and creative uses for macro shots are almost endless, so here are some simple ideas for you to try.

- Photographs of your jewellery or stamps in a stamp collection can be shot in close-up for insurance purposes, as well as being attractive images in their own right.
- Garden flowers make stunning subjects and are easy to find and...
- Insects such as bees and butterflies, which you'll find on those garden flowers, can also look great in close-up.
- Textures and patterns often look dramatic in close-up too. If it looks bad 'big', think small and close in for a macro shot, it may just be worth it.

MORE MAGNIFICATION

One way to get greater magnification if you cannot focus really close is to shoot from further away, zooming in to get a closer crop. You can then use software on the PC

to crop closer still later. But this means you lose pixels (you've cropped them away) so you won't be able to enlarge the prints as much. Zooming in will also reduce the DOF.

small area is sharp and the rest of the subject will be out of focus (see the poppy shot example) so you may need to shoot several pictures until you're happy with the focus point. Adjusting the aperture to use a smaller F-stop (F8 for example) will help deepen the DOF but will result in slower shutter speeds, so you may need to use a tripod to steady the camera in order to prevent camera shake.

Subjects such as butterflies or jewellery make for good shots, but insects tend not to sit still for long, so timing is everything. Practise on static subjects such as in our example here — of a pair of cufflinks — where you can control the focus and lighting and your subject is not likely to fly away!

This shot was taken using the camera's macro setting and focused on the stamens. Note the shallow depth of field.

Avoiding Flash Problems

Because the close focus distance on most digital cameras is very close indeed, using the camera's built-in flash will either not illuminate the subject at all or the lens will get in the way and cast a shadow over it. Natural light offers an even lighting over the whole subject, but artificial light from a table lamp is also ideal as you can set the camera's white balance to take away any colour casts (see *White Balance*). If you want to use flash, then you may need to use an off-camera flashgun, if your camera can use one. These can be positioned away from the camera, angled to give the best effect for creative shadows or angled for all-over lighting – whichever you want to use.

Black & White

Black and white photography provides another creative weapon for your digital photo armoury and it's easy with today's digital cameras.

Here's how.

Almost all digital cameras have a series of black and white or monochrome ('mono') modes within their menus that provide a host of easy ways to get more creative with your photography. Monochrome simply means the camera uses only one range of tones to make an image, so everything in a picture is shown in shades of just one colour.

Different Monochrome Modes

The black and white mode is the most popular mono mode, used to add a certain arty flair to otherwise mundane photos.

Sepia is another popular mode that mimics the look of an old faded photograph. It uses a range of brown tones to create an image with an 'antique feel'.

The document mode is another useful mono mode. This is primarily used to shoot documents, as you might have guessed, where you want to make sure the wording is clear and crisp by creating a very high contrast mono image.

Thinking in Black and White

Shooting colour is one thing, but a successful black and white shot requires just a little more thought. Although you can still shoot anything in black and white if you wish, what looks good in colour will not always lend itself to this approach. But it is ideal for capturing texture, form and shapes, as these can look better with the more graphic representation that black and white offers.

Good subjects range from stark, winter tree lines, rocky mountains, landscape vistas or close-up images of textures such as stone, wood or the walls of buildings. Look out for these and the small details that may stand out to make that 'graphic' look in the shot. Try to imagine it in black and white. Pick the best angle to exaggerate the lines or rugged bits and it should provide the right look in the shot.

If shooting people, remember to look for those graphic elements such as a craggy, characterful face, or the mood created by shadows, which all help to give the image

Textures are an ideal subject for black and white photography, as this driftwood on a beach reveals.

Think laterally, as in this shot taken from a light aircraft. The sky, wing, sea and clouds combine for a great graphic effect in black and white.

the right feel. It takes a little practice but once you've taken a few successful black and white shots, switching from colour to black and white will become almost second nature and you'll know just by looking what will look good and what won't. When shooting sepia shots, it's best to try and frame the subject so that modern paraphernalia, such as lamp posts, telegraph poles, cars and pylons are excluded. This helps keep a timeless look and makes the old fashioned sepia look work more successfully.

Practical Advice

Use the camera's LCD in the mono mode of your choice. When you switch your digital camera to its black and white mode, either from its relevant menus or the control assigned to this task (check your camera's manual), you'll see the image in the LCD

turn from colour to a greyscale image; that is, an image that has all the colours represented by a range (or 'scale') of greys, from black all the way to white. This is helpful as it lets you see how the image will look when you shoot it in black and white.

Be warned that some colours will look identical once converted into black and white. Yellow and blue end up looking the same, for example.

It's worth noting that even very basic image editing software can perform the same sepia or black and white trick on any colour image on a PC, and we look at just this technique in the topic Creating Black & White.

Even common or 'in-the-garden' subjects can lend themselves to black and white, so you don't need exotic locations.

Portraits & People

Taking pictures of people sounds simple enough, but there are key ways to make sure these precious photographs do their subjects justice. First, we'll have a look at the basics, and then move on to some great ideas and tips to make your people shots really stand out.

The Basics

The most common problem with people pictures is 'amputation'. How many times have you seen photos with a person's head mysteriously cut off or their feet missing?

This is very easily avoided with a digital camera as you can see everything in the LCD screen exactly as it will appear in the photo. Always use the LCD to help you compose correctly: you will be able to see if you have got it wrong, and can delete the shot and try again.

Another basic trick, if you're not doing a close-in portrait, is to put the person in context. This is ideal if you're shooting a candid style image of someone working for example. Rather than cropping in tightly, shoot the subject in their environment to 'tell a story' with the photo.

Don't be afraid to photograph people small in a scene, allowing more of the background in. This gives space around the subject in the shot, and is ideal if you want to convey a sense of scale.

Formal Portraits

A formal portrait is any portrait where the shot has been deliberately set up, as opposed to a candid shot (see overleaf). However, formal portraits don't have to look posed - you can still get your subject to pretend and set up the

shot to look like you've caught someone behaving naturally. For any type of pose to be successful, you need to try to relax your subject and get them to be themselves. Try to get a rapport going.

The classic formal head and shoulders crop, where you compose so the subject is cropped across the shoulders just below the collar line, is effective and looks clean. But you don't have to stick to this. Full body portraits can be equally as effective, particularly if you want to convey a character trait such as flamboyant clothing.

- Look for character and emphasise such features as a craggy, lined face or flamboyant clothing.
- Remember to focus on the eyes.
- Use a long focal length, around 100mm can be ideal.
- If your camera has Face Priority AF, use it. It will help to focus properly on a person's face.

Above: Candid portraits can work well if you can capture the person unawares. Here the woman has relaxed, seemingly 'drifting away' as her hair is being styled.

Lighting

If shooting outside in daylight, getting enough light is not an issue, but if shooting indoors the quality of lighting will play a big part in the success of your people shots.

CANDID PORTRAITS

Candid or 'informal' shots of people are probably the most common type of picture you'll take, and include anything that's not posed. To capture a good candid, you'll normally be shooting on the hoof, without a tripod or stopping to 'set up'. Roam around to look for unusual angles or just to capture spontaneous or emotional moments.

A classic environment where candids work is at a wedding. The subjects are usually relaxed, unaware they're being photographed, and you're left to snap away to your heart's content. This spontaneous style of people picture is increasingly being used by professional wedding photographers for just these reasons.

To take a successful people picture, you must think about what, who and how to shoot. Use a focal length suitable for the effect you want: telephoto for longer focal length shots to remove distracting backgrounds; wide lenses for group shots and where you want to include the background of the scene. And don't limit yourself to upright format shots; landscape format images can work too.

If you intend to photograph a stranger, vou should be courteous and ask their permission before you snap away. While it's not always possible to do this, it can make the situation more relaxed, so you'll have more time to shoot and get a better snap. If the person poses making the shot look awkward, ask them to ignore you while you shoot for a more natural picture.

Clearly, your camera's built-in flash or additional lighting can help here (see the topics Extra Flash and Creative Flash). However, a simple way to get a great lighting effect is to use natural light streaming in through a window. It'll be diffuse and provide nice soft shadows. However, if the light is too bright and shadows too harsh use a white sheet of paper or card to reflect light onto the face's shaded side as a 'fill-in'.

If you are using flash and the exposure is harsh, lower the flash power (if you have the flash exposure compensation function on your camera) or switch to fill-in flash. Or just turn the flash off and use the available light. remembering to adjust the camera's white balance accordingly to stop unsightly colour casts (caused by indoor artificial lighting).

- Don't be afraid to 'grab' a shot. If a scene presents itself in a fleeting moment, go for it. You can always just delete it if it doesn't work. You never know!
- Always fill the frame; don't waste a pixel anywhere.
- Don't forget to 'think in black and white'. Your digital camera's black and while mode can make the difference on a grey day or if the person in the shot would be great photographed this way, at a historical event for example.
- And last but not least, don't be afraid to experiment.

Above: Portraits that are formally posed can be very effective. Use of light and shadow here has given the shot 'mood' as has the sitter's characterful face.

Still Life

Still life photos capture everyday objects in a way that can make even the seemingly mundane look beautiful - if handled well. Check out these tips for making the 'still' come to 'life' with your digital camera.

'Still life' is defined as photographing inanimate objects, and can include almost anything, from flowers in a vase, coloured beads, sliced fruit and vegetables to ornaments and obiets d'art.

When shooting still life, you need to consider both the subject and the surroundings. You'll need to think about how you arrange your subject, where you'll place it and then how it will be lit.

Composition

Pay close attention to the subject's arrangement. Don't place objects in a line for example, as regimented composition rarely works well. Stagger your subjects - but not at equal distances from each other - and if you have to have them in a row then overlap them.

Then try to shoot from an unusual angle such as directly overhead or from very low down. Remember to think about the background. Neutral backgrounds work well, and can be provided simply by a draped cloth. But you may want to include some of the surroundings. Try it and check what looks best in the camera's LCD.

Opposite: These flowers make a stunning still life image. Note how natural light from a window, controlled by curtains to create shadow, has been allowed to fall across the flowers, which stand in a vase on a simple, plain wooden floor. Also note the depth of field is quite shallow, helping to keep attention on the flowers.

Above: This is a classic still life image, shot in available light, of a Tibetan monk's scripts and robe shot in situ at a monastery. Again, the background is out of focus due to a shallow depth of field, keeping the viewers' attention on the main subject.

Lighting

Still life subjects tend to be on the small side, so lighting is important. Using your camera's built-in flash may be adequate for this but if it lacks a flash exposure compensation function, the light it emits may be too harsh and could also create a heavy shadow.

Additional off-camera flash can be helpful here, and you can also exercise more control over this. The light from a flashgun can have its angle adjusted (by bouncing the light with a bounce head flashgun for example) or be softened with a diffuser. Diffusers are accessories usually supplied with a flashgun that fit over the gun's lamp to soften ('diffuse') the light. If you don't have one, a simple

piece of tissue or tracing paper placed over the flashgun's lamp will be just as effective.

If you don't have a flashgun, it's not a problem because natural light from a window is also ideal for still life. A good idea is to leave a slit in the curtains allowing a stream of light to flood across the subject. This works really well for glass, coloured or otherwise, and any reflective subjects, where the spectral highlights (the bright, reflective parts of an object) are enhanced and add sparkle.

Alternatively, you can use any suitable table lamp (or even include them in the shot if they're attractive or ornamental) and reset the camera's white balance accordingly. Try the trick of using white card to act as a simple reflector, or aluminium cooking foil to help get dazzling reflections and shadows falling where you want.

As you'll need to use longer focal lengths in more subdued lighting, your camera may need the aid of a tripod or some other support to avoid camera shake. Longer focal lengths also affect the depth of field so use your camera's aperture control (if it has one) to adjust this as needed.

- Use natural light from a window or artificial light and adjust the camera's white balance to compensate for any unwanted colour cast.
- Use white card or paper as reflectors to help control the light and shadow on a subject.

Below: This image shows a typical mundane subject that can still make for a stunning still life image. The table top makes up the background thanks to careful framing while control of the depth of field focuses attention on the coffee beans in the cup. Natural light from a window to the left (you can see it reflected in the saucer) keeps unwanted reflection to a minimum.

Above: Tomatoes cleaned and lit with bright natural light are a simple but effective still life composition that anyone can try. The light has been judged by spot metering from the tomatoes, not the bright background.

Right: A superb still life of jewellery taken using natural light on a white backdrop. This is also a classic use of creative control of the DOF.

 Don't use regimented lines of subjects, stagger them or allow them to overlap for a pleasing composition.

Reportage

Reportage – using your digital camera to tell a story in a series of pictures – is one of photography's greatest uses. Here are some inspirational ideas for projects, and tips on getting the best results.

Project Ideas

Almost anything can be given the reportage treatment, but family events such as an important birthday or birth of a new baby are of course very popular choices. If you've ever taken a series of photographs of quests enjoying themselves at a wedding, then you've already tried reportage.

They needn't be one-off events, however. You can just as easily keep a photo record showing how your children grow up, from newborn baby onwards, which would become a fantastic memento. Or maybe you want to record the progress you make as you redecorate your house or work on some other long-term practical or creative

endeavour. Projects such as these are the essence of reportage.

Enthusiast photographers might want to tackle more ambitious projects such as changes in their community or home town as it's redeveloped. To make this easier to cover, you could follow the developments in just one part of your locale or the changes to a famous building for example.

Another good subject to follow is a local historic event. You could even find that your 'documentary' work, particularly if it's comprehensive, can become a valuable social document that local museums or historic societies would be interested in.

In the example shown here, the photographer was asked to capture and

PRACTICAL TIPS

- Store the photos carefully by date but remember...
- Because your photos are digital, the date and time of each photo is embedded in each shot and can be read on a PC, perfect if you can't remember when a picture was taken.
- Take many pictures and try to cover all the 'angles'. It doesn't matter if you 'waste' shots – you can always delete the ones you don't need later.
- You may want to re-shoot the same place time and again, over many years in some cases, and from the same viewpoint, so use a tripod and be patient.

- Shoot at regular intervals, once a day or week, dependent on the subject you're following of course.
- Keep a diary of events if photographing something that will be a long-term project. Using your PC it would even be possible to combine your words and pictures and print out your own 'publication' on the project.
- With long-term projects, you really don't want to take any risks with all the work you've put in. So don't keep all your images on memory cards alone. Make sure you back them up to your PC or other external memory device (see Backing-Up).

explain the hand signals used to transmit betting information to and from trackside bookmakers in greyhound and horse racing. His aim was to show the different signals the bookmaker uses as the betting progresses.

The four shots shown here are just part of an extensive selection that formed a dictionary of bookmakers' gestures used in a national newspaper. You'll need to give your subject a similar 'sequential' treatment.

Travel

Travel to foreign climes often presents photo opportunities that will never come your way again. Make sure you make the most of these once-in-a-lifetime images by following these inspirational ideas and our practical travel checklist.

From the Plane

If you're flying, there's usually an opportunity to get some stunning images from the aircraft. You won't be able to carry loads of photographic kit into the cabin of course, but even a simple digital camera with zoom lens can get good shots. Use the telephoto end of the lens to exclude the porthole in the shot. or go with the wide-angle end of the lens, as in our picture, to include it as an extra framing device. Look for shapes and patterns in the cloud - or on the ground - and you'll have a good chance of shooting a breathtaking image before you've even arrived at your destination.

Local Flavour

When away from home, it's always nice to capture local flavour. Unusual buildings and architecture make eye-catching images that can tell the viewer where you were in a single shot. But also look out for other

elements of the locality. If you travel to an exotic location, don't just shoot the mountains or the local scenery, get shots of the locals too, particularly if there's a festival or local event. This shot, taken at the Jaipur Festival, has captured dancers in traditional clothing.

The Early Bird

Try to get up early on holiday, particularly if you travel to a country with a very hot climate. Early morning light is often the best for any photo. And if it's very hot, the heat of the day creates haze and dust, which can lower contrast, reducing your photo's impact. Another advantage of being an early riser is simply, with the sun lower in the sky, you get better shadows, ideal for enhancing landscapes. The same is true for landscapes shot later in the day at sunset though light tends to be warmer at dusk than dawn.

Sunset Shots

A beach holiday abroad can often provide stunning sunset shots (right), but then so can a trip to the mountains. Either way, one sunset can look much like any other unless you try to include something extra in the scene. To get spectacular beach sunsets include other foreground interest, perhaps someone standing at the water's edge (using the rule of thirds to place them, the horizon and the water lapping the shore). Alternatively, use palm trees arching into the shot to create a 'frame' for the sun. Even beach huts can add interest and give the sunset a 'place'.

Away from the beach, the options are usually more obvious - mountains in the distance for example - or once again, a person placed carefully to 'balance' the composition. Experimentation is the key, but remember that low light could mean you need to use a support for the camera to stop camera shake.

TRAVEL PHOTOGRAPHY CHECKLIST

- Unlike film cameras, digital cameras and their memory cards are NOT affected by airport X-ray machines, but always carry your camera as hand luggage (rather than checked into the hold) so you can shoot from the plane's portholes.
- Carry spare memory cards or a portable storage device to free up space on your memory card. There's nothing worse than running out of memory as a great shot presents itself.
- Take a support of some kind, even a small, table top tripod is better than nothing if you need to keep the camera steady for a crucial shot.

- Spare batteries are an absolute must, particularly if you're travelling to a country where getting hold of replacements is going to be difficult.
 If you use rechargeable batteries then remember to take your charger and a travel power adapter.
- Protect your camera from excessive heat and dust. Never leave it in the window of a car in the sun and always keep the camera in a case. You could even buy a waterproof housing which will help protect the camera not just from water but also from dust and sand.

Architecture

Architectural photography is rewarding but also very challenging. It can even be hard to do justice to famous buildings that offer potentially stunning results. Here's how the professionals do it.

Architectural photography can include anything from churches, castles and monuments to bridges and sculpture, so there's plenty to choose from. Whatever your subject, there's a natural temptation to try to cram the whole building into one shot and that urge should be held in check. It can work on some buildings but it's often not successful.

Less is More

If you don't have a wide enough lens to take in a whole building from where you stand, you may have to step so far back in order to force everything into the shot that there's no visible detail left. In addition, you can end up with

- Use the wide-angle end of the lens (that's around 35mm or wider) or get a wide-angle adapter for your lens to help get broader views. Alternatively, use your camera's panorama feature to stitch many shots together on vour PC.
- The telephoto end of your zoom will enable you to crop in closely on a detail if you can't, or don't want to, fit in the entire structure.

clutter in the foreground that can ruin the shot.

The telephoto end of your digital camera's zoom lens is the solution here. You can use it to crop in close for a more detailed image and you'll quickly find that, with architecture, less is often so much more. Look for the little architectural details that will make an interesting image. Alternatively shoot only part of the building in context, revealing some of the background.

In this way the building will still be recognisable, particularly if it's a famous structure, but you get a unique view of it that can add interest to an otherwise bland or well-known facade.

Exaggerate Perspective

Exaggerating perspective can work really well with tall buildings by shooting them from a low angle, particularly if you have an interesting or clear blue sky. In the tall building image shown opposite, the buildings have been shot to exaggerate the converging verticals, and the clouds in the blue sky balance the composition.

Go Black and White

Don't forget to try out your digital camera's black and white mode. This can work really well on older buildings or where a modern building lends itself to the 'graphic look' that black and white so often creates.

Above: Using a wide-angle lens from a low viewpoint has worked well on this shot; the sky balances the two buildings compositionally too.

Change Your Viewpoint

If it's at all possible, change your viewpoint. Some buildings provide access to towers. balconies, basements or viewing platforms utilise these whenever you can. It will add interest and once up (or down) there, other interesting shots will become apparent.

Shoot vertically up the wall too, but if you try the reverse of this - from a high vantage point looking down - make sure you always have the camera attached to you via its carry strap. Look for natural frames such as an

archway or go for reflections in lakes or ponds, all can make excellent alternative views of buildings.

Bridges can be so huge that you have no choice but to stand well back to fit everything in. Again look for details and perspectives that offer a new and unique shot. For example, go to the river bank or try to shoot down the length of the bridge to get a receding perspective of the structure.

Above: To fit all of this building into one shot would look very 'busy'. But in this shot, closing in using the zoom lens has helped to give a sense of scale, show detail and make for a superbly graphic shot.

Night shots

Another professional's tip is simply to shoot at night. Even stark or uninteresting buildings can take on a completely new personality at night. A tripod or other support will be needed to hold the camera steady. Also, it's best to survey the building during daylight so you'll already have an idea of the best angles and views.

Shooting Statues

Statues can make excellent subjects but involve extra considerations. First, because statues tend to be relatively small, there's a danger of underexposure as there's usually a large expanse of bright sky behind them which fools the meter. Switch the metering to centre-weighted or spot to ensure the

metering is from the statue not the sky behind.

Walk right around statues to look for the best shot or to see if there's a better background. Try to balance the shot with other compositional elements such as trees or parts of the background to 'set the scene'.

- Watch out for underexposure particularly if there's a bright background. Use centreweighted or spot metering.
- Avoid clichéd shots move around to find a unique view, particularly of famous monuments or buildings.

Landscapes

Landscapes are ideal images to grace any wall. Here are a few ideas on how to make them as striking as possible.

The single most important thing in landscape photography is to get up early to catch the morning light. Why? Because morning skies are clearer. A lack of haze in the atmosphere produces a better quality of light, and you get raking shadows from the lower angle of the sun which is a good effect. That established. here are more expert tips to improve your landscapes even further.

Below: Here the tree in the foreground helps to guide you into the shot, and without it the image would be ordinary. Also note its positioning using the rule of thirds.

Leading the Way

One of the best ways to make a success of a landscape shot is to have elements placed within the composition that lead the viewer's eye into the shot. Anything in the foreground such as a plant or rock, then a tree in the middle distance and then, perhaps, a distant hill all help.

A swooping hillside with the ridge running across the frame and receding into the distance works well, or even rows of crops in a field that all run into the distance or up the

side of a hill. Once the viewer's gaze is drawn to the distant part of the scene, it helps to have another element sitting there waiting: a building, tree or even an interesting cloud formation on the horizon.

Framing the Picture

Don't be afraid to have things intruding into the shot at the top and sides. The idea is to frame your landscape with something actually in the scene; tree branches just hanging into the shot across the top edges for example. The combination of the photo's shape and the other 'framing' elements help to draw the viewer into the scene and add interest. This so-called 'frame within a frame' technique can work well but practice and experimentation is needed to see what works best.

Rule of Thirds

The rule of thirds can make a huge difference to a landscape shot (see *Composition*). All the elements of your composition can be brought together in many ways, but by placing key elements using this rule, you can make an

- Get up early to capture the best of the early light.
- Shoot at the highest resolution your camera has and its highest quality (compression) settings.
- Use small aperture settings (larger F-stop numbers) to ensure narrow depth of field.
- Use a shutter speed fast enough to freeze any potential camera shake.
- Or support your camera on a tripod or other prop. Keeping your camera rock steady is a good way to ensure sharp landscape shots.

CORRECT SETTINGS

Your digital camera has a finite number of pixels to employ on any image, but with landscape shots, it's vitally important to use every single one of them and to use them at the highest quality setting. This is because detail in a landscape shot can be tiny in the frame, perhaps only one or two pixels across, particularly if it's a distant part of the scene.

So select the camera's highest resolution possible. Then select the camera's highest quality mode. These usually run from 'Standard' or 'Good', through 'Better' or 'Fine' to 'High Quality' or 'Best'. Check your camera's manual to be sure you have picked the best settings in all these departments.

White balance should be set to the conditions: Sun for bright sunlight, Cloudy for cloud and so on. If you're not sure then stick with the Auto setting which will be adequate in most cases.

Use a small aperture (a high F-stop number such as F8) to make sure the depth of field is narrow, and set the camera on a tripod or other support to keep it steady – or make sure you use a shutter speed fast enough to freeze any potential camera shake.

even stronger composition. Experimentation is important here – shots that don't work can easily be deleted. Sometimes it even helps if the rule is broken.

The Right Format

Just because it's a landscape shot, you don't have to use the camera in its landscape or horizontal format, with the longest edge across the top. Portrait format works as well, depending on the subject. Some of the images we've used here are upright shots that would not work as well with a 'wider' perspective. You can check both options in your LCD.

Left: In this shot, the foreground grasses quide your eye into the shot, the ridge on the sand dune takes it in further and the deep blue sky adds dramatic colour contrast

Above: This shot of the San Juan River uses the curve of the canyon, the shape it forms and dramatic clouds to help create a stunning image. Here the rule of thirds has been broken so the interesting sky can become a key part of the scene.

Overleaf: The upright (or portrait) format has worked well to emphasise the leading lines created by this shot of a road. The sky has been given the top third of the frame with the road filling the entire foreground. The white lines and telegraph poles help add further dynamism to the shot.

Sports & Action

Capturing the action with a fast-moving subject such as sports can be a real challenge. But with a few key tips you can shoot the fastest of fleeting moments to dramatic effect.

Sport or action photography can include everything from photographing super fast sports cars, your child running at their school sports day or your dog jumping to catch a ball. In short, it's any shot of a fast-moving object which can be difficult to shoot sharply.

Helpfully, even the most basic of digital cameras has some form of 'sports' mode that can help capture these moments. But here are some additional techniques that will help you avoid blurring or even completely missing your subject.

Panning with the Subject

One way to help get shots with a sharp subject and blurry background is panning with a moving subject. This involves watching the subject in the LCD (or viewfinder) as it moves and judging the right point to capture it.

Stand with your feet firmly planted and smoothly swing the upper part of your body as the subject moves across and in front of you and, as the subject hits the point you want to take the photo, fire the shutter.

Previous page: In this shot, a fast shutter speed of 1/2000th second and large F3.5 aperture were used to ensure the action was completely frozen. This aperture has allowed plenty of light to get to the sensor and helped blur the background slightly.

Above: For this shot of washer women in Mali, a shutter speed of around 1/30th second and panning with their motion helped give the shot a dynamic feel.

Shutter Lag

Many digital compacts, however, are affected by shutter lag. This means that there's a short time delay between pressing the shutter release and the shutter actually firing. This is no problem for standard photos but in action shots this delay means you risk missing the subject completely.

Basic digital cameras suffer the most from this. It's caused by the on-board computer taking time to focus, set the metering and generally get the camera primed to take the photo. More advanced cameras have faster processing and so suffer less from this problem. The best way round this with a basic model is to use a pre-focus technique.

Pre-Focusing

This technique solves the problem of shutter lag because you pre-focus the camera at a predetermined point. Set the camera's focusing system to manual and focus it using the chosen point. If you don't have a manual focus setting, find the point you know the subject will pass, and half press the shutter button to focus on that point. Then, keeping the shutter half pressed, follow the subject, pressing the shutter the rest of the way when the subject gets to the right pre-focused point. This will give a sharp action image with a blurred background. Use the same techniques but without panning to get a sharp subject and background.

Slow Sync Flash

Another idea to try is slow sync flash. Here, a slow shutter is combined with a burst of flash. The flash freezes the subject motion and the slow shutter speed keeps the background blurred. It's the same mode as used in low light, but can be equally creative in daylight.

Timing

Timing is everything, particularly the timing required to catch the subject at the right point in the action. Practice makes perfect, but whatever the subject take plenty of photos. Set your camera to shoot continuously, which is usually around three frames per second. Some can shoot more, some less, depending on their sophistication.

If the camera has a sports mode it will do all this for you. Just keep the shutter button pressed and it will just keep on taking pictures until you let go.

What Focal Length?

You'll find that a longer focal length is best for capturing sports or action shots where you cannot get close to the subject. Racing tracks or stadiums are good examples – you've probably seen the banks of sports photographers at sporting events using huge telephoto lenses. You'll need a digital camera with (ideally) a 10x zoom lens or use a D-SLR with a 250mm or longer lens.

Longer focal lengths mean slower maximum shutter speeds, particularly if it's gloomy. Watch out for camera shake, increase the sensitivity (ISO), which helps get faster shutter speeds, and open the aperture to a larger setting (a smaller F-number) such as F2.8.

PROFESSIONAL ACTION TIPS

- Use a fast shutter speed to freeze the action. The faster the subject is moving, the faster the shutter speed will need to be around 1/250th second or faster. Increase the ISO (sensitivity) if required, but only bump it up to that needed to get the right shutter speed.
- Use slower shutter speeds to add 'creative' blur. Not all subjects lend themselves to 'freezing' and might look more dynamic if there's a little motion blur in the shot. Speeds slower than around 1/30th second are best in daylight but a smaller aperture (higher F-number) might be needed to stop overexposure.
- Flash can help freeze action but you'll need a flashgun with plenty of power and a camera with a hotshoe to accept it.
- Use a slow shutter speed at night to get action blur such as car light trails or funfair rides 'streaking'. Speeds of around 1/10th second or slower are good depending on the amount of 'streaking' you want.

Left: Slow shutter speeds can be used to capture light trails from cars or, as in this case, a funfair's Ferris wheel, shot with a shutter speed of around eight seconds.

Weddings

Getting stunning shots at a wedding can be tricky. But there are some simple steps you can take to ensure that this most important of days is beautifully and safely recorded.

Be Prepared

The key to successful wedding photography is preparation and planning. You need to get organised: visit the venues beforehand, talk to the bride and groom so that they're relaxed for the photos on the day, and plan out what shots you'll need to keep everyone happy.

A professional photographer can easily rack up over 200 shots at a wedding, so if you're planning to cover the whole event, ensure you have plenty of suitable capacity memory cards available - or a way to back photos up such as a portable hard drive. Also check your camera is functioning properly, your batteries are charged and you have any necessary accessories to hand.

Group Shots

Group shots can be difficult to coordinate but one way to achieve good groups is to watch what the professional photographer does and take the same shots. But you must make sure you don't get in their way or in their shot.

Big groups will need the wide-angle end of your camera's lens, then zoom into the group as it gets smaller. If you can, shoot each group with different backgrounds. Control depth of field with the apertures (F-stops) and use larger apertures to blur the background. Keep checking the shots on the LCD to ensure they work, and if not, take them again.

Above: A classic 'bride getting ready' shot taken at home before the service and the sort of intimate image that helps sum up the day.

Candid Shots

Candid shots are a great way to capture the spirit of a wedding in the way formal, posed shots don't always allow and such informal shots are also easier to take. Catch relaxed people chatting and happy figures enjoying the day. Also, look for closely cropped shots of faces, and target the small animated groups that congregate at a wedding. Don't be afraid to use unusual angles or the camera's black and white mode.

Shots in the Church or Venue

Flash will be almost essential indoors. But it's even better if you use a support such as a tripod and slow sync flash to give an ambient exposure that will capture both the people and the atmosphere. If in a church, check whether you're allowed to shoot inside and if you can use flash. It's unlikely you'll be able to shoot during the ceremony.

Above: Another idea is to shoot aspects of the bride's or groom's outfits. This shot of a bride's shoes on a windowsill using only natural light was taken while she was getting ready.

Below: Don't forget the bride and groom's more intimate shots after the group photos; this one has been taken using the camera's sepia setting.

ESSENTIAL SHOTS CHECKLIST

There are a number of traditional shots you'll need to take at a wedding:

- The bride at home: including preparations, and individual and group shots of the bride and bridesmaids
- The groom arriving at the church or venue: don't forget the best man and ushers, the groom's parents and other immediate family.
- The bride's arrival: don't forget the bridesmaids, and waiting to enter the church or venue.
- Inside the church/venue: ideally a tripod shot (it'll be dark) to capture the atmosphere.
- Signing the register: the bride, the groom and a group shot with witnesses if possible.

- Walking down the aisle: including the happy couple outside the church or venue with guests swarming round and the crucial confetti-throwing.
- Groups: if you are arranging this, do the biggest groups first so that some quests can then depart to the reception, leaving more time for shots with the bride and groom. So start with big friends and family groups, then the bride and groom with the bride's family and the groom's family, followed by closer family and the bridal party, and finally intimate portraits of the bride and groom.
- Entry to the wedding reception. followed by cutting the cake, and the toast with glasses raised, being clinked together.

Opposite: The black and white mode on your camera is ideal for candids such as this shot of a demure bridesmaid. The gentle blurring is deliberate and helps give the shot a softness, ideal for the subject, and was achieved by using a slow shutter speed.

Right: This type of slow sync candid image at the reception is fun and simple to take.

Gardens & Flowers

Photographs of gardens in bloom or individual flowers can make stunningly colourful photos. With these ideas, the flowers in your garden can be made to look just as beautiful as any botanical garden.

Lighting

One of the key aspects of flower photography is careful consideration of the light. Although bright, direct sunlight brings out the colour, it's also very harsh and creates deep shadows. Often you'll find an overcast sky can provide the best lighting, particularly if you're shooting close-ups. Flash, while available to you, is not always ideal as it can 'blast' so much light onto the flower that it bleaches out the detail and colour.

A great tip for controlling the available light is to use pieces of card. You can use them to shade a close-up shot from direct sunlight. White card can be used to reflect flash (if using an accessory flashgun) or to reflect available ambient light to fill in shadow. Alternatively, you can deaden 'hot spots' with black card. You can also use the card as a backdrop, helping remove a cluttered background from a shot of a single bloom for example. Try the same shot using either white or black card for a different backdrop in each shot.

Close-Ups

The close-up techniques already discussed (see the topic *Close-Ups*) are particularly effective with flowers. You can really use the camera's macro power here. Don't just shoot

the entire flower head, get even closer and shoot the detail of stamens or even just the veins in the leaves or petals, if your camera can get that close.

You'll need to fill the frame. Remember to use a small aperture (high F-stop number) to increase depth of field and use a shutter speed that will not only stop any potential camera shake but also freeze the flower if it's windy, typically a speed at least equal to the reciprocal of the focal length in use. Don't forget those bits of card, they come in handy as a wind shade too. If you have a tripod or other camera support, use it for even more stability.

Wider Vistas

As with landscapes, you need to think about composition when photographing a vista of plants: the shape of flowerbeds can be important, as can ranks of plants with the same colour. Zoom in and out of the shot to see if a smaller part of the scene looks better or offers unusual patterns that would be missed with a shot of the entire area. Move your viewpoint constantly and look for the best angle or vantage point.

Shutter speeds should be kept fast enough to stop camera shake and motion blur and at least equal to the reciprocal of the focal length in use. However, one technique is to use motion blur to your advantage, particularly if it's windy and if there's a field of swaying flowers or corn for example. Set the camera on a sturdy support, and use a small aperture and slow shutter speed to catch the motion of the swaying plants. The result should be a sea of attractively swishing plants that will look like brushed cotton or a beautiful smoothed surface.

Getting Creative

Avoid the temptation always to stand up when shooting flowers. Changing your point of view even just by dropping to your knees can have a dramatic effect. If you want to emphasise a single plant or bloom in the foreground with a distorted perspective, lie down and use the wide-angle end of the

zoom lens. Focus on the foreground flower – it must be close to the lens – and you'll have an (apparently) giant bloom or plant in a wide, distorted landscape. This is very effective if you choose your bloom wisely – a single prominent plant is better than a larger bush for example.

Again you can use your pieces of black and white card, along with a water spray bottle. Use the spray to add a mist of water droplets to the flowers and plants. This adds fantastic 'freshness', mimicking morning dew for example and this also catches the light, making even boring plants look more succulent and attractive.

Below: Filling the frame works well if there's a cluttered background. You may get a more interesting interplay of form and colour, such as in this close crop of crocuses.

PRACTICAL CHECKLIST

- The basic approach is to shoot the entire flower or flowerbed to fill the frame.
- Use a household water sprayer on blooms and leaves to add attractive highlights which help make the flower look crisp and fresh.
- Don't ignore other elements of gardens such as interesting fountains or buildings. Each may be worth a shot on its own or to give contrast to the plant elements of the scene.
- Hunt for the best blooms. Look for blemish-free flowers; you don't want anything that has marks or brown patches.

Opposite: A windy day doesn't have to stop your creative flower photography. Here, a slow shutter speed and metering from deep within the poppy head overexposed the background and gave the shot 'creative' blur.

Above: You can combine flower photography with close-up work and get great results like this shot of a butterfly on lavender.

Right: If there's any architectural interest or features use them to your advantage. Here, a backlit fountain has been shot with a fast shutter speed to freeze the brightly sunlit spray.

Children

Children are understandably the most popular photographic subject. So make sure you know how best to capture those childhood moments for posterity.

From newborn infant to graduate, children are in front of the lens for most of their lives. Despite this, getting great shots can be a challenge as children rarely stand still and will get bored when you want a more serious or studied family portrait. Here are some ways round this.

Babies

Newborn babies offer plenty of scope for creative as well as fun shots. For instance, a close-up of a baby's hands (or feet) juxtaposed against an adult hand can make a moving image. Such shots will require a close zoom and should ideally be taken when the baby's asleep, unless they're particularly relaxed after a feed. Use natural light for a charming softly lit image.

Other ideas include portraits with the happy mum and dad where the baby is held proudly cheek-to-cheek, and shots with the baby cradled lovingly across a parent's chest. However, avoid a full body shot while the baby is sleeping, particularly a shot from above as this can look dull and lifeless, especially if harsh flash is used. If you want to shoot a full body image, get down to the baby's sleeping level and close in. Use soft natural light from a window and the image will look full of life, relaxed and natural.

Opposite: By constantly looking and waiting for the right moment you can get wonderfully wistful shots, as with this natural light shot of a little girl.

Toddlers

When babies are starting to move around, real fun can be had. Set your camera to its sports mode if it has one or use a fast shutter speed. Try to get in on the action; if they're playing on the floor lie down with them. If you want a vibrant shot, get colourful blankets and dress them in bright clothes. If you use flash, watch out for dark backgrounds generated by flash fall off. However, this might be desirable in a portrait image for example.

If there's more than one toddler, then drop to one knee or lie down to get on their level. Zoom out and try to capture their play. A slower shutter speed can help here – motion blur can make things look both active and humorous. Don't forget the camera's slow sync mode where a burst of flash can freeze the children's play whilst the slower shutter captures the ambient atmosphere and some movement too.

Parties

One of the most challenging child photo opportunities is a party. Try to get a fun shot of the whole group – get the other parents involved if needed. For slightly older children, get them all to pull a funny face in one shot, and a serious face in another. Making more of a game of the photography and showing them the results on the camera's screen often means they'll want to do more photos. But work as quickly as you can.

At the party table, you must of course get the candles-being-blown-out shot and use

slow sync flash for the best effect. You'll also need to shoot all of the children seated at the table but it's usually hard to fit everyone in as it's unlikely you'll have a wide enough focal length. In this case, shoot from one end of the table and try to get the kids to lean in – ensure you get every face. If you have room stand on a chair and shoot using the wide-angle end of your zoom lens. Get someone to hold the chair and be careful.

Younger children will often not cooperate for such shots so the best technique is to move around looking and waiting to get the 'moment', snapping as you go. Look for small groups of two or three children and you'll eventually get all of them this way. Remember to keep the children on side by continuing to show them the pictures on the camera's LCD.

Growing Up

Photograph the key moments in your child's life, everything from the first tooth appearing, starting at school, being a bridesmaid or pageboy to college graduation. The photo techniques used will depend on the moment and atmosphere you want but keeping a record of such momentous events can build into a wonderful album of images or a PC slide show (see *Creating Slide Shows*). But remember to back up all these priceless images (see *Backing-Up*).

Above: Intimate shots such as this baby's hand can work well in both colour and black and white and when juxtaposed with a parent's hand for example.

Opposite: An unguarded moment for these children at a wedding has been captured well. The timing is great as the young bridesmaid has just realised the shot is being taken.

Pets & Animals

Photographing animals and pets can be very tricky but the following tips will help you get prize pictures of all different kinds of creatures.

Basic Techniques

Pets can be treated just like any subject when considering the photo techniques involved. All the elements such as composition, exposure and focus must be right. Focus on the eyes, compose the shot so the animal looks 'natural' and set the camera to its portrait mode for posed-style shots. Use the sports setting if you want to get photos of a dog jumping around in the garden for example.

Accurate exposure can be problematic, as all-white or all-black animal coats can fool the metering and under or overexpose. Check the results on the camera's LCD and adjust the exposure (lower or higher shutter speeds for example if you have manual control).

Flash

Like humans, pets can suffer from redeye – although in animals it's often bright greeneye! Use an off-camera flash to avoid it if you have one. If using a camera's built-in flash unit, use the redeye reduction mode and, if indoors, turn on more lights. This will help reduce the animal's pupil size, cutting down the chance of greeneye. Remember, however, that flash can startle an animal, so use natural light whenever possible.

Timing

One major source of frustration will be getting your pets to stay still once you point

the lens at them. Timing is everything. You'll need to be patient and watch the animal playing, poised for *the* shot. A squeaky toy can come in useful here to get moments of alertness as they play or start to slumber.

Alternatively, recruit a helper, someone able to occupy the pet and keep it lively. However, you'll have to try to keep them out of shot to keep the photo looking natural. Move around searching for the right angle as the helper encourages the pet to sit or play as you want it to.

Zoos and Safaris

Photographing animals in zoos can be difficult as the cage may get in the way. Use a large aperture (lower F-stop number) and a long zoom, and focus on animals further back in the cage. The resulting narrow depth of field means the fencing should be practically invisible in the shot.

If you're on a safari or travelling to see other animal life in the wild, the most important consideration will be your lens. You're unlikely to be able to get close to the animals you're photographing, so a long zoom is essential, the longer the better. Some of today's 10x and 12x zoom compacts are ideal for this and if you own a D-SLR you'll need a lens with at least a 300mm focal length equivalent.

Opposite: For humorous shots, use a wide-angle lens setting to exaggerate the shape of an animal's face. Be sure to focus on the eyes though.

Left: If you can't get a shot of an animal in action, go for detail or colour, as in this striking portrait of an owl at a summer fete.

Opposite: This shot of a cheetah was actually taken through cage bars. Using a large aperture and long focal length of 200mm gave a shallow depth of field ensuring the cage didn't intrude into the shot.

Left: This resting, but alert, dog just needed a little help to prick up its ears. A quick whistle from the photographer did the trick.

TIPS FOR SHOOTING PARTICULAR ANIMALS

- For dogs and cats, the best bet is to give the animal something to play with, such as a squeaky toy or a bone if it's a dog. This takes their mind off the camera but you'll have to be ready to trigger the shutter quickly.
- Shooting fish in a tank can be tricky as you need to avoid reflections from the glass (or water if the fish are in a pond). Avoid flash and get the lens as close to the glass or water surface as possible (you may need to switch on the camera's macro/close-up mode for small tanks). Wait for the fish to pass by the lens or to stop moving.
- For smaller pets such as hamsters, mice or guinea pigs getting close enough can be a problem. The best solution is to shoot them in someone's hand. Use

- the camera's close-up mode and fill the frame with the animal. If the animal is in a cage, use a larger aperture as the narrow depth of field will help to ensure that the cage bars aren't visible.
- For sea life, many digital cameras can be used underwater with a special. waterproof housing, ideal when snorkelling. You'll need to get close to the subject and the lower light underwater means a higher sensitivity setting (ISO 400 or greater) should be selected. Flash presents a problem as a phenomenon called back scatter means light is bounced back into the lens from particles in the water, ruining the picture. This can only really be avoided by waiting until there's less muck in the water or more available light.

Abstracts

Abstracts are the potentially stunning and unusual patterns in a landscape or scene, from large-scale cloud formations to the small-scale geometries of grains of sand. Our tips will help you search out the best abstract shots.

The human eye is tuned to look for patterns in everything we see. It's the reason our ancestors could 'see' constellations in the heavens: we love to find order in seemingly random things. In photography the trick is to spot these patterns and then crop the image properly to achieve the effect you can see. Depicting a subject with the thrust of the shot aimed at internal structure or form, rather than the thing in its entirety, can make shooting abstracts very gratifying.

Inspiration for Abstracts

Abstract patterns occur in almost anything: shadows, freshly mown grass, wooden fencing, leaves on the floor, a multitude of illuminated windows in a building at night or even people milling about a railway station, but abstracts from nature are the most common. To shoot any type of abstract successfully, you have to think about what you're seeing in terms of shapes and forms (in a similar way to how you must think in black and white when snapping mono shots). For example, a macro shot of a flower can unveil an interesting cell pattern on the leaf, which then becomes a striking image in its own right.

Man-made objects can provide inspiration too. Perhaps take a tight crop on a manhole cover that shows its stippled surface and dirt or rust. Either zoom in or, simply, move closer to the subject and use the wide-angle end of the lens. Both approaches will provide an abstract shot with an 'industrial' feel.

Colour and Abstracts

It's not just shape and form that can create an abstract. Looking closely at colours, and patterns of colours, will help too. An abstract can lurk anywhere within a colourful vista – markets are great examples of this, as our image of colourful shoes shows. Perhaps an easier example to find would be a selection of ties hanging on a shop rail? But remember colour is as important to the look of an abstract as the form of the subjects themselves.

Above: Regular patterns can help form abstracts as can colour, but here both combine – in rows of colourful new shoes – to produce a great abstract image with strong form. Note the use of an unorthodox angle; the shoes have been photographed to exaggerate the perspective of the racks in which they lie. A flat 'straight on' shot might work but not as effectively as this.

Using Angles

Another tip to help get abstracts from seemingly mundane subjects is to change the angle from which you shoot. Even tilting the camera so it is composed neither landscape nor portrait but diagonally can help, and may provide a better frame within which the abstract will work. The shot here of shuttered windows provides an example of how looking for other angles can be used to produce unusual shapes and form in your images.

Below: Looking around you at unusual angles can present photo opportunities. Here the shuttered windows, narrow confines of the buildings and overexposed sky all contrive to make a pleasing 'form' abstract.

Large-Scale Abstracts

If you are flying, grab the chance to shoot from a completely new perspective. The shot opposite of white clouds over the red-looking desert is a classic, large-scale abstract. The clouds start the whole composition. A tight, zoomed-in crop helps exclude all but the colour of the red earth below which is vitally important to the composition, and keeps a graphic feel. Best of all, the shadows formed by the clouds add a 3D feel to the shot. But you don't have to shoot from a plane to obtain large-scale abstracts, they can exist anywhere. You just have to look for them.

Opposite: Large-scale abstracts can be found when flying, like this stunning image of clouds and their shadows floating over the red earth.

Below: Without looking down, the photographer would have missed this shot of pots drying in the sun in India. To catch abstracts you need to look around you and really see what's there.

ABSTRACTS CHECKLIST

- Zoom in, zoom out, move closer and move away. A seemingly boring leaf on the floor might become something else entirely if you move in to capture the pattern of its veins, or zoom out to include all its fallen fellows on the ground.
- The subject you're shooting will dictate the exposure parameters you need to use, but don't be afraid to experiment. Assess the results in your LCD then try another approach.
- A trick to see abstracts more easily is to look through the camera's viewfinder or its LCD to see if a shape or pattern presents itself that is not immediately apparent otherwise. Try it and it might just surprise you.
- When shooting close-up, look for the finer patterns within the subject.
- Think shape, shine, form, colour and scale.

In this section, you'll find all you need to digitally enhance photos on your PC, including:

Starting To Use Editing Software

Image editing software allows you to manipulate your digital photos on a PC, from simple corrections to complex special effects. First we'll introduce you to finding and using the editing functions.

Image editing software comes in many varieties, from the basic tools included with your digital camera to the highest level of software designed for imaging professionals and true enthusiasts.

The software that comes on the CD-ROM with your digital camera is okay for basics such as resizing and modest corrections to colour and image size, but for the majority of editing tasks, as found in this book, we recommend you buy one of the many off-the-shelf image editing packages available (see *Which Software?*). With these, you'll have a powerful editing tool for just about any image editing task you can think of.

Throughout the image editing topics of this book we will use examples from a very popular consumer-level editing software package, Adobe Photoshop Elements. As it's a typical package, you should be able to achieve all the effects described in this book, whatever commercial software package you are using.

Finding Your Way Around

Though there are lots of different image editing packages on the market, all of them use very similar tools and editing functions. They'll even have very similar workspaces, with the main tools ranged down one side (usually the left side though you can move them around). Across the top, an 'options' bar

provides ways of changing individual tool settings (such as brush sizes) and access to other menus with even more choices.

Helpful hint windows or 'wizards' are often incorporated into the software, and these will automatically pop up when needed to assist you with simple editing techniques.

Tools and functions can be accessed in a number of ways: through menus that appear (or 'drop down') when you click on them in the options bar; in a small window that pops up on the desktop; or by clicking on an icon (a small picture that indicates a function). Usually, if you hover the mouse cursor over an item for a moment (without clicking), its name will appear over the tool so you can always check what it is if you're not sure.

While your software will have all or most of these menus/tools, the names and locations may differ depending on the package, so always read the manual that comes with your editing package or use the on-screen help assistant in the program to search for a particular function.

What follows overleaf is a list of the key tools from the most popular software packages so that even if the names vary, you'll know which tool icon to look for.

Menus and windows you could find on your desktop

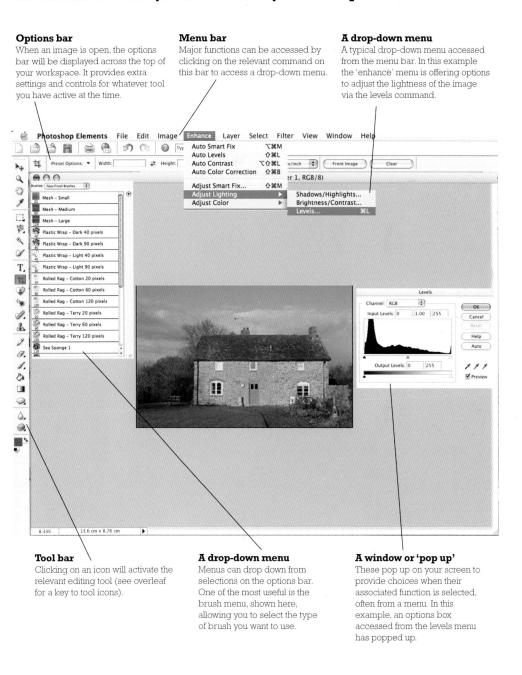

Tools Explained

Marquee Tools: Used to outline a selection in an image for copying or cutting.

Lasso Tools: Used to surround specific objects in an image in order to select them for cutting or copying for example.

Healing Brush/Patch (not available in all

packages): This tool samples pixels from one area and copies them using the texture of the pixels from a selected area to 'heal' marks such as spots in a portrait shot for example.

Clone Tool (or Rubber Stamp):

Allows the copying of

pixels from one area to be pasted over another area.

Eraser: As the name suggests. this is used to remove/erase

pixels from an area in an image.

Blur/Smudge Tools:

Tools that allow you to blur or smudge pixels.

Path Selection Tool (also see Pen

Tools): Allows you

to draw a selection around objects in an image that can then be removed. Paths can be saved for use on other images.

Pen Tools:

Allow you to draw, create and adjust 'paths' around objects in an image.

Crop Tool: Allows you to define an area in an image so that you can permanently 'crop' away the rest.

Hand Tool: This tool allows you to move an image around in an open window if, say, you've magnified the image and want to see an adjacent area without altering the magnification factor.

Foreground Colour (a):

This allows you to define the

colour of the foreground in a layer.

Background Colour (b): Clicking this lets you define the background colour.

Exchange Colours Tool (c): Works with both the Foreground and Background Colours (above) to swap quickly between the two.

Default Colour Settings (d): Clicking this resets the colour of the foreground and background to their respective black and white positions.

Display Mode - Standard: Sets the software to display the images in the standard edit mode.

> Display Mode - Quick Masks (not available in all packages): Sets the software to display the

images in the Quick Mask edit mode.

Screen (Display) Modes: This controls the way images are presented within the workspace: maximum size for example.

> Move Tools: Allow you to pick up and move elements within an image or on layers in a document being edited.

Magic Wand Tool: Allows you to quickly select (or make a selection of) all the pixels of a similar colour to the ones clicked on.

Brush Tool: Selecting Brush Tool this tool activates the Pencil Tool brush currently active in the Brush Palette.

Selection Brush Tool (not available in all packages): Paints a selection (or Mask in Mask mode) onto an image or layer.

Pencil Tool: As the Brush Tool.

Gradients Tool: Allows you to apply predefined gradients across an image or layer.

Zoom Tool: Magnifies an area of the image you're working on.

Paint Bucket Tool: The paint bucket allows you to fill (or 'pour') a chosen colour into large areas of an image (or selections) without the need to 'paint' it in by hand.

Dodge Tool: Mimics the traditional darkroom effect of lightening part of an image by reducing the 'exposure' of those pixels.

3

Burn Tool: Mimics the traditional darkroom effect of darkening an area of the image by increasing the exposure of those pixels.

Type Tools: These tools allow you to apply text into an image or layer.

Shape Tools: These draw

custom shapes into an image on a separate layer or layers.

Colour Samplers: A

pipette style icon for a tool that lets you

'sample' colour from pixels for use elsewhere in an image or layer.

Saving Your Photos

If you adjust images on your PC and don't want to lose your work, you need to save those changes. But there are various ways to do this – here's how to pick the best one for any situation.

Save/Save As

You have two main saving options: 'save' and 'save as'. The first overwrites the existing data with your changes, in other words you lose what was there before and it gets replaced with the new, edited data.

The second option lets you save the image as a new file with a new name of your choice. In this way, you preserve the original file as it was and create another image file that has had the changes applied. This is ideal should you make a mistake, as you can go back to the original file and work on it again and 'save as' again.

While the latter means you double up on files – you'll end up with two files; one edited and saved and the other original, left untouched – it also allows you to retain the original files for future use and for archiving (see *Backing-Up*). So now let's look at the commonest file formats available, for you to use in most image editing programs.

File Formats

Digital images are created by your digital camera using a range of special data structures – or formats – that allow them to be 'seen' by a variety of programs on PC. Each format has advantages and disadvantages that may mean you prefer one

type over another, depending on what you want to do with the finished image.

Each time you save an image, you need to decide which file format to use. Some formats save the image using compression, which is a special computer algorithm that crunches your images down to fit into a smaller memory space.

Some compression algorithms remove data to do this and are called 'lossy' formats, here data is 'lost' in order to 'squeeze' (or compress) the file. Other formats offer compression without losing data or creating artefacts, and these are called 'lossless' formats. The amount of compression is nowhere near as high as with 'lossy' formats, but you'll still be able to reduce the file's size by around 50%.

JPEG or JPG Format

JPEG (denoted by the 'JPEG' suffix or sometimes 'JPG' depending on the camera, program or PC you use) is a lossy format and can be compressed down to around 10% of the original file size with slight loss of quality. If a file is saved using JPEG compression, the JPEG format looks for similar pixels and removes those that are not needed, then it makes a 'best guess' to put them back again

when the file's opened, say on a PC screen. It is for this reason that small errors in the compression algorithm can cause a drop in quality as occasionally it gets those 'guesses' wrong. This compression process can also create JPEG artefacts, small blocks of unwanted pixels in the image.

You can save JPEGs at settings between 1 and 10, with one being the lowest quality (most compressed) setting and 10 offering the highest quality, least compressed file. A setting of five or six usually provides the ideal balance between file size and quality for most uses.

Photoshop **BMP** CompuServe GIF Photoshop EPS **√** JPEG **IPEG 2000** PCX Photoshop PDF Photoshop 2.0 Photoshop Raw PICT File PICT Resource Pixar PNG Scitex CT Targa TIFF

This is a typical save menu in image editing software indicating the various file formats you can choose to save the image. JPEG is highlighted with TIFF at the bottom of the list

TIFF Format

TIFF (denoted by the '.TIFF' or '.TIF' suffix) is a 'lossless' format and is the best file format to choose if you need to maintain the image's quality; memory space is not an issue; and you don't want to compress the file as heavily as you might with JPEG. TIFF stores information about colour and dimensions as a 'tag' appended to the file (and hence the name: Tagged Image File Format) and is the

standard file format to use for saving high quality images ready for printing for example.

Photoshop File Format

Photoshop is an image editing software package that uses a file format denoted by the suffix '.PSD'. It has become so popular that it is practically a 'standard' file type and therefore extremely common. It is able to support enhanced colour information (better even than TIFFs) and holds other image edit specific information. Some non-Photoshop software packages use this file type even though it may be called something else in those programs. It creates large-sized files.

GIF Format

Another compressed format for images uses the suffix '.GIF' and was originally designed for Internet applications such as web site graphics. It uses a very limited set of colours (just 256) and is ideal for graphic images with large expanses of even colour. Photographs saved in GIF format lose a great deal of colour information and any smooth gradations between shades of the same colour. This can make the image look 'stepped'.

RAW Format

RAW files are created in the camera without any in-camera processing affecting the data. They provide all the information captured by the camera's sensor. You can process the images later on PC and access all the unprocessed information within the image file. You will need special software to be able to edit RAW photos which is usually supplied with the camera.

PICT Format

This is a file type developed for use on Apple Macintosh computers designed primarily for on-screen only images with a limited resolution. It offers a way to see an image with very basic software, so even some text programs will be able to see a PICT file, although they cannot be used to edit it.

PNG Format

Another lossless compression format, PNG (suffix '.PNG') is built for use over the Internet and is therefore ideal for web images. It supports information on colour, greyscale and true-colour images and is designed to be a more advanced replacement for the GIF file format.

PDF Format

The Portable Document Format (suffix '.PDF') is a file type that is used by Adobe Acrobat. As its name suggests though, the document can be looked at anywhere. You need to have the Adobe Acrobat Reader software to do so, but it should be included free with your computer operating system. You cannot edit the document with 'Reader'.

PDF is ideal for use on documents such as newsletters or other designed jobs that will be printed, such as posters, because it retains information about the images, typography, graphics, text and the layout all together within the document.

WHEN TO USE EACH FORMAT

- TIFF: Lossless compression with best quality for images that are to be printed.
- JPEG or JPG: Lossy compression format, ideal where quality needs to be retained but memory space is at a premium or for internet use when a better quality is required.
- PSD: The generic file format used by the popular Photoshop editing programs, again for high quality usage.
- GIF: Lossless file format designed for web graphics. Not for printed photographs.
- PNG: Offers lossless compression and is ideal for Internet use, similar to 'GIF' but better quality.

- RAW: RAW images are composed of the raw data as captured by the camera sensor. Most, if not all, digital SLRs have this option as do many of the more advanced 'enthusiast' compact style digital cameras. Most current image editing packages can edit RAW files; alternatively use the software that comes with the camera.
- PICT: An Apple Macintosh specific format designed for use on on-screen images with a limited resolution.
- PDF: A cross platform file format readable by most computers and ideal for newsletters, posters or letters containing graphics and text.

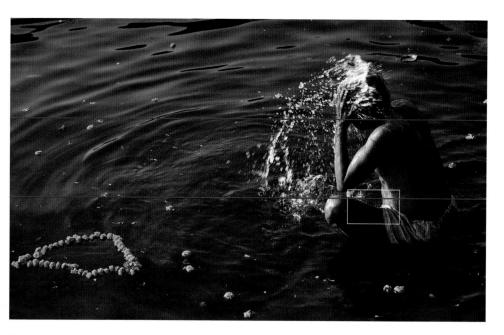

This shot has been split into three elements. The top section is a TIFF file, the central portion a high quality JPEG and the bottom third a very low quality JPEG. The enlarged area shown below reveals the blocky JPEG artefacts caused by the JPEG compression from the area indicated in the rectangle above. The high quality JPEG has almost no visible problems at all. Also, note the way the colours have blocked together in the water below the washing man.

Auto & Quick Fix

Image editing packages provide easy-to-use tools that allow you to make fast edits to images at the click of a mouse. Here's how to make the best of these 'auto' or 'quick fix' tools.

A quick fix is exactly that, a fast and easy way to adjust common problems, such as low contrast or under and overexposure in an image, simply by using a couple of clicks of your mouse. Some packages call it 'auto fix' or 'smart fix' because the program itself analyses the image, looks for problems that either make the image dull or colourless and then adjusts the settings to compensate.

Each editing package works in a similar way and, whichever software you use, the auto fix has a similar effect – improving the image. The function is usually found in a drop-down menu.

With the image you want to be fixed open in the program, highlight the auto fix option and the program will go to work. If your software has other settings such as auto levels, auto contrast and auto colour correction, each operates in the same automatic way applying corrections according to their titles. If one produces an unsatisfactory result, try one of the others. The

auto fix however (as it works across all the image variables at once) will usually be sufficient for most minor image corrections.

Some packages allow you to adjust the amount of correction that is applied as you go. This is ideal if, after applying an auto fix, you think it has overdone the 'fix'.

Other programs have a preview screen that provides a before and after window (as the example below illustrates) to show how the edit will affect the image. This allows you to adjust the amount of auto fix applied by judging its effect 'live' on screen.

Fixing Colour Casts

In this shot taken indoors in a museum, the display's lighting has created an unnatural orange colour cast that has completely hidden the true colours of the statue. Using an auto fix, the program has analysed the shot and completely removed the orange colour cast, without affecting the dark background thus revealing the true, more neutral bluish colour of the statue.

Fixing Low Contrast

In images such as the top one here, where there's little contrast (contrast is simply the difference between the blackest and whitest areas in a shot), the whites are muted, the blacks look brown or grey and detail is pretty much invisible. An auto contrast fix can work wonders here. In the second shot, the auto

contrast fix has checked the image for the brightest and darkest parts, and fixed them. It has boosted the colours as well, making the shot look brighter and more natural.

Fixing Exposure Problems

Under and overexposure can be adjusted in auto fix too. Underexposure is caused when the camera has not recorded enough light to get a bright, colourful image; overexposure is the opposite. Using auto fix will help brighten or darken an image. The cake shot shown below was underexposed, but with auto fix it has been brightened and the colour has been enhanced.

A problem with correcting exposure issues, however, is that the auto fix can sometimes overdo the processing. This means you may lose detail in some areas of a shot and colours may be adversely affected. You may need to judge the amount of auto fix you apply if this is the case.

Cropping

There's no need to worry if an image isn't framed as you'd like. The cropping function of your imaging software is a great way to remove unnecessary details from a scene or to add emphasis to a shot.

Cropping an image can be done at the beginning of the photography process, when you take the snap, or later on when you edit the images on PC. The process you go through when taking a picture – zooming in for example – is a form of cropping. It simply means cutting away parts of the scene in order to improve a photo or to remove aspects you don't want. All image editing programs contain tools to crop images.

Removing Unwanted Detail

As the images on the facing page and below show, cropping can dramatically improve a photo. Just as they took the snap below, the photographer caught a disembodied arm protruding into the bottom-right of the shot. This is a very distracting intrusion indeed. Cropping, as shown in the image above right, has removed this and helps to emphasise the viewer's attention on the main 'action' in the finished photograph, below right.

Using the Crop Command

By clicking on the crop icon, the cursor changes to the cropping tool. You then click the mouse button, hold it down and drag the cursor across the image to mark out the area you want to crop around.

If you don't get it right first time, don't worry. The hatched line that will have appeared,

denoting your currently selected crop area everything outside of which is deleted - has a series of small, box-like 'handles' half way along each edge and at the corners. They can be clicked and dragged to a new position to fine-tune the crop or even rotate the cropped area.

Once you are happy with your

Below left: The intrusive disembodied arm. **Above**: Cropping removes this distraction. **Below**: The finished photograph.

selection, double click inside the crop area indicated by the hatched line and the unwanted, 'cropped away' parts of the image, indicated with a shaded area, will be deleted, completing your crop. Remember to save the image once you've finished.

Creative Cropping

Cropping can also be used to change the emphasis of a shot, alter its format or to zoom in on a smaller area of interest. This improves its creative

merit. Here's an example of a shot which has been cropped to create extra emphasis on the model and her extraordinary finger nails. Removing the background also helps balance the photo.

Pixels and Memory Considerations

Cropping not only removes unwanted parts of an image but, as it is permanently deleting areas of the shot, it is also removing pixels. The number of pixels in an image directly affects the file size, so when you remove them by cropping, you also reduce the file size of the image. A 50% crop of an image will reduce the file size up to three quarters. While this saves on computer memory, it also has implications for printing as the larger the file size and the more pixels you have, the larger the print can be (see *Printing* for more details).

So always consider what you want to do with an image later if the intended crop is to be a large one. This is another reason why it is always better to shoot images at the digital camera's maximum resolution – you will always have the optimal number of pixels to play with for larger cropping edits.

Straightening

Probably the most common problem for any photo is the sloping horizon effect. Luckily, with image editing it's easy to rectify.

Sloping or lopsided images are caused when the camera is not held sufficiently level, and so can happen very easily. The safest way to avoid this is to use a tripod, and to make sure that the camera is level before you press the shutter button. However, setting up a tripod is not always practical, and often you may not even realise that your picture is not level until later when you look at the image on PC.

There's a simple image editing function which can quickly correct a sloping horizon. Straightening the horizon is particularly important in landscape images that need to be printed at larger scales, say for framing on the wall.

This straightening function does crop a little of the original image but not enough to cause major problems. Here's how to do it.

Step 1:

Open the image to be straightened and activate the 'grid' overlay pattern, in this case using the **View > Grid** command. A grid of lines and squares will overlay the image, but will not affect the image as the grid sits over the picture.

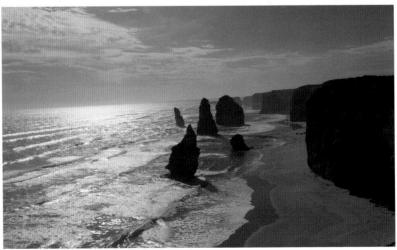

This image has an unnatural sloping horizon that needs to be straightened.

Step 2:

Using the grid of lines and squares as a guide, use the **Image > Rotate > Free Rotate** Layer command. Depending on the software, a box may appear asking you to make a 'layer'; don't worry about this but click the 'OK' button. The image is now transformed into a movable image layer called something like 'layer 0'. You'll see a new box appear around the image with handles similar to those used to crop an image.

Hover the mouse cursor over a corner handle and little arrows appear indicating you can rotate the image in either direction.

Step 3:

The technique's the same as for cropping an image: you click and hold on a corner handle but this time rotate the image until the horizon is aligned correctly with the overlaying grid.

Once you're satisfied the horizon's straight, double click inside the image and the transformation will be complete. You will see, however, areas around the edge of the straightened image where cropping is required to tidy up the edge. Simply use the previous topic's crop technique to complete the image edit and then you're done. Now save your image.

The final straightened image, without the sloping horizon.

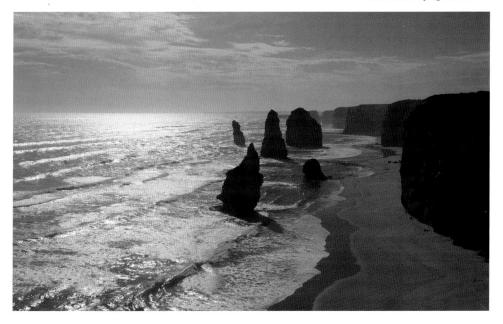

Resizing

It's very simple to change the resolution, dimensions or file size of an image. Here's how and why to resize your photos.

Whether you need to reduce the resolution and file size of an image for use with email or the Internet, or you want to enlarge the file in order to print the image at a size that its current resolution would not otherwise allow, there is a simple method to achieve your goal: the 'resize' command.

Resampling

When you resize an image you can change its output size without altering its physical, pixel or file size. Or you can 'resample' the image, which actually changes the dimensions of the pixels as the image is resized, and therefore its file size will alter too. Resampling is necessary in some circumstances, but to be avoided in others. Let's look at some examples to explain what's involved.

Making Images Smaller

Here's how to resize an image which is only needed at a small size, for use on a web site for example. Resampling will reduce the file size, but won't be detrimental to the quality of the final smaller image.

Step 1:

To make an image smaller, open the image you wish to reduce in size and use the Image > Resize > Image Size command, which brings up a new dialogue box indicating the current size of the photo. Specifically, it presents information on the pixel dimensions, the document's size in centimetres and the current resolution, and the resample check box as shown here.

Step 2:

To reduce the resolution from 300 pixels to screen resolution, 72 pixels per inch (ppi), click the 'resample' check box and the 'constrain proportions' check box which ensures the aspect (height-to-width) ratio of the shot will not change, then type '72' into the 'resolution' box.

Notice how when you click in the resample box, the 'pixel dimensions' box becomes editable. Click OK to make the change. The image will shrink on screen to its new size. Use the **File > Save As** save command and give the new, smaller image a new name, otherwise it will overwrite the original file and you'll lose it.

Making Images Bigger

Here's how to increase the size of an image so that it can be printed at a larger size. This can be done with resampling, thus increasing the size of the file, or without resampling, leaving the file size unchanged. If resampling, the software will use interpolation, which is the name given to a calculation that adds pixels based on those that are already there. Unfortunately, interpolation can cause a softening or blurring of your image as the program 'quesses' what pixels to add.

Step 1:

Open the image you want to enlarge and use the Image > Resize > Image Size command here to bring up the image size dialogue box.

As discussed, there are two strategies that can now be used to make the image

bigger: with resampling, which changes the file size. or without resampling.

Step 2:

To resample and make an image bigger, check the resample and constrain proportions boxes, and type the required dimensions into the width or height boxes. Typing in one affects the other and the pixel dimensions will change as well as the file size, which will increase dramatically. To keep the quality, don't enlarge an image with the resampling set to more than double its start size.

Step 3:

Enlarging without resampling requires typing the required dimensions into the height or width boxes but leaving the resample check box clear. The file size and pixel dimensions remain unchanged, but the 'document size resolution' has now reduced. To keep print quality high,

don't let this drop below around 180ppi. Use the File > Save As save command resaving the shot without overwriting the original image.

Resizing Example

These three images below reveal the effect resizing with resampling has on both the pixel dimensions and the file size. The largest image has 2048x7032 pixels with a file size of 18MB, ideal for printing at over A4. The middle image has 1536x1024 pixels and a file size of 4.5MB, okay for smaller print sizes and the smallest image has just 640x427 pixels and only a 800KB file size, ideal for email.

Sharpening

If you have a soft image or a shot not quite focused, and think it's ruined, think again. Your editing software can sharpen the image quickly and easily.

Occasionally, the very digitising process involved in creating images introduces 'softness' which appears as a slight lack of focus. All digital cameras have built in settings that can process this softness away but when you add camera shake or the camera not focusing properly, the pictures can look even

All image editing packages have functions designed to help sharpen digital images, called 'filters'. Sharpen filters have a variety of modes but one filter stands out as the best tool in the sharpening armoury, the 'unsharp mask'.

Using Unsharp Mask to Sharpen

The unsharp mask filter is generally the best to use for sharpening, as it can be finely tuned to each image. It works by increasing the contrast between adjacent pixels: the higher the contrast at these pixels, the more the unsharp mask works. Because these points usually represent an 'edge' in an image, the overall effect is to sharpen the shot.

But the settings you use will depend on the image's content; a portrait may require completely different unsharp mask settings, to say, a shot of a building. Here's an example that will make this clearer.

Step 1:

less sharp.

File > Open the image to be sharpened and then navigate to the unsharp tool via Filter > Sharpen > Unsharp Mask menus. A new dialogue box appears with a preview window and three 'sliders', which can each be dragged to a desired point.

Step 2:

The first parameter to set is the 'radius'. It controls the width around the pixels it sharpens (similar to a halo effect). Entering a radius of 1 tells the software to

'look' outwards one pixel as it evaluates each pixel. The higher the radius number, the bigger the halo of sharpening around each evaluated pixel.

Step 3:

The next setting to adjust is the 'amount'. Think of this as controlling the 'volume' for the unsharp mask as it determines the strength of the sharpening effect. A small radius setting will need a higher amount than a bigger radius setting to produce the same visual sharpening effect.

Step 4:

Last but not least comes the 'threshold' control, which acts like a noise reduction setting by instructing the software to ignore certain differences between pixels as it sharpens, helping prevent over-sharpening in areas such as skin tones in a portrait for example. Move all three sliders to get the best sharpening effect for the shot.

This shot shows before (top part) and after the sharpening effect. The detail in the roof has been revealed without adversely affecting the rest of the image.

Settings For Best Results

As a rule of thumb, start by using an amount setting of 200 to 300%, then a threshold of zero and a radius setting to match the photo's content, typically between 0.5 and 2. Overdoing the radius will generate white lines (the halos become visible) around everything with an 'edge' in the shot. You rarely if ever need a radius of more than 3 for example.

To sharpen the image above, which lacked sharpness primarily in the roof detail, the amount needed was '222', a radius of just 1 was set and a threshold of 5 used, primarily to reduce noise artefacts that appeared in the blue sky.

Other Sharpen Filters

Sharpen

The sharpen filter can be used to increase apparent focus but needs to be used sensitively. It is best applied to smaller parts of a shot rather than the entire image, as it can actually be detrimental to some types of image.

Sharpen More

As you might expect from its name, this sharpen tool adds a strong focus-like effect, again better used on a smaller selection in an image rather than across the whole photo. It can improve clarity in smaller areas effectively and is a much stronger, sharper effect than sharpen.

Sharpen Edges and Smart Sharpen

The Sharpen Edges filter finds areas in an image where colour changes are strongest and sharpens just those points. In this way, edges can be sharpened but the overall 'smoothness' of the shot is retained Smart Sharpen can automatically sharpen images based on the image content; various settings such as 'lens' or 'motion' blur help to tailor it more accurately too.

This enlarged area shows the effect of over-sharpening an image (inside the red box). Detail around edges of pixels has been blasted and noise has been ramped up unacceptably.

Brightening & Darkening Photos

Some photos are too dark or light to be adjusted using a quick fix.

But don't despair, the photo can still be rescued.

Images can come out 'too dark' or 'too light' due to under or overexposure, meaning they have detail missing in their shadow or highlight areas: the pixels have just gone completely white or completely black. These problems can be improved by putting back some of that detail to brighten or darken the problem areas. This is usually very successful for shadow areas. Highlight areas can also be improved but not usually to such a large degree.

Brightening an Image

Depending on your software, you'll have a menu offering a control for highlights and shadows and/or a levels adjustment control.

We deal with levels, a more advanced method of adjusting lighting and colour, later in the topic *Levels*. Let's stick with the 'shadow' and 'highlight' controls here.

Step 1:

File > Open the image that needs to be lightened. In your

This before (bottom section) and after picture shows how a 50% adjustment to the lighten shadows slider has lifted fine skin detail out of the shadowed elephant that was completely missing in the original shot.

image editing package, choose **Enhance** > **Adjust Lighting** > **Shadow/Highlights** or equivalent from the drop-down menu.

Step 2:

Drag any of the three lighten shadows, darken highlights or midtone contrast adjustable sliders (or enter a numeric value into the relevant boxes) until you're happy with the result. In our example (below), an

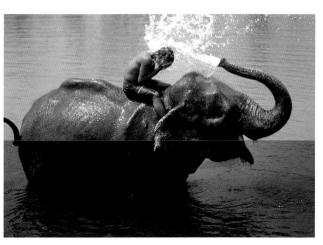

adjustment of 50% was applied to Lighten Shadows. Ensure you check any preview box to preview the effect and accurately assess the adjustments before they're applied to the shot.

Step 3:

Click OK once you're happy, then save your photo and you're done.

Darkening an Image

Step 1:

As before, **File > Open** the image that needs editing to make it darker. In your image editing package, choose **Enhance > Adjust Lighting > Shadow/Highlights** or equivalent from the menu.

Step 2:

Drag the darken highlights and, if required, the midtone contrast sliders (or enter a numeric value into the relevant boxes) until you're happy with the result. Below a setting of 50% to the darken highlights adjustment was required and the effect on the contrast meant an additional adjustment to the midtone contrast was needed, in this case plus 10%. Once again, check the preview box to preview the effect and accurately assess the adjustments as they're applied.

TOOLS AT A GLANCE

- **Lighten Shadows**: Brightens all the dark areas in a photo, revealing more of the detail hidden within but still captured by the digital camera.
- Darken Highlights: This darkens the lighter areas in a shot and can reveal more detail contained within the brighter areas of a scene. Bear in mind that any pure white areas won't have more detail so will remain untouched by this setting.
- Midtone Contrast: This control lets you adjust the midtones (greys for example) in a picture if, after you've adjusted the highlights or shadows, the contrast doesn't look right.

Step 3:

Click OK once you're happy and then save your photo and you're done.

In this shot, the image was overexposed and as a result, all the highlight detail had gone from the clouds and colour has been leached too. Using the darken highlights and midtone contrast correction has recovered most, if not all, the detail and colour previously not visible.

Removing Redeye

We've all had pictures of our friends and family ruined by the dreaded 'redeye'. But even if your camera can't prevent it, you can still edit it out.

PREVENTING REDEYE

Redeye is caused when light from a camera flash is reflected from the back of the eye (the retina) into the lens. The closer together the camera's lens and flash, the more likely it is your photos will suffer from redeye. Redeye is red because the blood vessels in the eye colour the reflected light producing the effect you see in your photos.

It becomes most prevalent in low light when the subject's pupil is bigger and in children, whose eyes and pupils tend to be naturally bigger all the time. It's a common problem simply because of the small size of most modern digital compacts. Their tiny size means the flash and lens are always quite close together and hence the reason practically all digital cameras have a redeye reduction mode.

To help prevent or reduce the redeye effect always make sure the redeye reduction mode is on when shooting with flash and/or in low light. The redeye mode will either fire a burst of quick flashes or project a beam of light towards the subject before the shutter fires. This has the effect of helping reduce the iris's size, thus reducing the pupil size and so reducing the redeye effect in the final shot.

Redeye is a common problem with today's small digital compact cameras, which even with their redeye reduction modes (see left) can still produce shots marred by *that* demonic look.

If you have a shot with redeye don't worry, most editing software packages have a simple-to-use tool for removing or reducing the effect, saving an otherwise ruined photo.

This slow sync shot taken at night has a dramatic redeye problem. Let's see how we can fix it.

Step 1:

File > Open the image that needs redeye removing. Using the zoom or magnify tool, magnify the eyes of the subject suffering

redeve by clicking and dragging around the eyes with the magnify tool. This will enlarge that portion of the photo sufficiently to work on.

Step 2:

Click on the 'redeye removal' tool and in the same way you clicked and dragged the image to magnify it, click and drag the redeye tool around each eye separately. The software will 'look' at the red pixels and replace them with a dark grey series of pixels (also preserving any catch lights in the eyes – as shown above) producing a natural looking pupil colour.

Step 3:

Repeat steps one and two above for each person suffering the effect in the shot until the redeve is removed.

Step 4:

Save your photo and you're done.

The same slow sync flash photo after the redeye reduction tool has been used. It has produced a natural looking effect, keeping the catch lights and rescuing an otherwise unusable picture.

Creating Black & White

You can easily create black and white photos from colour shots – ideal if you want to make a dramatic change of emphasis in an image.

Removing the colour from a perfectly good image may seem a little odd but it is a useful device when a shot has not worked the way you intended in colour. There may be distracting colours in a portrait image or the texture and shapes in the photo may strike you as something that could be better treated in black and white or 'mono'. Some images have such muted colours that it may be possible to derive more impact from a mono version than the original colour image.

Subtle Colour to Black and White

This photo of a lake in India has such subtle hues and tones that it is an ideal shot to use this technique on.

Step 1:

File > Open the image that you'd like to convert to black and white. Use the

Enhance > Adjust Colour > Remove Colour command, or use your software's equivalent – it may be called 'desaturate'.

Once the 'remove colour' command is activated, all the colours in the original image's pixels are given equal red, green and blue (RGB) values but lightness is not changed. This actually gives you the black and white effect. But it's possible the shot can have a lack of contrast. Without definition between blacks and whites it looks almost too grey.

Step 2:

If the image does lack contrast then a quick fix (or smart fix or auto fix depending on your software) will help sort it out. Follow the steps in the topic Auto & Quick Fix to apply a quick fix and you'll find the image's blacks become blacker, the whites whiter and overall the contrast will be improved.

Step 3: File > Save your image with a new name.

The finished image works well in black and white thanks to the graphic-looking nature of the subject matter.

Strong Colour to Black and White

Other types of image, such as the one below, have deep shadow and stronger contrast features which also lend themselves to a mono treatment. Here, the dark background and lighter skin tones would be a great graphic contrast in a mono shot.

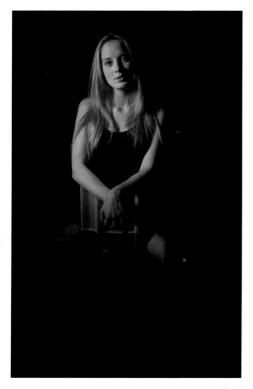

Step 1: File > Open the image that needs converting to black and white. Use the Enhance > Adjust Colour > Remove Colour

command as before. With the remove colour command activated, all the colours in the original image are changed to black and white once more. However, because of the dark background and lighter skin, the emphasis on the woman needs to be improved.

Step 2:

Because this image has stronger areas of contrast than the previous shot, a quick fix won't do it any good, it'll just try to equalise the dark and light areas, and ruin the shot.

This time use your software's Enhance > Auto Colour Correction command or equivalent. This looks at the (now grey) pixels. These all have equal RGB values, but with untouched 'lightness' parameters, so this command boosts the brightness of less grey pixels. This adds punch without damaging the blacker parts of the shot.

Step 3:

File > Save As your image and give it a new name so that you don't overwrite the original colour shot.

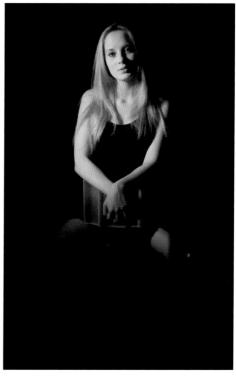

Colour Management

The way a colour is displayed on a PC's screen can vary dramatically when printed by an inkjet printer. Here's how to ensure the colours you see when you take a photo are the colours you get on screen and on the printed photo.

Digital cameras, computer screens and digital imaging devices, including scanners and printers, have their own specific way of 'seeing' and representing colours. These are called colour profiles, and in order to reproduce colours consistently across all of your digital devices, you'll need to ensure that they all use the same profile. This is the essence of colour management.

RGB and **CMYK** Colours

In the digital domain, colour is represented in two ways. The first, on a PC screen for example, uses red, green and blue (RGB) pixels which combine to create all the colours of the rainbow. The second is via coloured inks from printers that use a basic set of four colours, cyan, magenta, yellow and black, often abbreviated as CMYK. These four colours are used to represent the RGB colours, which are converted by your printer when printing your photos.

Getting Accurate Screen Colour

Helpfully, most digital cameras and devices have industry standard colour management systems built into them. However, it's important that you can see them properly on screen, particularly when you want to manipulate colours using editing software (as we'll discuss in the following topics of this book).

So the first thing to do is to calibrate your PC's screen so that it uses the correct colour settings. This ensures it has the correct brightness and that its colour balance is set properly. The set-up process is judged by eye and is best carried out with as dark a background as possible for optimal accuracy. Consult your manual or on-screen instructions about how to do this accurately – most PCs will have a handy software wizard to guide you through the process. Once completed, you're prompted to save the information as a profile, which other programs, such as image editing software, can use to ensure colour is properly displayed.

You'll probably find that the colour accuracy of your monitor is almost spot-on out of the box. However, it is worth checking as so much of your later colour work will be based on this.

Colour Gamut

The 'colour gamut' is the name given to the range of colours available on a specific device, such as a digital camera, PC screen or inkjet printer. The larger or 'wider' the gamut, the more colours the device has at its disposal. This is usually represented by a

diagram or graph which shows all of the colours visible to the eye (the total gamut) and those colours within that which are actually able to be used by the device, indicated with a triangle inside the graph's colour range – as shown here.

Typically, printers have a range of colours smaller than those available to your digital camera or even your PC screen. This is because greens and

blues reproduce poorly on paper as do purples and oranges. However, with your screen calibrated correctly you'll be able to get a good idea of what a finished print might look like before printing and you'll be amazed at how lifelike it can look despite these apparent drawbacks.

In the set-up or preferences of all of your connected devices, such as printers or image editing software, ensure they all use the same colour settings, i.e. the same colour profile. One profile known as 'Adobe RGB' (sometimes called 'Full RGB') is particularly good because it has a larger gamut than many other image profiles, meaning it has more colours to utilise and is therefore ideal for digital images. Or use any profiles you have previously saved if you're happy with the results they produce.

Another common profile is called 'sRGB' which uses fewer colours than Adobe RGB for example and is typical of colour profiles used on the Internet and in many digital cameras.

Colour Settings in your Software

The image editing software you use will have a colour settings section that will always either preserve or convert the images you open in it to a specified colour profile, one that ensures standard colour control across all devices

Some digital cameras even allow you to save a specific colour profile into an image. Adobe RGB is one such profile and your camera will have a menu that allows you to embed this into your images. This is a good idea as Adobe RGB is an industry standard setting that can be used on PC too and as we've seen, has a large colour gamut.

To check the colour management in your software, go to the colour preferences or colour settings control panel and ensure the program can use Adobe (or Full) RGB. Switch on the 'full colour management' setting as shown below.

This is a typical colour set-up screen with full colour management checked ensuring all images have their colour profiles preserved or adjusted to Adobe RGB, the setting with the largest colour gamut.

COLOUR: AT A GLANCE

- Use the same colour profiles across all devices, ideally Adobe RGB (sometimes called 'full RGB'), which is the best setting for printing digital images.
- Use sRGB for images used on the Internet.
- Calibrate your monitor and always recalibrate it if you move its location or you change any ambient lighting arrangements around your workstation.

Adjusting Colours

It's easy to change and improve the colours of your images digitally.

All image editing software on the market provides for the control and adjustment of colour. Some of the more professional image editing packages will even provide you with individual controls for each element of colour. Some colour tools allow you to completely replace one colour with another, which can give dramatic effects.

For now, let's concentrate on getting the existing colour as accurately rendered as we can.

Controlling Colour Balance

Colour balance is simply the term used to describe the overall tones and hues in an image. The colour balance control can be used to make global changes to any image to help make the balance more natural, ideal for fast removal of odd colour casts.

Depending on your software, you'll have tools for controlling 'hue', 'saturation' and 'colour intensity'. Some will have a method of removing colour casts and most will have a tool which shows how variations of colour would affect your images.

Removing Colour Casts

Step 1:

File > Open the image you wish to adjust and use your software's colour adjustment tools to bring up the colour control dialogue boxes, in this case the remove colour cast dialogue box. By clicking with the 'pipette' icon that appears on grey, completely white or completely black areas of the shot, this tool neutralises colour casts by ensuring everything black, white or grey is actually black, white or grey. Trial and error may be required to get a pleasing result.

This shot of a model with her digital camera has an odd, orange colour cast on the skin that needs to be removed to make a more flattering shot.

Adjusting Hue and Saturation

If the colour cast tool doesn't achieve the desired result then the next weapon to use is the adjust hue/saturation tool.

Step 1:

The hue/saturation tool offers a powerful suite of colour control options. A drop-down menu offers various individual colour range settings, such as reds, greens, cyans and yellows (as shown below) or a 'master' control that affects all the colours at once by moving the hue, saturation and lightness sliders.

Step 2:

Move the hue, saturation and lightness sliders. This affects the colour range displayed in the image. Subtle movements of each slider are all that's required to remove any colour cast - or add a colour cast should you wish to.

Adjusting Using Colour Variations

To compare the effect of your changes with the original image, use the 'colour variations' tool.

Step 1:

The colour variations tool allows you to make fine adjustments to an image by selecting the brightness values you want to adjust. You have a series of buttons for midtones, shadows. highlights and saturation, depending on where you want the change to be applied in the shot. Large thumbnails of the image represent the 'before' and 'after' versions

Step 2:

The 'intensity' slider can be moved to fine-tune any effect and by clicking one of the smaller thumbnail images once the slider's been moved (each small thumbnail previews the change), the change is applied to the larger, 'after' thumbnail, as above. Specific software programs may vary a little in the layout of the controls, but the process is the same.

> The finished shot with the skin tones edited back to a more normal colour. Whichever of the methods is used, the application of such colour control can make a big difference to your photos.

Levels

Want to manipulate colour but with improved control over brightness? Use 'levels' to achieve this.

Using levels is another powerful way to control colour. It offers greater control over brightness than, say, the colour balance tool: each colour can be adjusted separately and the settings can also be saved for use on other photos in many software packages.

Levels use histograms (shown below and represented by the black curve shape within the graph) to represent the colour values in a shot. A histogram is a simplified graphic representation of the pixels in an image, graphing the colour intensity at each level. hence the name of this tool. In other words, it shows you the amount of colour in the image from the darkest pixels to the whitest and it allows you to manipulate the coloured pixels in order to improve colour rendition, brightness and contrast.

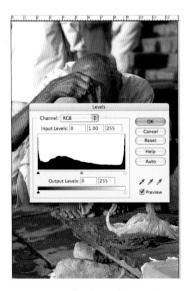

Using Levels Control

The levels control is accessed via your image editing program's Enhance > Levels or Image > Adjustment > Levels menus. When activated, a dialogue box presents you

with a histogram display of the colour values, a drop-down menu for the colour channels and small triangle sliders; one each for black, grey and white.

The aim of the levels control is to move the triangular sliders under the histogram to align them with the graphed pixels in the display. In this way, the colour is optimised across the spread of pixels.

The 'channels' drop-down menu chooses the colour that will be adjusted while the sliders can be moved freely to make changes in each colour, the changes affecting just the colour selected. Alternatively, the global RGB channel can be selected; all three colours are edited together. Also, the two black and white sliders affect the overall darker and lighter value pixels of the colours being worked on, so adjusting image contrast.

The top-left image on the opposite page shows how the pixels in the red channel have crowded into one end of the histogram towards the right, 'brighter' side. By moving the black slider and aligning it with the first pixels in the histogram, the red in the image deepens. Moving the white slider in the other direction would remove red from the shot.

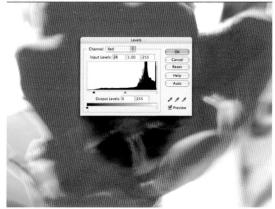

them with the pixels in each colour channel. Note the colour changes and then tweak the sliders as needed. Only adjust the grey slider to neutralise any colour casts (or add them!) and to adjust the midtone colour levels – if required.

Step 4:

Once you're happy with the result (which will depend on each individual image), click OK and the changes will be applied. **File > Save** (or **Save As**) the image to finish.

Other Levels Controls

Other controls include an 'auto' button, which automatically makes adjustments for you in a similar way to a quick fix. And there are three small pipette icons, one each for black, grey and white. By selecting these pipettes and clicking in those areas in the image that are supposed to be black, grey or white, the levels control will try to make the image more neutral, making whites whiter and blacks blacker for example. This is another useful tool for removing colour casts.

Controlling Colour and Brightness

Step 1:

File > Open the image you wish to edit using levels: the first step is to assess the histogram and check the preview tick box so that the changes you make can be seen before they're fixed into the shot.

Step 2:

Click the channels drop-down menu and select each red, green and blue colour in turn – adjust each as you go, as described above.

Step 3:

If the histogram reveals that the pixels do not reach both ends of the graph at any point, move the relevant – endmost – slider(s) to align

In this shot, the colour is muted and contrast is quite low, making the flower shot look very drab. Enter the levels control.

The finished image after adjusting the levels has boosted the natural colour – but not excessively – and sorted the contrast too.

Curves

Want fine control of the tones and brightness within your image?

The 'curves' command gives you this.

Curves offer the type of control gained using levels. However, because its edits are more precisely located within the tonal reproduction of your image's brightness values, careful management of curves allows you to finetune colour balance in your photos, without affecting any other part of the image. Let's have a look at how it works.

Using Curves

Although full of detail, which we don't want to lose, this waterfall image lacked dynamism. Using curves can bring out the best of the image without damaging the detail in the highlights of the waterfall. Here's how to do such an edit where all three red, green and blue colour channels can be adjusted together.

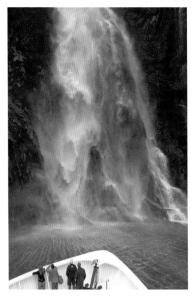

Step 1:

File > Open the image you wish to edit and activate curves. Notice the 'curve' is a straight, 45-degree line running from the bottom left (representing the blackest parts of the image) to the top right of the graph (the whitest parts of the shot) through the central (analogous to the grey areas) part of the graph/image. Click the preview tick box

so that changes you make can be seen before they're fixed into the shot.

Step 2:

Click the channel drop-down menu and select the red, green and blue colours in turn to adjust specific colours or, as with this example, leave it at the RGB (global) setting to adjust all three red, green and blue channels together.

This image of a waterfall is very subdued, lacks colour and contrast, but any adjustments need to preserve the delicate filigree of the waterfall. Levels could be used, but it might be too strong for the delicate nature of the detail in the waterfall. Using curves is the answer here.

WHAT CURVES CAN DO

Curves can be applied to all three RGB colours together or to each of these three channels in turn - depending on what you want to remove/add/adjust. You can also try the auto button and see if that takes care of any problems for you.

Altering curves separately for each of the red, green and blue channels offers an amazing amount of control over colour balance. These changes are produced so that any new colours will smoothly blend with those of the original shot.

Step 3:

Click on the line in the mid-point of the diagonal line in the graph. Note how you can click and hold the handle that appears and move it about, changing the curve as it moves. This makes changes to the image, which you can preview on screen.

Step 4:

Repeat Step 3, this time adding a handle at the mid-way point between the central handle placed in Step 3 and the top right corner. Do the same in the bottom left corner. Pull these new handles back towards the 45-degree angle, thus creating the S shape of the curve. Note how the colour and contrast have adjusted. The colours are much stronger and yet detail in the misty waterfall is retained.

Step 5:

Move each handle to achieve the best colour contrast boost for your image, and then, when you're happy, click OK to apply the changes to the shot you're editing. If you don't like an adjustment you've made you can simply click on a handle, drag it off the graph and the curve line will snap back to its starting point, ready for you to start again - a very useful feature. Try it...

The finished image after applying curves. The distinctive 'S' form of the curve (shown at the bottom of the page) is typical of the edit used to boost the midtones in a shot. In this case. where the image needed delicate colour control, a global RGB edit of the midtones has worked wonders without affecting the delicate detail of the waterfall.

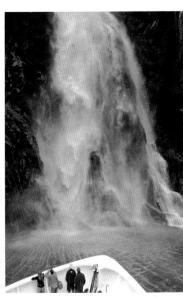

Also worth remembering at this point is that if you were adjusting individual colour channels (we look more at this in the next topic Advanced Curves) you'd carry out similar adjustments for each of the three channels until you're happy. A 'global' RGB adjustment may not even be required in this case.

Step 6:

Don't forget to Save (or File > Save As) your image to make sure you don't lose the edits.

The curves graph after the RGB channel adjustments have been made. Note the distinctive 'S' shape of the curve. Multiple handles can be added along the line at any point for even finer control.

Advanced Curves

Whilst you can use the curves control to edit an image sensitively, it also offers more extreme creative effects.

There are some simple but radical ways to play around with your digital images using curves. From neon-glow shots to 'negative' effects, curves offers plenty of tricks. You can even draw your own curve.

Creating a Curve

Creating a custom curve by drawing it onto the graph can help make fine adjustments to specific parts of the curve or allow dramatic edits to be made. Here's how.

Step 1:
File > Open the image to be adjusted in curves and access the curves dialogue box, typically through an Image > Adjustments > Curves menu, depending on your software.

Step 2:

Click on the 'pencil' icon tool when the curves box appears. This will change the cursor to a

small pencil icon. Now you can draw (click and drag the pencil icon) the

The pencil icon activates the curves 'drawing' control, so you can draw any curve you desire onto the graph.

shape you desire over the 45-degree line already shown. Here (below, left) three severe spikes were added at three points along the line in the RGB channel.

Step 3:

Click the standard curves edit button to reactivate the 'normal' curves control. This will show the just-edited curve but with new handles at each peak and trough in the line. You can edit these points further if you wish or use the smooth button to reduce the aggressiveness of the curve's steep sided peaks and troughs, calming the effect.

The same curve after the pencil tool has been switched off: new handles can be pulled to continue the edit further if required. Many handles can be used to provide finer edit control along the curve.

Step 4:

Click OK and then File > Save (or Save As) to save the edits you've made.

This is the result of using curves to their extremes. 'Normal' colours can be distorted or replaced with startling colour combinations

EXTREME CURVES IDEAS

Some of the best images to use curves upon, particularly if you're experimenting, are those with good shapes, outlines or strong features (such as the photo of Renoir's grave used here). The stronger the shape or outline, the more dramatic the effect that can be created using this extreme curves technique, but as ever, experimentation is the key.

Negative Curve Effect

You can create a negative effect using curves too. It's great for special effects and here's the way to do it quickly and easily.

Step 1:

File > Open the image to be adjusted as in Step 1 of Creating a Curve.

Step 2:

Ensuring you're in the RGB channel, slide the topmost (right hand corner or the white) handle all the way down the right side of the dialogue box and watch how the image becomes almost completely white.

Step 3:

Slide the bottom left (the black areas) handle all the way up to the top left of the dialogue box. Now you'll see the colours reappear, but this time they'll look just like a traditional

colour negative. And that's just what it is. By moving the sliders in this way (left), you're swapping all the lighter areas for the darker ones and vice-versa.

Step 4:

Make any final edits to the handles and once you're happy with your new, reversed and surreal shot, click OK to apply the changes, then **File > Save** (or **Save As**) to keep the changes.

Single Colour Curves

Single colour curves can be adjusted to finetune colour in a shot, or for more fun, to make dramatic special effects using bright neon-like colours that seemed not to exist in the original shot.

Step 1:

File > Open the image to be adjusted.

Step 2:

Select each of the red, green and blue channels in turn adjusting them as you see fit for the effect you require – as shown here. You may want to adjust only one colour as this would help remove a colour cast from specific areas of the image such as the

shadows for example. In this case, however, all three colours are adjusted to help give the required neon-glow effect.

Step 3:

Repeat the curves channel edit for each colour until you get the required effect.

Step 4:

Click OK and then File > Save (or Save As).

In this shot, changes have been made to remove neutral shadows and highlights and replace them with colours, giving a surreal, neon-glow look to the final image.

Channels

If you want superior black and white effects, 'channels' offers fine control.

We looked at basic methods of creating black and white images earlier, but the channels control – available in professional image editing packages such as Photoshop offers a more advanced way of creating high quality black and white pictures and provides extra control.

Three greyscale channels, one for red, one for green and one for blue, represent colour images. Each of these channels can be accessed and extracted to create a convincing black and white image.

Let's start by looking at the channels control and what it can do.

Using Channels Controls

The first thing to do is to assess how the image looks in each channel so that you can determine which of the three colours best represents the image as a black and white shot.

Because each channel is usually displayed superimposed over the others as a colour image you'll need to set the software to display each channel as a grey toned image.

Step 1:

File > Open the image to be edited in channels and access the channels dialogue box: typically it is displayed to the right side of the desktop whenever an image is opened. You may have a small box with layers and paths as well as a tab for channels. Click the channels tab to make it active if it is not.

Step 2:

Small thumbnails of the open image are displayed in the channels box with a full-colour one topmost, then greyscale thumbnails for the red, green and blue channels. A small eve icon sits next to each channel thumbnail. Click the red channel's eye icon.

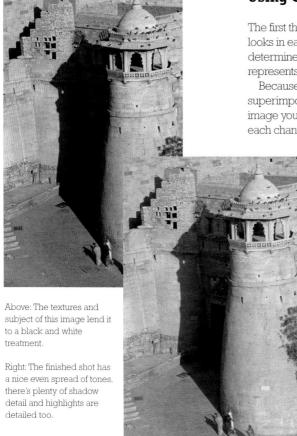

Step 3:

The red channel is now switched off. Notice how the image changes to a deep blue-green hue, the result of the remaining green and blue channels being left on. Click the green channel's eye icon.

Step 4:

The image should now display as a grey image, showing only the blue channel's colour information in grey tones. Double-clicking within any channel's thumbnail will display the image as a greyscale version of that colour channel. Try this and you'll soon get the hang of it.

Step 5:

Assess which of the three colour channels looks best in black and white. The red will usually be too bright, lacking fine tones and detail as there is usually a large amount of red in a photo, which looks white in its channel. Green offers a good range of greys in the shot used here (every shot could vary depending on its content) while the blue is too dark. So we have selected the green.

Step 6:

With only the green channel selected for this image, use the Image > Mode > Greyscale command to convert the green channel into a greyscale image. A dialogue box may appear asking you to discard the other channels. Click OK.

Step 7:

File > Save (or Save As) the image and now you have your black and white shot. The final image has the other colour channels removed (or extracted: this technique is sometimes called 'channel extraction') and as a result the file size will be a third smaller than the starting, full-colour shot.

THE CHANNEL MIXER

The channel mixer offers more control than that offered by simply extracting channels as it allows you to choose those colours that emphasise, say, greens over reds. In the monochrome mode, the channel mixer provides a simple way to mix all three colours as greys to control the amount of light, dark and shade to create a black and white shot.

In the full colour mode, it allows fine control of the colour too, simply by adjusting each of the red, green and blue output channels. The channel mixer is reached from the

Image > Adjustments > Channel Mixer menu and offers three sliders. Careful use of all the sliders allows you to control the hues in colour images or the way colours are mixed as shades of grey in the mono mode. To get the right look, experimentation is the key, but broadly speaking, boost greens for landscape work, and reduce blues and increase reds for shots with dramatic blue skies. Then simply tweak the slider values to get the desired results.

Below: These images show the full-colour and the three separate colour channels as greyscales when each channel is selected in the channel dialogue box. Note how the blue is very dark, the red very light but the green offers the best overall balance, making it ideal for a black and white shot.

Cloning & Healing

Stuck with unsightly blemishes or unwanted objects in a scene?

Cloning or healing can easily remove them.

Almost everyone has taken a photo where the subject has a tree or other odd object from the background growing out of their head, or the subject of a portrait might have an unsightly spot or blemish. The 'clone' and

This informal portrait was taken quickly and it was not until later, reviewing the images on screen, the antenna in the distance became apparent 'growing' from the subject's head. In order to save this otherwise perfectly fine shot, cloning must be used.

'healing' tools are perfect for removing these unwanted pixels from a digital photo, by copying pixels from one part of the image and using them to cover the blemish. They can even be used to repair marked photographs by touching up scans of the damaged prints.

Using Cloning and Healing

Cloning works by creating a pixel-by-pixel copy of a part of an image, which is then applied to another area of the same image; healing works in almost the same way in terms of applying the edit, but in this case it assesses the pixels to be adjusted, matching the colour, tonality and texture to preserve the 'look' of skin as you apply the 'healing' effect. In this case, we are going to use 'cloning' to take pixels from the sky above and around the subject to cover the pixels forming the antenna sticking out of the man's head. 'Healing' is used in the same way as described below for 'cloning' but for use on spots, wrinkles and other blemishes on skin within portraits.

Step 1: File > Open the image and zoom into the area to be worked upon using the

magnify tool, leaving enough space around the part that must be cloned away to provide fresh pixels to clone over it.

Step 2:

Click on the clone tool button. The cursor will change to a small circle: effectively it has become a 'brush', which can clone pixels.

Step 3:

Pick a brush with a soft edge and size it to suit the object you're removing.

Step 4:

To use the clone tool, hold the control key (or alt key on Macs) and click an area adjacent to the part of the image to be removed that has similar pixels, suitable for the background. This step selects the new pixels you'll use to cover the offending object in the shot.

Step 5:

Now click and drag the clone brush over the pixels to be removed. You'll notice the pixels from where you control/alt clicked earlier are now being copied over the pixels you want to remove.

A small cross indicates the pixel pick-up point as you progress. But, in order to ensure the pixels being cloned are as similar as

The clone brush and clone pick-up cursor appear each time you click and drag over the area being cloned away. Frequent reselection of the clone point may be needed, depending on the fiddlinesss of the image parts that need to be removed.

possible to those being covered, frequently reselect the clone area with similar pixels to those from the background.

Step 6:

Repeat Step 5 until you've completely cloned away the offending part of the scene. The more fiddly the bit to be cloned away, the longer it will take. Zoom in closer if you need to, to get a more detailed view (you'll need a smaller brush size too). Check the 'aligned' check box to ensure the clone point is always parallel with the brush point, particularly when cloning linear subjects, as is the case in this example.

Step 7:

Once you're happy with the final result, **File > Save** (or **Save As**) the image.

Right: The finished picture now has the offending mast completely cloned away using the surrounding sky and cloud pixels to seamlessly cover it up. Practice will help you judge the best way pixels are cloned and help hone your technique.

Dodge & Burn

Want to darken or lighten small sections of an image? Here's how.

Traditional film photography darkroom techniques included 'dodging' and 'burning',

where the printer of the photograph was able to allow more light into some parts of a print (the so-called 'burning in') to make them darker or hold light back ('dodging') from reaching the print, making them lighter. In essence, dodging and burning simply means you're controlling local areas of light and dark.

This has been translated to the digital domain and it is a fantastic technique to help get the tones in smaller areas just right. It can be used to brighten shadows to reveal detail in a shaded face, or to add deeper tones to, say, a landscape, where you might want to emphasise a stormy, brooding sky by deepening the tones or colours of clouds. This can all be achieved without affecting the photo as a whole.

It can be applied to black and white shots or to colour images. All that matters is that you can lift shadows if need be (dodging) or deepen them (burning). Here's how to do it.

Using Dodge and Burn

The image we are working on requires two things: shadows lifted from the faces of the subjects; and a deepening of the background shadow to de-emphasise the distracting image content. We don't want to affect the whole shot, just the faces and

deeper background shadows, so dodging and burning is perfect here.

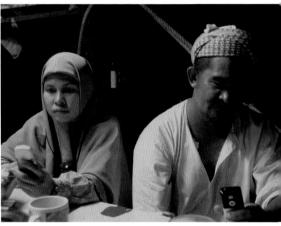

Above: This shot has deep shadows in the background and on the man's face on the right. Lifting the facial shadows but darkening some of the background distractions without affecting the rest of the image will keep its contemplative atmosphere and will help direct the viewer's eye to the two subjects.

Step 1:

File > Open your image and select the dodge tool. Also, pick a softedged brush (in this case of 65 pixels) ready to start dodging.

Step 2:

Now zoom into the shadow area on which you want to work. The dodge and burn tools can be set to work on a specific range of pixels: shadows, midtones or highlights. With the dodge tool and the midtones selected. start with an exposure of around 25%, selected from the adjacent exposure menu.

Step 3:

Click and paint with the dodge tool over the shadow area you want to lighten, just a small brush stroke at a time.

Once you've zoomed in, you can work to lighten the darker areas.

DODGE AND BURN COLOUR

The process of dodging and burning colour images is essentially the same as that for black and white; lightening and darkening localised areas of an image. However, such work can sometimes make image noise more evident, so you have to be careful. Switching from midtones to shadow and highlight modes can help but experimentation is needed to see which works best on different images. But again, you need to use both dodge and burn tools sensitively or risk overdoing it. As with most image editing techniques, less is often so much more.

Step 4:

To deepen shadows, switch to the burn tool by clicking on its icon and continue to click and paint over the required pixels. The pixels being painted will begin to darken.

Step 5:

Repeat the processes of Step 3 and Step 4, going over each area, dodging shadows on faces and, as in this case, burning unwanted background detail away by deepening the shadows. Keep going until you're satisfied. You'll need to change brush sizes and the zoom ratio depending on how fiddly the task gets. The more 'zoomed' you are, the smaller the brush required and vice-versa.

Step 6:

File > Save (or Save As) your image once you're happy and vou're done.

Below: The finished shot has lightened the man's face and deepened the background shadow to help hide distracting elements such as the plug socket on the pillar and items behind the woman's left side. The rope's been darkened too, but it's important realism is maintained. The lady's face has been dodged, brightening the eyes, as has her cowl in order to help make her stand out.

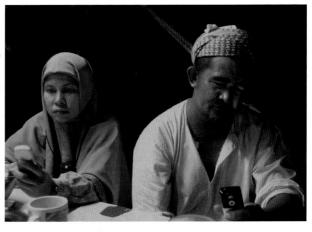

Layers

Don't risk changing your photos when image editing. Here's how to make dramatic changes without affecting your original pixels.

Layers are powerful tools available in higherend editing packages and it's a good idea to get into the habit of always using them whenever you're image editing. While they make the edited image's file size bigger, they allow you to completely change an image. You might want to add text to a shot, add a new element from another photo, change the colours of a specific part, or add a pattern, all without affecting the rest of the image. By using layers, you can do almost any edit imaginable and yet not affect the original underlying pixels.

You can think of layers as transparent sheets of glass stacked one on top of another and onto each of which you can 'paint' images. Because the layers are transparent, you can see through them to what's below.

The bottom layer in the stack is labelled 'background', but each new layer you make can be given a name of your choice so that it is always recognisable. These layers can be worked on independently, allowing you to experiment with an effect to see if you like it. Once you've finished, the layers can be merged together to give you your finished, edited image.

Although we've not dealt with layers until now, all the image editing tasks we cover in this book can be carried out on layers.

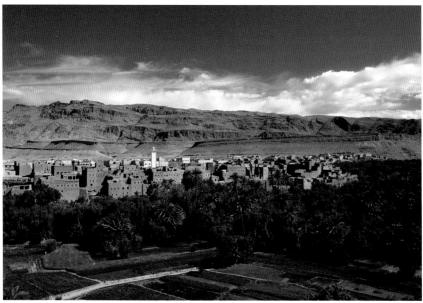

Using this image, we'll apply a couple of easy-to-do layer edits, sorting out the colours with levels. changing the colours and then adding text.

Basic Adjustment Layer

To keep the first one simple, we'll use a simple 'levels adjustment layer' to correct colour, saturation and brightness in an image.

Step 1:

File > Open your image and navigate to the Levels Adjustment Layer via the Layer > Adjustment Layer > Levels command.

Step 2:

A levels dialogue box will appear, and a new layer icon will appear in the layers palette. The new layer is named by you and below it is the original image layer called 'background'.

Step 3:

Adjust the levels for the image in the normal way – as dealt with in Levels. If you click on the eye icon to close the new layer, you'll notice the image switch back to its pre-levels state. The underlying pixels have not been touched by this level's edit.

Step 4:

Once you have the levels right for the image click OK. Now you can merge the layers if required. Use the Layers > Merge Layers command. Notice in the layers palette how the two layers become one, simply called 'background' again.

Step 5:

File > Save (or Save As) your image.

Fundamental Changes

This time using layers, we'll make a more dramatic change and completely alter the colour of the sky.

Step 1:

File > Open your image and just as in Step l of the basic adjustment layer, adjust the levels for the image on an adjustment layer first. Once done, merge the result to give a new, correctly adjusted background layer.

Step 2:

Create another new layer, this time an exact copy of the original via the Layer > Duplicate Layer command. A dialogue box will appear asking you to name the new layer 'background copy'. Click OK. You now have a duplicate of the original image (after the adjustment layer has been applied) above it in the layers palette.

Step 3:

Use the Enhance > Adjust Colour > Replace Colour menu to bring up the replace colour dialogue box. Using the colour selection tool, click on the sky in the image to select that colour (blue here). If necessary, switch to the 'add to selection' tool and keep adding to the sky selection. If you pick too much, use the 'remove from selection' tool.

The replace colour dialogue box has selection tools (the three pipettes at the top) and a large black and white preview to help you check your selections.

Step 4:

Using the replacement section of the replace colour dialogue box, click in the result box. A new colour selection window appears. Pick any colour you like. In our case, it was bright green! Watch the sky change to the colour you selected. Once you're happy with the effect, click the OK button. Note that the change has only been applied to the new background copy layer. Clicking the icon for the background copy layer you'll see the newly changed sky colour vanish as the layer is turned off.

The bottom section of the replace colour dialogue box houses the replacement colour selection tools. Using the hue, saturation and lightness sliders you can fine-tune the colours selected.

Step 5:

If you're happy, you can either File > Save (or Save As) the image with the layers intact or merge the layers using the Layers > Merge Layers command and then File > Save (or Save As), permanently embedding the new coloured sky into the image.

The finished image with the sky colour replaced, but on an editable layer which means the underlying original image pixels are untouched by this extreme effect.

Adding Text With Layers

On some images, say for a home-made birthday card, you might want to add text and, with layers, you can do it quickly without damaging the original pixels.

Step 1:

As before **File > Open** the image onto which you will add text (we've used the same shot here). Go through the levels adjustment on a layer again and Layer > Merge Layer it with the background layer if you want to embed the levels changes into the photo.

Step 2:

Use the **Layer > New Layer** command to create a new layer, this time name it 'text layer'.

Step 3:

Click on the 'horizontal type tool'. Select a reasonably large type size (depending on your image) and a typeface from the selection offered (in this case a typeface of Helvetica at 50 point size and medium bold was used).

Step 4:

Now type 'Happy Birthday' (or whatever you want to type) onto the 'text layer'. Once typed, you can alter the typeface and size by first highlighting the text and selecting any new parameters. If you want to move the text about, click on the move tool and then click on the text. By clicking and dragging it about, you can change its position as required.

Step 5:

To give it impact, select the warp text tool and select a style ('arch' in this case, below). The text will change shape - to the shape chosen - and now, using the move tool, once again position it as required.

Step 6:

Either File > Save (or Save As) to preserve the layers for future editing, or Layer > Merge Layers the document to create a single background layer and then File > Save (or Save As) as required.

LAYER TYPES

- Ordinary Layers: These are pixelbased lavers, in other words they're the image layer.
- Fill Layers: These can contain colour gradients, solid colours or a pattern effect.
- Adjustment Layers: These layers are used to edit and control colour. brightness and saturation.
- Type/Shape Layers: As the names suggest, these let you create and use text or shapes in your photos.

The finished image with the text applied and distorted into an arch. This shot might not make a great birthday card but with practice, these techniques can be used to great creative effect.

Masks

Want to protect sections of your image, whilst radically editing others? Masking areas will keep them unaffected by any changes you make.

You can use masks to paint on effects to selected areas or paint away unwanted parts of an image. Using masks on a layer means you can use an edit or effect that does not permanently affect any underlying pixels.

Using Masks

If you want to change a large element in a photo, such as replacing the sky in one shot with pixels from another, masks come into their own. You can cover over and reveal portions of two images so that you create a composite of the two shots.

The shot of the mosque below has a bland, neutral sky so we want to add more colour; ideally matching the blue of the woman's clothing. You can use any two shots to do this, but the more simple the sky and foreground outlines on the second shot, the easier it will be.

Step 1:

File > Open both the images you're going to use, call one the 'sky' image, and the other the 'ground' image. If you haven't already done so, and they need it, apply a levels adjustment layer to both shots (as described in *Layers*) and merge the images.

The two images side by side ready for compositing.

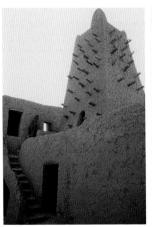

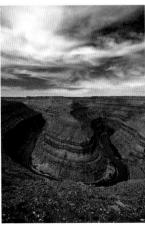

Step 2:

Create a copy of the ground image (called the 'background' layer) in the layers palette with the **Layer > New Layer Via Copy** command ('background copy' layer may also be called 'layer 1' – depending on the software you

Step 3:

use).

Using the magic wand tool (used to select all pixels of a similar colour with a single click – it looks just like a small wand), click on

the sky in layer 1. The layer will highlight to show it's the active layer. This will select the sky pixels, which must be deleted in order for the image pixels from the desired sky shot eventually to show through. Select the paintbrush tool (mask mode) and the non-sky area will change to a red mask protecting it.

Step 4:

Feather the selected sky area by about 2 pixels with the **Select > Feather** command. Feathering helps smooth hard edges, blurring them slightly to limit abrupt joins of different pixels, and making a more natural-looking fit.

Step 5:

If any of your selected sky in the ground image has not been properly selected using the magic wand tool, click on the brush tool. Check you're in selection mode and paint more selection into the area NOT already selected by the magic wand tool, in this case, the window in the wall. This new selection area will also become part of the mask. Paint more selection into the areas which need it – with an appropriate brush size and zooming as required. Remember, if you make a

mistake and paint in too much selection, switch back to mask mode and paint back in the mask again. Keep going until you're happy.

Step 6:

Hit delete to remove the sky (and other selected areas) from the ground image.

Step 7:

Select the sky image and using the rectangular marquee tool, click and drag across the entire image to select its pixels. Use the **Edit > Copy** command to copy the selected sky image. Close the sky image.

Step 8:

Click on the ground image and then click the background layer, in the layers palette. Using the **Edit > Paste** command, apply the copied sky image pixels over the ground image. A new 'layer 2' is automatically created containing the copied sky pixels, overlaying the ground image. You can check this in the layers palette. The new sky is now composed with the transparent layer 1 and you have added your new sky.

Step 9:

Click on the relevant layer if any aspect of the image requires further fine-tuning. The finished image should have three layers: a 'background', then 'layer 2' (containing the sky image) and on top, the 'masked layer 1'. Its mask/selection protects and covers the unwanted parts of the sky image. Note the bottom 'background' is untouched. Once

you're satisfied, use the **Layer > Merge** Layers command and File > Save (or Save **As**) your new image.

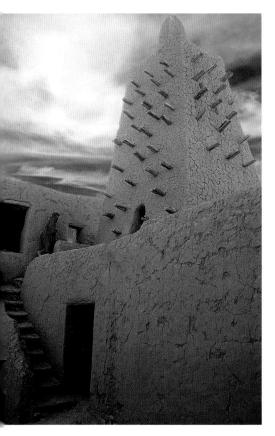

The final image will have a single background layer after merging and will have the new colourful sky pixels in place of the old, bland sky pixels. With practice, you'll be able to use this technique with multiple layers to edit in - or out - almost anything in a shot and without permanently changing the original image's pixels.

Painting Onto Layers

Another technique to use for a more creative or arty effect is to paint a mask onto a layer to protect one part of an image from a filter effect for example. Here's how to do it.

Step 1:

File > Open your image and do the levels tasks again if you need to and then, using the Layer > Layer Via Copy command, create a new copy layer as we did in the first task above. It will be called 'layer 1'.

Step 2:

Now use the **Layer > New Layer** command to make another layer (name it 'paint' layer in the dialogue box that appears) and make sure you have the mask mode and a soft edge paintbrush selected from the paintbrush selection drop-down menu.

Step 3:

Paint shapes over the image on layer 1 (simple squiggly lines over the food were added - below) and a red mask will be painted on, representing protected areas of the image - those that will NOT be affected by future edits. (You can also invert the mask in the **Select > Inverse** command, which means the areas not painted over will be masked and protected instead.)

Step 4:

Once you've painted your mask onto the paint layer, click on layer 1 (the background copy) to make it active and use the Filter > Distort > Ripple command to apply the filter (you can use any filter you wish though). Then, apply the Filter > Sketch > Chalk & Charcoal filter (or any other filter of your choice that's suitable for your image) to strip the colour away and add another texture effect. Note how your painted mask area has been left untouched as below.

Step 5:

Once you're happy with the effect, you need to de-select the mask/selection layer by clicking on any other selection tool (such as the rectangular marquee tool) and clicking

inside the image. Then use the

Layer > Merge Visible command to merge the lavers. then File Save (or Save As).

The final effect leaves colour in the protected masked areas and the effects of the filters you've applied everywhere else.

MASKING TIPS

- **Feathering**: Feathering allows you to soften edges (it makes them fuzzylooking) for a more realistic joining effect. You can define the number of pixels around the selection that will be feathered: the larger the number, the more pixels outward from the selection that will be made fuzzier.
- Selections & Masks: Selections are the area you've defined in a layer using a selection tool such as the magic wand or selection brush. You can add to a selection by painting onto the layer in mask mode. By switching back and forth, you can...
- Add and Subtract a Mask: If you paint too much of a selection onto a layer in selection mode, you can remove it by switching to mask mode and painting it back in again. Careful use of the right brush size and zooming allows very accurate masks to be made, even around complex features such as tree branches and hair.

Blurring Backgrounds

This pro technique allows you to emphasise your subject by reducing the impact of the background.

Adding 'blur' to a shot allows you to lessen the impact of a distracting background. This is similar to the effect of a shallow depth of field. For example, in the shot below, we want to reduce the detail in the background (the sun shade, table and chairs), creating emphasis on the person in the foreground.

Step 1:

File > Open the image to be worked upon, perform a 'quick fix/auto levels' if required and then create a duplicate layer: Layer > Duplicate Layer and rename it something you'll remember. Working on this layer protects the original pixels while you're editing.

This is an otherwise good image that would benefit from emphasising the figure in the foreground.

Step 2:

Working on the newly created layer, select the selection brush and in mask mode, paint a red mask around the subject which should look something like this.

Step 3:

Choose a 'soft' brush with a size small enough to paint more mask carefully around the subject, right up to the edges. This additional step means that the initial selection does not have to be very accurate – you can adjust it as necessary.

Step 4:

If you make a mistake while painting, switch back to selection mode and you'll see the selection's 'wriggly' line denoting the selected area. Paint the selection away from any overlaps on the main subject if needed. Adjust the

- Remember to feather the selections to make the edges blend more naturally with the background.
- Adding to or removing elements from selections can be achieved easily with masks.
- Step the level of blur. More blur should be applied to the parts of a scene in the distance than those close to the main subject.

brush size to that required as you progress and ensure that the mask does not cover anything in the foreground or in front of your subject. In this case, we made sure that the fence cables and the post, level with the person, were also masked to help make the effect more natural.

Step 5:

Use the **Select > Feather** command and feather the selection by around 2 in the dialogue box that appears. This helps blend the edges of the selection making it look natural. Now, invert your selection using **Select > Inverse**. This selects the background (rather than the main subject you've been painting round with the mask).

Step 6:

Now, apply the blur effect (mimicking a large aperture lens) using the **Filter > Blur > Gaussian Blur** command. Select a level between 3 and 5, judging the effect in the preview. You can experiment to see what seems most natural. You'll notice everything except the masked subject (above, right) is now blurred. Click OK.

Step 7:

If the blur has invaded the main subject, which is not supposed to be blurred, use the **Select > Modify > Contract** command and select 1 pixel in the dialogue box that appears. This will pull the blur back very slightly (by 1 pixel) from the selected area.

Step 8:

Once you're happy with the final effect, you can flatten the layers (**Layer > Merge Layers** or **Flatten Image**) and **File > Save** (or **Save As**).

The finished image with emphasis placed on the person in the foreground by blurring the background.

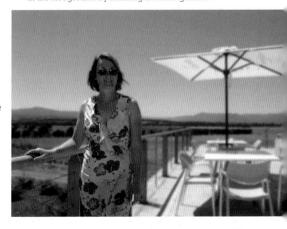

Adding Movement

This Masterclass shows how to add the appearance of movement to a photograph.

Occasionally a photo can be improved by adding 'artistic' blur, for example adding motion blur to emphasise the feeling of speed in an event.

This shot of a dancer has some natural blur in the background but to make it even more dynamic, 'motion blur' is going to be added to the main figure in the foreground. This technique can be used on multiple

elements in a shot if you repeat the following process for each element.

Step 1:

File > Open the image you'll be adding motion blur to, and create a duplicate layer Layer > Duplicate Layer. Rename it something you'll remember and, working on this layer, apply 'quick fix/levels' if your image requires it. (From now on, let's assume that you'll already have done this where necessary on each image.)

Step 2:

We need to place each part of the scene that will have motion added onto a separate layer. Use the rectangular marquee tool to draw a rectangular selection around the subject(s) to have motion added.

Step 3:

Switch to the magic wand tool; press the alt (option) key, which allows you to remove from the rectangular selection you've already made.
Keep alt (option) clicking until the selection is right. If you have a fiddly selection to make that the magic wand cannot

help with, you'll need to use a mask to add to the selection. Select the selection brush in the tools palette and switch to mask mode and paint in more mask, as needed. Switch back to selection mode once you're done.

Step 4:

Now choose **Layer > New > Layer Via Cut**, which will become the 'blur layer'. Go through steps two, three and four for each element of your original image (the background layer) that you want to apply blur to. Each will become a separate layer.

Note, your background layer will have a 'hole' where each element of the image has been selected and put onto a new layer.

Step 5:

Before we add the motion blur we must use the clone tool to fill in any holes in the background layer that were left by selecting the elements for the addition of blur. Click on the background layer to make it active, use the Layer > New >

Layer (name it

something memorable, such as 'fill in holes' layer) and click OK. Select the clone tool and check the 'use all layers' check box at the top of the work area in the options bar.

Step 6:

Turn off the blur layer, and using the clone tool click in the new 'fill holes' layer. Alt (option) click on the background areas (not the holes!) and using the selected pixels, paint in the holes. With the 'use all layers' control active, it will copy pixels from the background layer to the new layer and fill in the holes. Make frequent 'alt clicks' in different areas to make sure you don't get any repeat marks from the cloning process. Keep going until the holes are filled in and to check this, make all the layers active and ensure you're happy.

Step 7:

Click on the blur layer (or each layer in turn if you have more than one) to which you'll add blur and choose Filter > Blur > Motion Blur. In the dialogue box select an angle for the blur that more or less follows the direction your subject's facing, and a 'distance' for the pixel blur, in this case of 27 degrees and 100 pixels respectively.

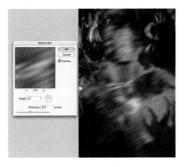

Step 8: Once you're happy, click OK, Layer > Merge Layers and finally File > Save (or Save As).

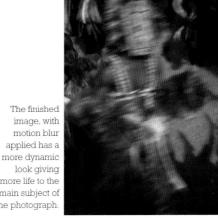

more life to the main subject of the photograph.

Making Panoramas

Separate images can be stitched together to create a seamless panoramic image.

Most image editing programs have special panorama-making tools that automate the process of joining photos together. It's relatively easy to get a good result providing you take a little care when shooting the images in the first place. You need to shoot images from the same position (ideally from a tripod), with the same focal length and with careful attention paid to the exposure values, so that the brightness is as even as possible throughout. Then you can use software techniques to remove any minor differences.

Step 1:

Use the File > Automation Tools > Photomerge command to launch the photomerge system. Your package may have a different name for this function, but the process is essentially the same for all software packages. A dialogue box appears asking you to browse to find your images.

Navigate to them and highlight those that will be used for the panorama. Click OK and they'll import into the software.

Step 2:

The software either automatically starts to build the panoramic image by placing the images next to each other where they overlap, or you can move them around manually into the correct order. Then it attempts to 'stitch' them together. Once completed (the length of time it takes depends on the number and size of the images being merged), the images will appear together in the window making a long, thin image. If the software (or you) make any mistakes, you can move them using the move tool. Adjust the images that require it, until you're happy with the alignment.

The finished image, consisting of separate images stitched together to create a long panoramic image.

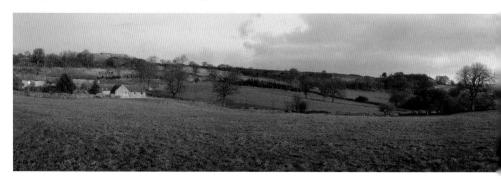

- Always name your images something that will let you know where they should go, particularly if they're very similar shots. Left, Middle Left, Middle, Middle Right and Right for example.
- Leave image edits such as colour, brightness (levels and/or quick fixes) until after you've merged the shots. The automatic software will almost always apply an exposure correction during its processing anyway and it's best to add such edits to all the images to get a smooth and seamless look to the shot.

Step 3:

Some elements may still not fit perfectly, but don't worry, we can sort those out later. Click the 'advanced blending' check box and preview the result. You'll see where any poor exposure areas are corrected.

Step 4:

Once the merge process is complete, zoom into the image and check the merge areas have done so properly. If not, use a combination of the clone tool and the healing brush to repair any small elements of the panorama that don't quite fit, typically across the skyline. Use the healing brush for any areas without defined joins such as in the sky around clouds for example.

Step 5:

Once you're happy with the fit, you must use the crop tool to remove any uneven edges round the panorama as shown below. Try to keep as much of the image as you can. Once you're happy with the crop, double click within the crop area to crop away the unwanted panoramic elements.

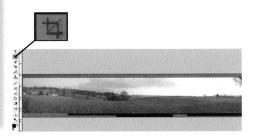

Step 6:

Use the **Layer > Flatten** command to remove unwanted layers and then the **Layer**

> New Adjustment Layer > Levels

command and carry out general levels or auto levels (just like a quick fix) on the image to help even out any other exposure and colour problems. Once you're finished use

Layer > Merge Layers (or Layer > Flatten Layers) to get rid of the unwanted layers.

Step 7:

Once you're happy, File > Save (or Save As).

Restoring Old Prints

Precious old photos don't need to be lost to dirt or scratches – you can repair them with some basic software techniques.

Scanning and editing techniques make it easy to restore damaged, scratched or dirty photographs. First off, you need to scan the original to bring it into your PC in a digital format (see *Scanning Your Photos*). The image can then be manipulated just like any of your digital photographs.

This old scanned negative below suffers from the ravages of time: it is covered in scratches and specks of dust.

Step 1:

File > Open the image, create a duplicate layer with the Layer > Duplicate Layer command and rename it something you'll remember. Do a quick fix/auto levels but only if your image requires it.

Step 2:

Apply a dust removal filter using the **Filter > Noise > Dust &**

Scratches command but be careful as this can reduce sharpness. Use it to remove only small defects. Check the effect, monitoring

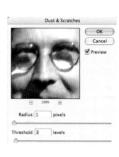

changes to the radius and threshold parameters – or adjust the sliders – checking the results as you go. When happy, click OK.

Step 3:

With the topmost layer active in the layers palette, create a new layer with the

Layer > New Layer command and rename the layer to something you'll remember, here

'clone/heal layer'. Note that this layer sits atop the first 'dust and scratches layer' and the original image (or 'background') layer.

Step 4:

Select the clone tool from the tools palette, ensuring you sample from all layers (i.e. the 'use all layers' box is checked). Magnify an area to work on and select a soft brush size from the brush menu. Make sure any brush you use is suitable for, or just slightly larger than, the dust marks you're going to remove.

Step 5:

Sample the pixels you want to clone by placing the curser over a clean area close to a mark you wish to remove. Hold down the option (or alt on a Mac keyboard) key and click with the mouse. Release the option (alt) key and click on the dust mark. Cloned pixels from the area you selected will be painted over the top of the mark.

Step 6:

Repeat this process to repair all the blemishes on the image, but remember to sample pixels from fresh areas near to the marks you want to remove. Keep going and continue to paint until the image has been cleaned up. This can take some time depending on the state of your images. Any mistakes made while cloning can be undone quickly with **Control > Z** (or **Apple > Z** on Macs).

Step 7:

Once you've finished cloning/healing and you're happy with the finished and repaired effect, you should flatten the layers (**Layer > Flatten Image**) and save your image **File > Save** (or **Save As**).

9

Don't heal near edges

- Use the clone tool to sample pixels from one part of the image and place (or 'clone') them elsewhere.
- Repeated sampling will be required and remember to sample from similar areas to help ensure the cloned effect looks natural.

The finished, cleaned image. All blemishes have been diminished or removed, enough for a respectable-size print to be made with ease.

Special Effects

You can create new and unusual images using image editing techniques.

By bringing together the image editing techniques described in this book so far, it's possible to completely re-invent an image. These techniques can be used on almost any image or element within an image to add something to a shot. We'll work through one fun example to demonstrate what can be done.

This image is ideal for fun experimentation. Here we'll swap all three heads around using layers and some fine-tuning with the clone tool, masks and selections.

Step 1:

Open the image you want to experiment with and create a copy of the 'background' layer. Call it something you'll remember easily as we'll have quite a few layers open in this technique. This new layer will have the background removed to help isolate the heads or objects you're moving. Use the magic wand tool and click on the background to select it. Switch to the selection brush, then add or subtract from the background by changing between the

mask and selection modes. Paint them in until you're happy the background is selected. Change to the selection mode and hit delete to remove the background; it should look something like the image below.

Step 2:

Copy the layer from which you just removed the background with **Layer > New > Layer**Via Copy and repeat this step for each element you want to move. In this image we will use one layer for each head. Name the layers something you'll remember, in this case 'right', 'left' and 'middle head' as shown below. Turn the background layer off by clicking its eye icon in the layers palette.

Step 3:

Click on the first 'head' layer to work on and zoom in to make it easier. Using the selection brush (in mask mode) paint a selection over the element you'll be moving. Switch between the selection and mask modes to get the mask just right. Once you have it, it'll look similar to this.

Step 4:

Make sure you're in selection mode and hit delete to remove everything but the head. Repeat this on each layer in turn (if there's more than one element you're moving) and you'll be left with something like the image below. Make the background active again and use the clone tool to tidy up stray background elements (hair, ears showing through etc). Make sure you select 'use all layers' – this way you'll pick up layers from the background and paste them onto your active layer.

Step 5:

With the background still active (click on relevant thumbnails in the layers palette), select the move tool and click on the object (or head in this case) and drag it to its new location. An elastic 'box' will appear round the object you're moving, and this will have handles which can be pulled. Use the handles to rotate and change the size of the object until you're happy with the placement. Repeat this for each head/object: activate the object's layer, use the move tool to drag it into position and resize/move until it fits properly.

The only head that needed major work was the woman's. It had to be scaled up slightly using the box's handles to make it fit successfully over the man's head. The clone tool was used to tidy up the join and make the fit more convincing.

Step 6:

Once you have positioned all the objects correctly, tidy up with the clone tool and the healing brush. If needed, use the paint brush. Change each respective layer's blend mode, then use 'multiply' to darken and lighten any areas by carefully painting over them. Use the pipette tool to sample skin colour (by clicking where you want to grab colour from on the image) and then paint over a layer that requires pixels of the same colour – the paint brush will use the sampled colours. The neck of the man on the right and the woman were too light and were darkened in this way.

Step 7:

Once you're happy, **Layer > Merge Visible** (or **Flatten**) the image to remove
the layers and blend everything together
and then **File > Save** (or **Save As**) and
you're done.

The finished image with the heads swapped around.

Astute use of the clone tool and paint brush has helped blend everything nicely for a convincing swap!

Special Effects Using Filters

There is an amazing array of special effects filters, which can quickly and simply apply striking effects to your shots.

Image editing packages come with a host of special effects built in, called 'filters'. Some filters perform edit-style changes (sharpening for example), while others create special looks such as mimicking a style of art.

Each filter is applied to an image using the same steps. Filters can be used in combination with each other, and with other techniques.

Using Filters

Usually the filters are found within the filters menu for your software and are applied by scrolling the drop-down menu of filters which appears and highlighting the filter of your choice. Some filters have preview windows and sliders to adjust the values and strength of the effect before it is applied to the shot. In this way, you can quickly see if you like what the filter does before applying it to the image. Good practice when adding filter effects is to apply filters to layers so you can apply the filter effect without it changing the original pixels.

Step 1:

Open the image you want to play with and create a new layer with the **Layer > New Layer Via Copy** command.

Step 2:

Use the **Filter > Pixelate > Crystallise** (or whichever filter type you want from the menu) to activate the filter. This brings up a

dialogue box in which you select the parameters you want and then click OK.

Step 3:

Check the effect and then continue with other edits, or if you're finished, **Layer > Flatten Layers** (or **Merge Visible**) the image and **File > Save** (or **Save As**) and you're done.

Here, a combination of filters has been used with adjustment layers to alter the saturation and mask out certain layers. It shows how you can build filter effects one on top of the other.

The Lens Flare Filter

The lens flare filter produces the same effect as direct sunlight entering the lens, for various lens focal lengths. Use this effect sparingly as it can be easily overdone.

The lens flare filter dialogue box allows you to choose between lens types (50-300mm zoom in this case) and the position and intensity of the 'Sun'.

The Crystallise Filter

The crystallise filter provides a faceted effect useful for textures and making unusual shapes from blocks of colour.

The crystallise filter's dialogue box allows the adjustment of the intensity of the effect, prior to application on the image.

The Stained Glass Filter

Like crystallise, this filter applies a texture and light effect but here it is one that mimics stained glass windows.

The dialogue box provides adjustment for the size of the glass cells, the borders and the light intensity.

The Wind Filter

This filter replicates the effect that wind would have on pixels if it could blow them around on the PC's screen. Here, the wind filter was set to 'blast' and a direction of right to left chosen.

The wind filter adds streaks of pixels with the direction and intensity of the 'wind' controlled in the simple dialogue box shown here.

Using Filters With Layer Modes

Each layer you create, whatever its purpose (adding a filter, text or some other edit) can have a variety of settings applied to it. These socalled 'laver modes' can be used to make a layer more transparent or darker. They can apply special colour effects, changes to saturation or lighting styles (such as hard light or soft light) and even the luminosity can be tweaked. In short, you can adjust not only the pixels on the layer, but the way the layer behaves as well. Experimentation is useful here to help discover what each layer mode does.

This image is made up of several layers that have been manipulated both in terms of the filter effect and the layer

Layers can be adjusted to be more transparent and the type of effect the layer produces can be changed too. The fibres filter was applied to a layer at 50% opacity and then a colour burn filter was applied to boost the saturation in the areas where the fibres filter was still visible.

Making Art: Poster Effects

With this Masterclass technique, it's easy to create a perfect pop art poster from any of your images.

The starting image can be any portrait but ideally one with lots of contrast. As this image does not have that much contrast, we'll need to adjust this first and then proceed with the rest of the process.

Editing software can be used very effectively to give a portrait image a poster look. Here we'll create an example in the style made famous by Andy Warhol to show how easy it is to add a new spin to the 'traditional' portrait.

Step 1: File > Open the image and using the Layer > New Adjustment Layer > Levels feature click and drag the black point and white point sliders towards the centre of the histogram. Brighten the image if needed by sliding the central (grey point) triangle towards the black point slider. Layer >

Flatten the image.

Step 2:

Next, just like Warhol's technique, we must reduce the number of colours in the image to give us those big blocks of colour. To do this, use the software's 'posterise' feature. Create a new layer (Layer > New Layer Via Copy) and use the Filter > Adjust > Posterise command. Call it 'posterise layer' or something memorable. In the dialogue box that appears, the smaller the number chosen, the fewer the colours that will remain in the final image. Use four levels of colour as below (or whatever best fits your image). Assess this by checking the effect of your changes in the preview box.

Step 3:

Now we must increase the canvas size. Think of your image as being stuck onto a canvas the same size as the image. We must increase this canvas size in order to fit more than one image on to it. Use the Image > Resize > Canvas Size command and double the width and length ensuring the 'anchor point' is central, as shown below. Click OK.

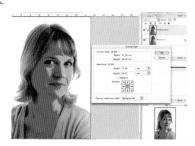

Step 4:

With the posterise layer active, use the Layer > New Layer Via Copy four times to produce four versions of the same image. Name each one and turn the background layer off. Using the move tool, click on each layer and position its image within the new, larger canvas. Make sure there are no gaps between the four images. Use the crop tool to trim the image if necessary.

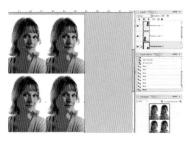

Step 5:

Now you can make the colour adjustments to each layer. Use the Enhance > Adjust Colour > Adjust Hue/Saturation command and create a unique colour combination for each layer using the hue and saturation sliders in the dialogue box. Click on the layer you want to work on to make it active and keep adjusting, experimenting as much as you like with each layer until you're happy with the results. Use the levels control to brighten (or darken) the layers as necessary.

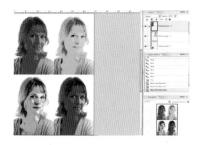

Step 6:

If you're happy with the results, all that remains is to **Layer > Merge Visible** (or **Flatten**) the image and then **File > Save** (or **Save As**).

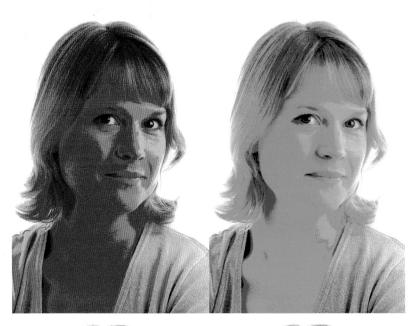

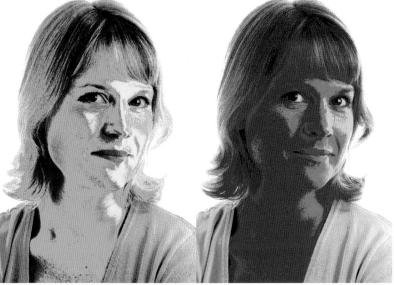

The finished image has all four layers merged into one and each image has its own colour palette, creating a bright, colourful 'Warhol-style' poster.

Making Art: Painted Effects

Turning a digital image into a 'painting' can give it a new lease of life.

With astute use of filters and masks, it's possible to create vivid digital imitations of painting styles, ideal for hanging on the wall or as unique-looking presents. In this example we'll create a look similar to the painting effect used by Impressionist artists such as Claude Monet.

This is a nice image but it lacks punch. It is therefore ideal as the basis for an art-style edit. It needs a crop to focus on the house but apart from that, we can get started.

Step 1:

File > Open the image and using Layer > New

>Layer Via Copy

create a new laver upon which we'll apply the first edits. Call it 'watercolour' and then change its blending mode to luminosity. Crop the image if necessary to close in on the detail. A slight crop was applied here to make the house larger in the frame.

Step 2:

Use the Filter > Artistic > Watercolour command and select levels of 8, 0 and 2 in the brush detail, shadow intensity and texture sliders respectively. Click OK to apply the edits.

Step 3:

To duplicate the background layer, ready for a new effect, click on it to make it active in the lavers palette and use the Laver > Duplicate Layer command. You'll get a new background copy layer. Click OK. Using the layers palette options at the top, set the opacity to 50% (making the layer more

transparent) and set the blend mode to 'lighten'. Move this layer (by clicking, holding and dragging it) to the top of the stack of lavers in the lavers palette. You'll see the darkest parts of the previous watercolour effects brighten.

Step 4:

With the new 'background copy layer' active, use the Filter > Artistic > Fresco command. Set the parameters to 1, 8 and 1 in the respective brush size, brush detail and texture boxes (or use the sliders to suit your image).

Step 5:

Now use **Layer > Flatten Image** to remove the layers. Then draw a selection using the rectangular marquee tool and switch to mask mode. A red mask border will appear. Select a large (200 pixels should do it) textured brush and paint around the border as shown below.

Step 6:

Switch back to selection mode, and use **Select > Feather** to a level of 2 or 3, and click OK. Now use **Select > Inverse** and hit delete, making a nice soft edge, and deselect the selection by clicking anywhere inside the image with the rectangular marquee tool active.

Step 7:

Now use **Layer > New > Layer Via Copy** and with the rectangular marquee tool, make a selection around the whole image. Switch to the selection brush and then mask mode. **Use Filter > Artistic > Rough Pastels** in canvas mode and click OK.

Step 8:

Use a levels layer to brighten things a bit more if needed, and then use the **Layer > Flatten** (or **Merge**) command to make one final layer. Finally, **File > Save** (or **Save As**) your image.

The finished image, with the artistic brushes and layer effects building together to form an Impressionist-style image with a softened border.

Output

In this section, you'll find all you need to know about how and where to output your pictures, including:

Printing – how to get the best results

On-line – email or build a web site of your pictures

Backing-up – send your files to secure storage

Slide shows – display a picture collection on-screen or on TV

Scanning – output your old prints into the digital realm

Making money – with an on-line or traditional portfolio

Backing-Up

If you keep all your images on your PC, one computer problem could wipe out your entire picture collection. Here's how to keep it safe.

Saving your images onto additional storage that is not your main PC should be an automatic task. This is sometimes called archiving. You need to consider all your data as vulnerable and you must back-up regularly.

There are software packages available, often bundled with external hard discs or with your computer's operating system, which allow you to quickly and simply set up automatic back-up routines. This means the computer does the hard work.

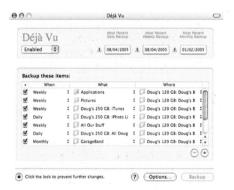

This is a typical back-up window. It shows when, where and what items have been selected for backing-up. Some files are designated for daily back-ups while others will be backed-up on a weekly or monthly basis. You can check the status of back-ups by checking the back-up logs, ensuring everything is saved properly.

Built-in Back-Up

The most important thing, when using any back-up strategy, is to keep all your data organised on your PC. Save things logically with relevant names or by the date so you know where everything is. Most PC operating

systems (OS) come with a back-up system, Microsoft's Windows XP in its various guises and both Windows Vista and, more recently, Windows 7.

Windows Vista and 7 have much simplified back-up systems than the process for XP (as outlined below) each with a dedicated 'Back-up and Restore Centre' that can be tailored to suit your back-up requirements, quickly and easily from within either Windows Vista or Windows 7.

For Windows 7 type 'Backup' into the search box and click the item in the results list; for Windows Vista click the 'Start' button and you'll see the 'Back-up and Restore Centre' in the menu. In each case select the back-up options and follow the instruction to set-up and initiate good back-up protocols.

If you have Windows XP Home Edition (still prevalent on the majority of home PCs at the time of writing) the back-up software will need installing from the discs supplied with your PC. Here's how to activate and use it. Remember, you'll need to have a back-up hard disc ready (also see Computer Accessories and Extra Storage) to save your back-up data onto.

Windows XP Home Edition Back-Up

You may need to do some searching to find XP HE's back-up program.

Step 1:

Insert your Windows XP CD into the drive and, if necessary, double-click the CD icon in 'My Computer'.

Step 2:

On the Welcome to Microsoft Windows XP screen, click 'perform additional tasks'.

Step 3:

Click 'Browse this CD'.

Step 4:

In Windows Explorer, double-click the 'ValueAdd' folder, then 'Msft', and then 'Ntbackup'.

Step 5:

Double-click 'Ntbackup.mst' to install the back-up utility.

The Back-Up Process

While this is the process for Windows XP HE, the overall procedure is very similar regardless of the software you use.

Step 1:

By default, XP's back-up utility uses a 'wizard',

BACK-UP HINTS

- Back-ups should be performed on a regular basis. The frequency depends upon the maximum acceptable (to you) amount of work that would be lost in the event of a catastrophe!
- Various simple back-up software packages can be downloaded from the Internet, but these tend to be time limited (usually lasting about 30 days) so you get to try before you buy, but once the trial period is over, you're left without a back-up process again unless you're ready to pay.
- You may find any external hard disc you buy is complete with a back-up utility of its own that can save you money. Use it if you don't have anything else, as they are normally robust enough for most 'home' uses.

BACK-UP TO EXTERNAL HARD DISC

Probably the most common way to back-up your data is to use a high-capacity external hard disc. This is because with such a disc, you can set up a back-up protocol that happens automatically – so you don't have to remember to do it! And because you don't have to intervene to change discs (as with a CD or DVD back-up) it is very convenient. One drawback is that the external hard disc can crash so you may still need another strategy to back-up its data!

making the process straightforward. Click start, navigate to 'All Programs', then accessories, then to system tools, and then click back-up to start the back-up wizard.

Step 2:

Click 'next' to skip the opening page and choose 'back-up files and settings' from the second page. Now click 'next' and you should see the 'What to back-up' page.

Step 3:

Choose what to back-up, but if you're tempted to click 'All information on this computer', which backs-up everything on your computer, think again – your back-up could be many gigabytes of data. Choose the location of your image files and the 'My Documents and Settings' option to get other data files (including e-mail messages and address books).

Step 4:

If you know that data is stored elsewhere (say on an external hard disc already connected to your PC) click 'Let me choose what to back-up'. Browse the 'My Computer' folder to select the files and folders you need to back-up.

Step 5:

Next, decide where to store your backed-up files. On the 'Destination' page, Windows will

ask you to point to a back-up location. It assumes you'll back-up everything into a single folder; choose a location for that folder and give it a name such as 'All My Back-Ups'. It'll actually try to point to the 'A' or 'floppy drive', but you'll need hundreds of floppy discs for your images, so browse to the correct location (say a DVD burner or external hard disc – whichever you'll be using) and after you've chosen the location, click 'next' to display the wizard's final page. Then click 'finish' and the back-up will start immediately.

Back-Up to CD/DVD/Blu Ray

You can back up manually or with a schedule to CDs, DVDs and Blu Ray discs if you wish. Of course, you'll need a CD/DVD/Blu Ray writer and blank CDs or DVDs. The biggest difference here is that you'll need to be on hand to change CDs or DVDs if they fill up before all the data is written to them. Consider this before you start, as a CD holds only around 700MB of data and a DVD about 4.7GB. If you only have a couple of gigabytes of data to back-up, then using a writable DVD is going to be the way to go. If you have a CD/DVD/Blu Ray re-writer and re-writable discs for it, you can reuse the same CD and DVD disc (or discs) each time, saving money.

SCHEDULED BACK-UPS

Set a schedule and stick to it is the maxim you should always use for all backing-up. If you're disciplined enough and you can remember all the steps to a good back-up, say once each week, then great. If not, use a scheduled back-up.

To set up an automatic back-up schedule using the bundled Windows XP utility, click the advanced button instead of clicking finish when you get to the final page of the wizard. Click 'next' to open the 'When to Back-Up' page. Choose 'later', and then click 'set schedule' to open the schedule job dialogue box.

If using other back-up software, follow the steps to set up a back-up schedule in that software's wizard, or read the software manual if it lacks a wizard.

This Pioneer DVD burner is portable so it allows you the ability to back-up and burn on the move. It's compact and an ideal solution for backing-up to CDs or DVDs. You'll need a Blu Ray compatible burner to back-up to Blu Ray discs but they offer larger capacities (over 50GB per disc) although the discs are more expensive.

Fully Manual Back-Ups

You can of course back-up simply by making copies of the valuable data onto another hard disc, CD, DVD or Blu Ray disc. You don't need any fancy software but do need to ensure you have all your data properly organised on your hard disc so you know where everything is. The process is simply one of dragging the data files to be backed-up to the separate disc.

A good idea is to create a back-up folder and date it; that way you'll be able to keep track of what's been backed-up and when.

Printing

0

You're not restricted to viewing digital images on screen. It's easy to make 'real world' prints for framing, sharing or to put into a photo album.

It's easier than you think to make prints at home, on-line or when shopping on the high street. Here's some key advice on getting the best from each option.

Printing Your Photos At Home

Obviously this requires you to have your own printer. If you don't have one but want the convenience of printing at home, you'll find all the buying advice you need in the topic *Which Printer?* Let's get started with a few printer basics.

Step 1:

You'll need to install the printer's software (called a print driver) on your computer to make sure the computer can 'see' the printer. However, some computer operating systems have many printer drivers built-in, so this may be a step you can skip. Check with your computer's or printer's installation instructions.

Step 2: File > Open the

image you'll be printing in your image editing software and use the **File > Print** command to activate your printer's driver controls within the software.

The print preview (right) allows paper and print size selection; the software does all the working out for your chosen settings.

Printer: Stylus S20

Step 3:

Pick the paper and print size you need and click the print button. A new dialogue box (above) will appear which allows the changing of printer settings if required. Pick the correct paper type (many new inkjets can automatically set the paper for you), and

colour options in the drop-down menus. You can also preview your print job. Set the print resolution and hit print again – the print job will start. Always double-check that the correct paper and print resolution are selected, as these are essential to get the correct quality of print.

Printing On-line

On-line photo printing is very popular with dedicated photo-printing web sites easily accessed from all over the globe. Using them is fairly straightforward and inexpensive; you either email in your images or upload them via the web site. You pay on-line with either a debit or credit card and some sites accept PayPal payments too, if you have a PayPal account; photos are sent to you in the post. Make sure you use a service that is in your country though!

Ideally you'll need a broadband Internet connection (otherwise uploads will take too long). Such sites usually have virtual photo album functionality, where you can upload images and store them on-line – although there may be a charge for this. Then you can email links to the images for friends and family to view.

Printing in Shops

There are many retail outlets where you can take your memory card to print out images quickly and cheaply, in the same way you used to drop off your films. Some shops have print kiosks, where you insert the memory card and follow on-screen prompts to select and print the photos yourself.

However, whether you use a kiosk or an over-the-counter service, remember one thing: if you print everything on the memory card but don't have a back-up (say a CD of the images) then you will lose all the original images forever if your card is later reformatted in your camera. So, always have a CD made and get prints if you don't have a computer at home. That way, you can take the CD in to the shop for more prints and you never have to worry about losing images.

Using the Right Paper

There are many types of paper (or media) available for inkiet printers, and they come

in a range of sizes (A4 or A3 for example) or on rolls of paper.

Using the right paper is essential – you cannot get a photo-quality print on plain paper for example. On photo paper, the paper and ink work together to give the best possible effect and to help make the print last a long time. Here's a quick run-down of what to look for and when to use it.

- Plain Media: Use plain paper only for printing letters or basic graphics and text, not for photographs.
- Photo Media: Photo paper comes in glossy and matt finishes and is the best paper to use for photo-quality output as it is designed to make the most of every droplet of ink and to boost colour.
- Transfer (or T-Shirt) Media: A speciality media for printing images that can then be transferred, to a T-shirt for example, using a hot iron.
- High Resolution Media: Ideal for graphics and text (say a display banner) where perfectly smooth edges to text and colours are essential for a good impression.
- Transparency Media: Transparent media designed for presentations using overhead projectors for example.
- Speciality Media: There are many types of textured or special finish papers available that can add a canvas-look and feel to a print, which is ideal for framing or 'art' shots.
- Speciality Inks: You can also buy special inks such as dedicated black-and-white inks to get neutral black-and-white prints without odd colour casts.

GET THE BEST FROM YOUR PRINTER

To ensure perfect prints (or the print output you're expecting!) check these tips.

- Make sure the paper selection in the printer set-up dialogue box matches the paper you're printing on. If you choose plain paper but load photo-quality paper, the printed result will be very poor. However, many new printers automatically detect the paper and set the printer accordingly, unless you override it in the printer set-up box.
- Inkjets can print at very-high-resolution settings that are slow to print and can use a lot of expensive ink. To save ink (and time), use the lowest print resolution that's acceptable for the job at hand. A few test prints may be needed to ascertain these settings. Make a note of them for each paper type or print job (or save the settings for reuse if your software allows) then you don't have to experiment each time.
- You can alter the print size without changing the image's dimensions (also see *Resizing*) by altering its resolution in the **Image >Size** dialogue box. 300dpi is best, but don't go below 180dpi or the print quality will be poor. The lower the output dpi, the larger the print will become, which you can check in the print preview window prior to printing.
- Some image editing software can automatically create picture packages, ideal if you want more than one copy of a photo. The program does all the resizing and other changes so you can print many images on one sheet of paper.

The image size box allows adjustment of the output resolution (the document size) without altering the pixel dimensions.

The picture package dialogue box lets you select the number of images to be printed together on a single sheet of paper. Clicking on one of the image thumbnails lets you browse to another image if you want a variety of images to be printed together.

Scanning Your Photos

Scanning provides a route for traditional film images to be brought into the digital domain, where they can be manipulated and improved just like any digital image.

You probably have hundreds of old film photos that can be given a new lease of life by scanning them to create digital images (see also *Which Scanner?*). These can then be used to create a slide show or make printed copies for all the family.

Scanner Settings

It is important to scan at a setting adequate for the intended output. In other words, if you want to make an A4 photo print you'll need to scan the original at a setting that provides enough information for a good print at that size. Getting this right saves time and memory space as it is easy to create scanned images of hundreds of megabytes if you're not careful. These will take ages to scan and there will be far more image data than you need to make the print.

To control this, the resolution and the scanned image dimensions need to be adjusted but one measurement is linked to the other: adjust the finished scan dimensions and the resolution changes and vice versa.

A typical scanner software control-box: select tasks such as creating a scan for a print or for an email. In each case, the scanner will do the hard work automatically.

Here a scan will be made at 200% of its original size (or double) and to do it the resolution will also double from 300ppi to 600ppi.

The original is being scanned at 100% (the same size) and at a resolution of 300ppi. The histogram display allows you to adjust the image before scanning. Note, the final scanned file size is just 6.5MB.

Many of today's scanners have automated features to do this for you. You click a button corresponding to the task, say making a scan for a 6x4 print, and the software will do the rest.

The more adventurous can manually control these settings along with other image adjustments such as colour, contrast and brightness. The more advanced the scanner, the more options you'll be able to control.

How to Scan

Step 1:

Install the software that comes with your scanner. This is essential because without it your PC won't know the scanner is there. If your scanner installs its software as a plug-in (check the manual) used via other editing software, use the **File > Import** command in your editing software. You select your scanner's name from the list presented and then the process is the same as follows.

GET THE BEST FROM YOUR SCANNER

300ppi is the optimal resolution to scan at for prints, and 72ppi is sufficient for on-screen display. Here's a quick guide to the (approximate) file sizes you should make for various tasks.

Scans for Inkjet Photo Printing

- Scan for A3 prints: 25MB (with compatible printers)
- Scan for A4 prints: 18MB
- Scan for 10x8 inch prints: 10MB
- Scan for 4x6 inch prints: 8MB
- Scan for 3x5 inch prints: 5MB

Scans for Email and Internet Use

- Scan for use on screen/web only: 480x320 pixels, around 0.5MB
- Scan for email to print out: 960x640 pixels, around 1MB

Step 2:

With the scanner software open, choose a task, in this case making a print, and follow the instructions depending on your choice.

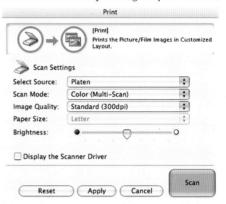

In this version, you select the resolution to use and the scanner software does the rest based on the paper size chosen.

Step 3:

If you're happy with the settings, click the scan button and the scanning will commence. Many consumer-oriented scanners will have controls on the scanner itself that allow you literally to scan at the push of a button: just place the original in the scanner, press a button and it scans.

Step 4:

Once the scan's completed, **File > Save** it. If you have already selected a place for the scans to be saved, each scan will be sent to that folder.

High-end scanners have more sophisticated control options but, nonetheless, the main scanning options remain the same.

Creating Slide Shows

A great way to display your photo collection is as a slide show on-screen or even on your TV.

Creating a slide show is actually simple with easy-to-use slide show creation software. You'll need to be able to save your show to a CD or DVD in order to play it. There's a wide range of such software available. A quick search on the Internet will provide hundreds of web sites that have slide show software for sale, demo versions to try-before-you-buy or even free, shareware downloads. Most packages provide effects such as Hollywood-style transitions between each image, and even allow you to add music.

Building the Slide Show

Although Apple's iMovie and iDVD software has been used here for illustration purposes, the slide show creation process is essentially

Since has the man the rate of 10 Columns of

the same for most slide show packages. First, gather the images you want to put in the slide show. Once you have them organised, they must be compiled into your software's workspace either by dragging and dropping them or by clicking on 'add photo' buttons and navigating to the images.

Once the images are in place, transition effects such as fades can be added between each shot. These are normally dragged from a menu to between each shot or an 'add button' is clicked, depending on the software.

Some software will have an image quality setting control. Set it so that you have a fair balance between the quality of the image and the file size of the show. This is particularly important if you're creating a

slide show on CD, where space is limited to around 700MB, rather than DVD, which can take over 4.7GB of data. The higher the quality of the images in a show, the more space they will take up on the disc.

While software differs, the process is essentially the same. Left, images for inclusion in the slide show are displayed at the right side of the screen and are dragged into the 'show' across the bottom where you can adjust their run length and running order.

In this software, the right hand side of the screen shows all of the effects, transitions, images and music which can be added to the slide show. Select as you see fit by clicking the relevant buttons. In this case, a starburst effect is shown.

Once you're happy with the sequence of images, you can follow your software instructions to add introductory text and music to the show.

In this image, music is grabbed from the list to the right and added to the slide show work area across the bottom of the screen. You can set slide shows to run for the duration of any added music too, so the images and sound will be synchronised.

Saving the Show to Disc

Once you've assembled all the parts of the slide show, you're ready to save or 'burn' the show to disc You'll need a CD or DVD

burner, either built-in to your PC or as an external device, to do this.

Some slide show programs allow you to burn directly from the software in which you built the show. Follow the on-screen guide (or wizard) once you hit the burn button or similar control, such as an 'export to disc' command. It will send your assembled slide show data to the burner.

Alternatively, the show may need to be exported to a separate CD/DVD burning program to be burnt to disc. Such programs may allow you to add chapter markers or menu screens.

Here the slide show (in this case using Apple's iDVD) has had a menu screen added in the program. Clicking the burn button starts the burn process.

Adding the Photo Files

Some slide show programs allow you to add the actual, original image files to the disc in addition to the slide show versions of the image. This is a great way of giving family members their own copy of the images, useful if they wish to make some prints for example. You must have room on the disc to be able to do this however, so if you have a large show, it's unlikely that it will all fit on a CD. Use a DVD instead.

Emailing Photos

Email is one of the fastest ways to get your latest shots to friends and family. Here are a few tips to make it even better for you and them.

To get your photos ready for emailing to friends and family, the most important consideration is the image's file size. Not everyone has broadband Internet access so sending large files by email may just jam up their system and make it expensive for them to download the pictures.

As some recipients may want to print the photos, while others just like to look at the images on screen, you can adapt the image sizes you send accordingly.

Many email programs can now resize images automatically – check your system to see how it is implemented.

Resize the Images

As we've already seen in the *Resizing* topic earlier in the book, it's a straightforward process to resize the images ready for email. Let's begin by looking at the 'start' size for an image you might want to share via email.

Checking Image Size

To check the picture's dimensions, open the image and use the **Image > Resize Image**

command. In this case, the shot to be emailed is a 15MB file at 300ppi with 23x15 cm dimensions. This is far too large to email.

Emailing for Screen Viewing

To resize this image to both a reasonable size in terms of viewing the image, and also a file size small enough for emailing, first check the 'resize' button in the resize image dialogue box. Change the 300ppi setting to 72ppi, the default resolution for computer screen viewing. Now the file size has plummeted to only 882KB and the pixel dimensions have dropped to 672x448 pixels. However, the document size is untouched.

Finally, **File > Save As** the image using a JPEG compression level of about 5 in the dialogue box that appears. This will provide a small email file without harsh compression, preserving image quality.

Emailing for Printing

With the same image as an example, we go through the exact same process but this time, instead of changing the ppi figure, we adjust the pixel dimensions. An image set to around 800 pixels on its longest edge (and left at 300ppi) will provide an image that has enough data for a decent 6x4 inch photo print and yet it will produce a file small enough to email.

The 1.22Mb file this has created must be saved using the **File >Save As** routine again, but this time you can adjust the JPEG compression in order to suit the Internet connection speed at the recipient's end. If they're using a dial-up modem, use a JPEG setting of around 2, but if they have broadband then a setting of 7 should suffice. Of course, you can successfully email the unaltered image if required with broadband connections, assuming it's not hundreds of megabytes in size!

Sending the Email

Once the image has been resized successfully, you can send the email using your standard email software. Compose and write the email in your normal way and then drag and drop the image (or images) into the message as an attachment. Or you can click on the add button to browse the computer's hard disc to find the photos you require. Click choose to select the pictures, which then appear in your newly composed email as attachments. Your email can now be sent as usual

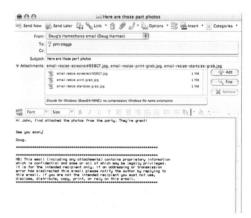

Microsoft's Entourage email program has been used here to show how the images being emailed are held within the email as attachments. You can either drag and drop them into the attachment window or click add to browse the photos and then click choose to attach them.

Getting Your Photos On-line

Putting your images on the Internet is an ideal way to showcase your pictures or create a themed web site. And it can be much less technical than you might think.

You don't have to let your images languish on your computer's hard disc, you can share them on the Internet. It's easy enough to put your images on the web, by building your own web site (as discussed below), or through sites such as Flickr and Facebook or by blogging (as discussed later in the chapter).

You won't have to learn any special programming languages. Most image editing software comes with an automated web gallery building function and on-line photo sharing sites take you through the process step by step.

Constructing a Web Gallery

If you want to build an on-line photo gallery or create a web-based portfolio of your images, modern image editing software can achieve this relatively quickly, with all the complicated programming code (HTML) written for you. Different software packages vary to a degree, but the process described below is much the same. Here we use screen shots from Adobe's Photoshop Elements as a guide.

Step 1:

First we must set up the images correctly by putting the images you want on-line together into a folder on your hard disc. Call this the 'source folder'. Create another folder called the 'destination folder'. When you've finished, this folder will contain all the web image files and the HTML for the web gallery.

Step 2:

Using your software, you'll need to start the web gallery build. Use File > Create Web Photo Gallery (or your software's version of this) and use the styles menu to choose a gallery design. Preview and select the one you like the best.

In this screen shot the gallery's style, name and other information are all entered. The style is previewed in the small window to the right.

Step 3:

Select the previously created 'source' and 'destination' folders for your web site. Source images will be processed and altered and then copies of them placed into the destination folder. Also, pick a size for the images to be changed to, for on-line viewing (in this case 450 pixels) with a JPEG quality setting of 5 in this software's options menu.

The source and destination folders have been selected as have the image dimensions and IPEG quality. Now the images will be resized and optimised properly for your web site.

Step 4:

As with Step 3 above, you'll need to decide on the size of the thumbnail images for your gallery. Here we've picked 75 pixels with a border of 2 pixels to help define them on screen. Some software will allow you to customise the thumbnail size to a large extent, but as with all things 'web', the larger the images the more memory they'll take and the slower the web site may be to use once it's up and running on-line.

change the thumbnail image size and border as you wish or, depending on the software, use the dropdown 'size menu which will choose for you.

Step 5:

Now pick the various custom colours for your web site, such as the link colours, colour of text and the background. Avoid patterned backgrounds - keep it simple - otherwise, the gallery can cause eyestrain if it's too 'busy'. Black is an ideal background for images as it helps show them to their best advantage. However, any neutral colour is also gentle on the eye: the template used in our example is grey.

Pick simple colours and plain backgrounds to make the most of the images on your web site.

Step 6:

You might want to consider including some form of copyright or security information. That way, visitors to the gallery cannot download your photos and use them without your permission (see the Copyright topic for more on this). Here, custom text has been included from the options menu. This is embedded into the on-line images and adds to the security.

Once you're happy click OK and the software starts compiling the site.

You can add copyright and security information into your images if required, for example if vou want to sell your photos.

Step 7: When the site has been built, use a web

browser (such as Internet Explorer) and File > Open the 'index.html' file created in the destination folder. This will now contain all your web gallery data. Incidentally, never move files from this folder or the gallery will stop working. Your web gallery should appear in the web browser window. This last step is just to check that your site looks as you intended and that all the links work.

GETTING THE GALLERY ON-LINE

Once you have your web site built, all that's left to do is move the web site onto the Internet. You can upload the destination folder of the newly created web gallery to your web host or internet service provider, which will then make the site 'live'. However, check with your provider for the exact process as it can vary depending on their site set-up.

Automatic Web Site Software

There are various free programs you can download from the Internet that allow you to build simple but professional-looking web sites of your images. While such programs are free (you can donate money to the developers if you wish), they have adverts for the software developer that must always be displayed on any site you make. WebPlus is one (www.freeserifsoftware.com) and another is called SimpleViewer (www.airtightinteractive.com). Both are easy to use and are effective ways of publishing your images on-line.

Flickr, Facebook and Blogging

There are also other routes to getting images on-line, from dedicated photo-sharing sites such as Flickr - where you can email links to your friends and family so they can view your image albums - to popular social networking sites. All you need is an Internet connection for your images to be out there for the entire world to see. Here are a few options to try...

Flickr.com

Flickr is a popular photography-oriented web site run by Yahoo that allows you to upload your photos and videos to create what it calls a 'photostream'. This is simply the overall term used for the series of images that you've uploaded and that people from around the world can view when they go on-line. There are two types of Flickr account: Free and Pro. The former has some limits on the amount of

uploads you can make a month (or at a time) while the latter Pro account allows you to use Flickr without these limits for an annual fee.

Once you've created an account, Flickr makes it easy for you to upload your chosen photos. It launches a window that allows you to browse your PC to find the pictures you want. Flickr accepts a variety of image types (TIFF and PNG for example) but it's advisable to upload JPEG images. (JPEG images are best for the web as they can be highly compressed yet retain good quality.) You can choose to make your photos 'private' (visible to friends and family only, for example) or 'public' (for all to see).

Once uploaded, you can do many things with your images to enhance your Flickr experience. Clicking on Flickr's Organize and Create allows you access a new set of tools, via the Batch Organize window, which enables you to get creative with your images. 'Edit Photos', for example, allows you to delete or manipulate images: rotating them,

Flickr allows you to upload and share your images with a like-minded photographic community across the globe.

adjusting the name of the photo and adding a description if you wish. If there are people in the picture, you can add their name or email. Flickr also lets you create 'sets': groups of photos organised by themes of your choice, for example a set of portraits.

You can also add a 'tag', which is a way to group photos by a keyword so that images of a certain type can be quickly searched/browsed. A simple example would be the tag 'tree', which when searched on Flickr would bring up images of trees from your photostream, from your contacts', or from everyone's, depending on the selection you make for the search. The benefit is that it helps you and other Flickr users to quickly find images of a particular sort.

Flickr is often used as a resource by publications looking for good pictures to publish, so good photos, good tags, naming and descriptions of your photos might even lead to getting a picture published.

Facebook

Facebook is another social networking site that allows you to share your images. Unlike Flickr, which is all about photography and sharing images, Facebook is about people and the sharing aspect of the site, and its ability to contact, update and create galleries

of images is all part of the fun. Setting up an account is a straightforward process, which the website takes you through step by step.

With your profile page set up and your privacy preferences in place, adding photographs to Facebook is a straightforward case of uploading via Facebook's simple upload system, or you can download and install a plug-in software which helps you to upload multiple images more quickly – it's up to you. You can then select whether images are available to friends only or to the wider Facebook community.

- On your profile page click the Photos link and from here you can organise images into albums by clicking the Create a Photo Album link at the top right of the screen.
- You can 'tag' your images with the names of the people in any shots (up to 60!). This makes sharing the pictures very easy too as they will automatically appear on the tagged person's Facebook pages as well as yours.
- Additionally, any photos of you that others have tagged and placed in their Facebook accounts can also appear on your profile page (in the 'View Photos of Me' link

ADVANCED FLICKR TIPS

- You can send images to Flickr groups you may join (or who invite you to join them); these are groups of people who are, for example, taking similar images to you. This all helps increase your photography's exposure to the whole Flickr community or simply to others who you'd like to view your images. The better your photography, the more groups might invite you to join them and therefore the more your images will get viewed.
- Via the Print and Create link you can create projects to print as normal prints, or select products to have your images printed on, such as cards, calendars or canvas.
- Although it's best to edit and enhance your images on your PC, you can also edit images on Flickr using Picnik. Click the 'Edit Photo' button on the chosen picture, agree to allow Picnik to open inside your Flickr and you're ready to go.

under your profile picture, or in the Photos section on your page), as well as being visible on the Facebook page of the person who uploaded them. It's worth remembering that they'll be visible to all who are marked as your Facebook 'friends' too.

 Remember too not to put images on Facebook you don't want others to see; the way it shares your comments, images and content means that any image will be visible to all your friends and any others permitted by your settings to see them.

Blogging

A blog or 'weB Log' is a personal diary on the Internet; a space to share your thoughts, opinions and experiences. It is also a fast way to create an on-line gallery of your pictures, since they can easily be uploaded to a blog.

The simplest method is to use a blogging web site. There are many available – a good example is blogger.com, which works with Google. You can give your blog a look and

The 'Choose a template' screen from the Blogger web site

feel to match your content by choosing from a number of templates. After you have done the basic set up, you can customise your pages by giving your web log a headline. You can then begin to post your blogs, either typing text or cutting and pasting text into the blog from another document. Uploading images is simple and you can adjust the image size and position on the page too.

Once your blog is up and running, there is more you can do to enhance it, and perhaps even make a little money.

MAKING THE MOST OF YOUR BLOG

- You can generate money from your blog by clicking the *Monetize* link on the Blogger settings page. This links to Google's AdSense scheme, where ads are placed on your blog that are related to the content (Google checks your blog automatically for content). By setting up an AdSense account, you can make money when visitors to your blog click on the adverts.
- As your blog grows in popularity, people who visit it regularly can, if they so choose, become 'followers', which means they can quickly get updates of your blog via their Google, Twitter, Yahoo or AIM, NetLog and OpenID accounts.
- By setting your blog to allow email links, visitors can quickly email your latest blog updates and images to their friends and contacts, which helps get more people to see your images faster and helps the blog grow and the money to flow.
- Do update your blog regularly to keep visitors coming back for more. Frequent updates also ensure your blog rises in search listings. All this helps to build popularity and traffic and, of course, money if that is of particular importance to you.

Making A Portfolio

If you're serious about your photography, particularly if you want to sell your images, you'll need to compile a professional portfolio of work.

Creating a portfolio of images is not just a matter of getting all your images together and printing them or putting them on a web site. If you intend to make any money, you'll need to cherry-pick the very best of your images and use only those. Being critical is essential as competition is fierce, and unless you focus on your best shots, you're unlikely to succeed.

An Internet or on-disc portfolio is a must, but you also need to have a high-quality print portfolio.

Print Portfolio

You'll need to get your very best images printed using high-quality photo output and ideally at a large enough size to give the viewer a good impression of what can be achieved with them. Print no smaller than A4 on fade resistant photo paper and buy a good quality portfolio folder with sleeves to house the prints. Beware, less expensive portfolios often use plastic pages that seep chemicals and can damage your prints over time.

stunning images that you might want to sell or hope to make money from, a portfolio – on-line and as prints – will be required.

If you have

On-line and On-Disc Portfolios

You'll need to put your portfolio on the Internet (see Creating a Photo Web Site) or on disc (see Creating Slide Shows). Ensure each image is annotated with its technical details, and that the slide show is made at the highest quality possible. Sacrifice the number of images in a show to ensure high quality. It's better to have numerous discs than all the images crammed as low-resolution files onto just one.

Organise all the images by content type: architecture, landscapes, portraits, animals etc. This makes relevant images easier to find and if you don't have software able to do this, consider getting the portfolio made professionally. Scrimping here could cost you money in the end.

INCLUDING IMAGE INFORMATION

There are key details that should always be associated with your images in any portfolio. Some may seem unnecessary, but all are, in fact, vital, Magazine editors. for instance, are likely to require detailed text information for captions and if it is with the image already it saves them time, making them more likely to use your image over someone else's.

- Copyright information: Include your name and contact details with each image. On prints NEVER write on the back of the print itself. Use special stickers or frame the shots in card borders (from art shops) and include the details on that. Digital images have the detail automatically appended with each image and it can then be viewed as the image is displayed.
- Image technical data: The shutter speed, focal length, sensitivity setting and lens aperture should all be included. All this information is to be found within the image EXIF data, using your image editing software.
- Date and location: Include the date. the image was made and the location where it was taken/what's in the shot.
- Image dimensions: Include the image's pixel dimensions and file size.

Portraits such as this can be an ideal way to start building a portfolio from your images. Practise on family and friends to help hone your skills and get the perfect photo for the portfolio you're building.

Making Money

Making money from your photography is more achievable than you might think.

Gaining income from your photographs doesn't always mean you'll need professional camera gear and the expense that goes with it because, today, the fastest route to getting your images to market is via the Internet.

But if you want to make money from your photos, family snaps won't be the type of image people want to buy, and you'll need to shoot images that are less personal and more commercial. It's best to have a commercial target market in mind, and then shoot images that are relevant to it.

Images such as this shot of Egyptian hieroglyphics are classic shots which can be used time and again, from historical publications to holiday brochures. If, for instance, you want to get your images into magazines, competitions are good ways to start as this helps to discover what's acceptable. The classic tropical beach with palm trees you see in holiday brochures would be an ideal example of an everpopular shot. Landscapes and architecture are always in demand, particularly if you get a novel angle on the subject. Macro style images of flowers and plants are good too. But what are the routes to making money that you can consider?

Put Your Photos On-line

We've already looked at building a web site from your images, but if you're going to take this seriously, you'll need to use only the very best of your photos. Eventually you'll need to think about getting a professionally built site, as competition is very stiff. This will cost money but will give you more chance of reaching a wider audience.

Set Up An Exhibition

Setting up an exhibition of your work will raise your profile, but this can be expensive and time-consuming. Look to local businesses such as cafes, to see if they would consider hanging framed prints for you (there may be a small commission) with your details on each photo.

Join The Professionals

Join a professional photo society or your local camera club. These will be able to offer advice on selling and improving your photography and have many connections that will help you get your images out to a wider audience

Print Postcards Or Calendars

Having postcards or calendars of your images printed is another good way to circulate your photos more widely. However, depending on how many you have printed, the cost can be prohibitive and you'll need to plan in advance who to send them to or where to display them. You could even start selling them at local markets.

Join An Image Library

Image libraries are businesses that hold photos for many different photographers and act as an agency, selling the use of your images to magazines for example. You get a fee each time an image is used and the library takes a percentage of that money. Most libraries have web sites too. Many image libraries have very specific criteria for the images they want (digital or otherwise and particularly for file size limits) so you'll need to contact them in advance to make sure your images are of the required type/standard.

'Timeless' images such as flowers as in this example are another great image type to use if you want to make money from your photography. And make sure you always shoot images at the highest possible quality to ensure you can reproduce the images at a variety of sizes, particularly larger prints which can also be framed to hang on a wall.

Copyright

You'll need to be aware of copyright issues in our digital age, particularly if you want to sell your photographs.

Copyright is the term describing the law that protects you from the use or abuse of your images by others without your permission. For example, if one of your photos was required for use in a magazine article, the copyright for that image rests with you, the photographer, and the magazine could not use it without a payment to you or your permission to do so.

Anyone who copies or reproduces an image without first paying – or at least getting permission from – the author to do so, is said to be breaching the author's copyright. While legal specifics vary from country to country (it's best to check) and can be dependent upon what is negotiated at the time, this is the basic rule.

This image has the author's name embedded for copyright information, preventing this image being used without payment. This is an ideal tactic for portfolio images off- or on-line. To obtain the image for reproduction, the author needs to be contacted and the non-marked image then supplied for use.

Types Of Copyright

Some companies might want to buy the entire copyright (called 'all rights') for any image, and this means that from that point on they don't need to pay you again. They have effectively bought the copyright from you and it is theirs to do with as they see fit. You should place a higher price on images you sell in this way. Typically, however, most photographers sell 'single-use rights' in their images, which means the photographer retains the copyright and can re-use and re-sell the image repeatedly.

How To Get Copyrighted

Copyright arises automatically in all works of art, including photography, writing and digital images as they're created. No formal registration is required to receive the basic legal protection this affords in over 140 countries around the world.

Protecting Your Images

- The Internet: While you cannot stop people from downloading your images, you can take precautions to stop them using them elsewhere without payment. Use watermarking technology (it will cost money but embeds a hidden code in the photo which is unique to you and which can be retrieved later using special software) or add your name to the image (as shown, left). This can be done discreetly in a corner of the shot; it's an ideal tactic for portfolios too.
- Ensure any images you put on the Internet are large enough to be viewed at a good size on screen, but small enough in terms of file size to make them useless for printing.
- In Print: Watermarking works well on prints too, but you are unable to either reduce the file size or add your name to the print as you can on digital images. You can, however, put a sticker on the reverse of the image with your copyright details. Remember, copying a print (a scan for example) without payment to you, or your permission, will breach your copyright.

Royalty-Free Images

These images are photos in which the copyright has been bought outright and which are then assembled, say on a CD, for which there's a charge. These shots can then be used (even commercially in many instances) without incurring another fee from the author for their use. The one-off charge for a royalty-free CD in this example is all that needs to be paid.

If you don't want to 'ruin' an illustrative shot with a big copyright notice, you can also create smaller, less obtrusive text and place it out of the way in a corner of the image as shown here.

Glossary

Aberration Imperfection in an image caused by deficiencies within a lens or optical system.

Ambient Light The natural or available light in a scene.

Aperture The circular opening inside a camera's lens that can change in diameter to control the amount of light reaching the camera's sensor. Apertures are expressed in F-stops; the lower the number, the larger the aperture. For instance, an aperture of F2.8 is larger than one of F8. Aperture and shutter speed together control the total amount of light reaching the sensor. Many cameras will have an aperture priority mode allowing adjustment of the aperture. (See also Shutter Speed)

Application A computer program, such as an image editing package or a web browser.

Archival Quality Term used to denote materials having a high degree of permanence. If the longevity of a material (such as printing papers) is said to exceed an acceptable defined time period before starting to degrade, it is said to be of archival quality.

Artefact An unwanted visual aberration within a digital image.

Aspect Ratio The proportions (or ratio) of a picture's width to its height.

Backing-Up Making copies of important computer files in case the originals are damaged and cannot be accessed.

Bit The basic unit of information used in computing. A bit

represents a one or a zero, or 'on' or 'off' in a computer.

Blog A blog (a contraction of weB Log) is a type of simple web site, usually run and maintained by an individual to post stories, images and commentaries on whatever takes their fancy.

Blu Ray Blu Ray (also known as Blu-ray disc, BD and Blu-ray) is an optical storage disc medium that's set to supersede DVD; its main use is storing high-definition video, video games and other data.

Buffer A memory reservoir built into digital cameras that stores the photos before they are written to the memory card.

Burning (CD/DVD) Creating a copy of your images by electronically saving image files onto an optical disc such as a DVD or CD. (See also Writing)

Burning (image editing)

Selectively darkening part of a photo with an image editing program.

Byte A data 'chunk' made up of eight bits.

Cast The effect of one (unwanted) colour dominating the look of an image. Often caused by exposure errors or incorrect settings of a digital camera's white balance.

CCD Charge coupled device. One of the two main types of image sensors (see also CMOS) used in digital cameras. When you take a picture, the CCD is struck by light coming through the lens and the millions of tiny pixels that make up the CCD convert this light into

electrons. The number of electrons is measured and converted to a digital value, a step that occurs outside the CCD, in the camera's analogue-to-digital converter.

CD-R CD-Recordable. A compact disc that holds around 650 to 700MB of digital information. A CD-R disc can only be written to once.

CD-ROM Compact disc readonly-memory. A type of CD similar to a normal audio CD but optimised for data storage.

CD-RW CD-Rewritable. Similar to a CD R, except a CD-RW can be written and erased many times. Suited to back-up tasks, but not long-term storage.

CMOS Complementary metaloxide semiconductor. One of the two main types of image sensors (see CCD above) used in digital cameras.

CMYK Cyan, Magenta, Yellow, Black. The four colours (or ink sets) of many photo-quality printers. Some photo-printers use six, seven, eight or more inks to achieve smoother, more photographic prints.

CompactFlash (TYPE I or II)

A common type of digital camera memory card. There are two types of cards, Type I and Type II, varying in thickness. Type I is thinner.

Compression Reducing the file size of digital data files by removing redundant and/or non-critical information within a digital image, helping to maximise storage space.

Contrast The difference between the darkest and lightest areas in a photograph. The greater the difference, the higher the contrast.

Copyright Legal protection against copying and the specific rights allowing copying applying to original works such as photographs. Copyright arises automatically whenever an original work, such as a photo, is created.

Depth of Field (DOF) The

distance between the nearest and farthest points that appear in acceptably sharp focus in a photo. DOF varies with lens aperture, focal length and camera-to-subject distance

Digital Camera A camera that captures a photographic image using an electronic imaging sensor (see CCD or CMOS).

Dodging Selectively lightening part of a photo, using image editing software

DOF see Depth of Field

Downloading Moving computer data from one location to another. Often used to describe the transfer of data from the Internet or to describe the transfer of photos from a camera to a computer.

dpi Dots per inch. Measurement of the resolution of a digital photo print or digital device such as an inkjet printer. The higher the dpi number, the greater the resolution. (See also ppi)

D-SLR Digital, single-lens reflex camera. A lens interchangeable digital camera that allows the scene to be viewed through the lens that will take the photo.

DVD Digital versatile disc. A type of high-capacity optical recording media (similar to CDs) but able to store 4.7 gigabytes of data.

EXIF Exchangeable image file. Image data (such as shutter speed, aperture and ISO) that's stored directly in the image file generated by a digital camera. The data can be read by any application that supports IPEG and TIFF file formats, such as web browsers and image editing applications.

Exposure The total amount of light allowed to fall on a digital camera's sensor during the process of taking a photograph, measured in EV. The higher the EV, the more light there is.

External Flash An accessory flash unit (or flashgun) triggered by the camera or the light from the camera's built-in flash.

Facebook A popular social networking site - or on-line community (see also Social Networking) - for individuals or like-minded groups to send messages to other on-line 'Facebook' users sharing images, videos and information.

File A computer document such as an image file

Fill Flash A flash technique common to most digital cameras used to brighten deep shadow areas, for example, outdoors on sunny days. This mode forces the flash to fire even in bright light.

Filter (photography) A camera accessory made from (usually) optical glass, which is inserted into the optical path to provide a specific effect, such as adding an artificial colour.

Filter (software) A software tool that can be used to produce special effects such as sharpening.

Fire Slang term for taking a picture; as in 'fire the shutter'. FireWire (also known as IEEE

1394) A cabling technology used to transfer data to and from digital devices at high speed as used by many professional digital cameras and memory card readers.

Flickr An image and video hosting web site set-up with a social network-like structure to create an on-line community of like minded people; provide image hosting for bloggers; and claims to host over 4-billion images.

Focal Length The distance between the sensor and the optical centre of a lens when that lens is focused on infinity. Focal length is marked in millimetres on the lens (or mount) on those cameras with adjustable focal lengths.

Formatting The act of writing a file system onto a computer disc or memory card that completely deletes all the previous information and file structure on that disc or card, replacing it with a fresh structure ready for new information. Formatting is the recommended method of clearing a camera's memory card.

F-stop (or F-number) The measure of the size of a camera lens's aperture. The higher the F-stop, the smaller the aperture and vice versa.

Gamut The total range of colours reproduced by a device such as a digital camera.

GIF Graphical interchange format file. A bitmap graphical format, ideal for logos, line drawings or images with solid colours.

Gigabyte (GB) A gigabyte is the amount of memory equal to 1024 megabytes (or 1,073,741,824 bytes) of information.

Greyscale An image made of varying tones of black and white. HDMI High-Definition Multimedia Interface or HDMI is a compact audio and video interface able to transmit raw digital data and is the ideal connection for HDTVs; the latest digital and video cameras capable of shooting HD video have HDMI sockets and can allow enhanced features and user controls with compatible equipment.

High Definition High definition (or high definition video or HDTV (High-Definition television)) refers to a video system with a resolution higher than standard definition (which has a 576p resolution) typically with display resolutions of 1280 x 720 pixels (known as 720p) or 1920 x 1080 pixels (either 1080i (HD Ready) or 1080p (Full HD)). There are increasing numbers of digital cameras (both compact and D-SLR) able to shoot HD video

Highlights The brightest parts of a photo.

Histogram A graphic representation of the range of tones from dark to light in a photo. Many digital cameras include a histogram feature facilitating a precise check on the exposure of the photo.

Image Editor A computer program used to alter the appearance of a photo.

Image Resolution The total number of pixels used to make up a digital photo.

Inkjet A type of printer that fires ink droplets onto paper through tiny nozzles.

ISO Sensitivity Digital cameras use the same rating system as was used for film to denote the camera sensor's sensitivity to light. Often a control for adjusting the ISO speed is included; some cameras adjust it automatically depending on the

lighting conditions. The higher the ISO number (100, 200, 400 etc.) the more sensitive to light the camera becomes, but as ISO speed climbs, image quality often drops. (See also Noise)

JPEG A standard for compressing image data. A JPEG is not, strictly speaking, a file format, it is a compression method used within a file format (see EXIF). Referred to as a 'lossy' format, some image quality is 'lost' in achieving the JPEG compression.

Kilobyte (KB) A unit of measurement equal to 1000 bytes.

LCD Liquid crystal display.

A type of colour screen often used on the rear of a digital camera to help with composition and to display the photo once it's taken, and to display setting/control memus.

Media Generic term used for any material that information can be written to and stored on. Digital photography storage media can include memory cards, CDs and DVDs while in printing the paper used is often described as print media.

Megabyte (MB) A measurement of data storage equal to 1024 kilobytes (KB).

Megapixel Equal to one million pixels (or 1MP). The higher the number of megapixels, the higher the resolution of a digital camera is said to be.

Memory Card Generic term for a flash-based storage device for photos and video, such as a Compact Flash card.

Memory Stick A proprietary flash-based storage device developed originally by Sony for digital cameras and other digital devices. MultiMedia Card A type of flash-based memory card similar to Secure Digital and able to support multiple data types (audio, image or digital movie data for example).

NIMH Nickel metal-hydride. A type of rechargeable battery, ideal for running digital cameras and flashes.

Noise (in an image) Unwanted random artefacts within an image created by the electronics within a camera and other environmental factors such as heat. Often used together with the term signal-tonoise ratio, which describes the ratio between actual image information (the signal) and the level of background noise. Many digital cameras have internal processing to keep noise to a minimum: a high signal-to-noise ratio is desirable.

Operating System (OS) The base software needed to manage, a computer/device's hardware and software applications; examples include Windows and Mac OS.

Panning Photo technique in which the camera follows a moving subject, keeping the subject sharp whilst blurring the background giving a sense of motion to the photo.

PDF Portable document format. A document file that can be looked at anywhere if you have Adobe Acrobat Reader software.

PICT A file format used primarily for on-screen images.

Pixel A picture element. Digital photographs are composed of millions of them; they are the building blocks of a digital photo and consist of a small light-sensitive photo site, a micro lens and the necessary wiring.

Pixelated Referring to images of poor quality where the balance between image resolution and output is not correct when printing. For example, if a low-resolution image (say 72dpi) is enlarged by 200% and printed, the pixels become visible – hence pixelated – giving a jagged effect to the printed image.

Plug-In Software program that enhances other computer programs and applications. There are plug-ins for Internet browsers, graphics programs and image editing applications.

ppi Pixels per inch. Measurement of the resolution of a digital image (or of a scan made by a scanner) is made in ppi. The higher the ppi number, the greater the resolution. (See also dpi)

Podcast A downloadable Internet broadcast, be it text, audio or video, for your iPod or other MP3 or music player, which allows you to experience such content on the move.

RAM Random access memory. The type of computer storage whose contents can be accessed in any order, used by your applications for processing and temporary storage.

(See also ROM)

RAW Image format where the data is unprocessed (by the camera) as it comes directly off the CCD. Mostly used by professional photographers (as a digital 'negative') who want to get specific effects from their images. Often provides superior quality (in an image editor) to a camera's internal image processing.

Redeye The reflected red glow from a subject's eyes when light from a flash is coloured by the blood vessels in the retina. Most common when light levels are low indoors, with babies or outdoors at night.

Resolution (of a lens, or resolving power) The ability of a lens or optical system to show fine detail. The higher the resolving power of a lens the more detail can be captured.

RGB Red, green and blue. The three primary colours into which digital cameras split/convert an image.

ROM Read-only memory.
Computer memory whose
contents can be accessed and
read but cannot be changed. (See
also RAM)

Saturation Measure of how richly colours are rendered in a photo.

SecureDigital A type of flashmemory storage card with built-in copyright security facilities.

Sensitivity see ISO

Sensor see CCD; CMOS

Sharpness The perceived clarity of detail within a photo. Can usually be adjusted in the camera or later using an image editing package.

Shutter Speed Measure of how long the shutter stays open as the photo is taken. The slower the shutter speed, the longer the exposure is said to be. For example, a shutter speed set to 1/250 means the shutter will be open for exactly 1/250th of one second. Shutter speed and aperture together control the amount of light reaching the sensor. Many digital cameras have a shutter priority mode allowing you to set the shutter speed to your liking. (See also Aperture)

Signal-to-noise ratio see Noise

SmartMedia A wafer-thin flashbased memory card, but now almost defunct.

Social Network(ing) A social network – or social networking – is a term used to describe many web sites, which have vast numbers of individual users – or members, or groups of users – all with similar interests or with the desire to 'meet' and interact on-line using email and instant messaging. These include sites such as Facebook, MySpace and Flikr. They're often termed as 'On-line Communities'

Thumbnail A small version of a photo. Image browsers commonly display many thumbnails at a time.

TIFF Tagged image file format. A widely used file format for images.

USB Universal serial bus. A protocol for transferring data to and from digital devices. Many digital cameras and memory card readers connect to the USB port on a computer.

White Balance A function on the camera that allows compensation for the different colours of light being emitted by different light sources. (See also Cast)

WiFi A method of wirelessly connecting cameras, printers and PCs.

Writing (a file) The process of outputting a data file to a CD, DVD or Blu Ray disc using a device that 'burns' to the disc.

xD Picture Card A tiny flashbased storage card typically used in Olympus and Fujifilm digital cameras.

Index

A
abstracts 114-7
angles 115
colour 115
large-scale 116-7
accessories (camera) 36-49
bags 22
batteries 49
connections 34-5
hotshoe flash 44
lenses 24-9
light meters 48
memory card cases 23
memory cards 16-17
monopods 43
remote release 43
slave flash 45
software 36-7
studio flash 45
tripods 42
waterproof housing 23
accessories (computer) 32-3
CD/DVD/Blu Ray burner 33
graphics pads 32
hard drives 32
image editing software 36-7
memory card reader 32
pendrives 33 portable CD burner 33
printers 38-1
scanners 40-1
action photography 95-7
adapter lenses 27-9
Adobe Photoshop CS 36
Adobe Photoshop Elements 36,
202-4
AdSense 206
AF assist emitter 9
aircraft (shooting from) 84, 116
all-in-ones (scanners) 39, 41
amputation 74
angles 115
anti-dust system 13
animals 110-3
aperture size (F-stops) 59-60
Apple iMovie/ iDVD 198
Apple Macintosh (Mac) 30-1

archiving 190-2

ArcSoft DVD SlideShow 37
ArcSoft PhotoStudio 37
art effects 182-4
audio functions 21
auto fix 128-9
colour casts 129
exposure problems 129
low contrast 129
preview screen 128
auto focus (AF) 56
avoiding problems 57
AV (audio visual) socket 11

babies 106 backing-up 190-2 built-in back-up 190 CD/DVD/Blu Ray 192 external hard disc 191 fully manual 192 scheduled back-ups 192 Windows XP Home Edition (XP HE) 190-2 bags, camera 22 balance (composition) 54 barrel distortion 28 batteries 11, 20, 23, 49 black and white 72-3 channels 154-5 creating black and white 142-3 textures 72 weddings 100 blogging 206 bluetooth 35 blurring backgrounds 168-9 blur/smudge tools 122 bounce head (flashguns) 45 bracketing 61 bridge cameras 13 brightening photos 138-9 brightness (curves) 150-1 brush tool 123 bull's eve composition 52 burn 158-9 burn tool 123

C

camera bags 22 camera features 8-11 auto focus (AF) sensor 9 battery and memory card cover 11 colour screen 11 DC (mains power) socket 8 flash 9, 21 jog buttons 11 lens 9 lens zoom control 11 on/off button 11 PC/AV socket 8 shutter release 10 viewfinder 9, 11 wrist strap lug 9 zoom lens 10 cameras 8-11 buver's quide 18-19 care 22-3 features 8-11 types of 12-13 using 20-1 camera shake 42-3 causes 42 monopods 43 prevention of 42-3 remote release 43 shutter speed 42 supports 43 tripods/tripod heads 42-3 candid shots 75, 99, 101 card capacity 17 care 22-3 case (memory card) 23 CCD 13-14 cameras 14 scanners 41 CD-ROM 36-8 channels 154-5 channel mixer 155 using channels controls 154 children 106-9 babies 106 arowing up 110 parties 106 toddlers 106

cleaning, of camera 22-3

clone tool 122 protecting your images 212 E cloning 156-7 royalty free images 212 close-ups 57, 70-1 types of copyright 212 editing software 36-7, 120-3 avoiding flash problems 71 Corel PaintShop Photo Pro 37 electronic viewfinder (EVF) 9 flowers 102 creative flash 64-6 emailing photos 200-1 ideas 70 auto flash 64 for printing 201 magnification 71 fill-in flash 66 for screen viewing 200 CMOS 14 flash fall off 66 image size 200-1 CMYK 144 flash off 66 resizing 200 colour redeve reduction flash 66 sending 201 adjustment 146-53 slow sync flash 65 eraser tool 122 balance 146, 150-1 cropping 130-1 exchange colours tool 122 brightness 149-9 crop tool 122 exhibitions 210 casts 129, 146 CRT (cathode ray tube) 31 exposure 60-1 contrast 148-9 crystallise filter 180 aperture and F-stops 60 control (levels) 148-9 curves 150-3 bracketing 61 curves 150-3 creating a curve 152 camera types 60 hue and saturation 147 extreme curves ideas 153 compensation 61 levels 148-9 negative curve effect 153 control 61 management 144-5 single colour curves 153 fixing exposure problems 129 preferences 145 sensitivity and ISO 60 profiles 144-5 D shutter speed 60 removal 142-3 samplers 123 daisy chain (storage) 47 F variations 147 darkening 138-9, 158-9 colour management 144-5 DC (mains power) socket 11 Facebook 205-6 colour gamut 144 dedicated flash 44 face priority AF 9, 56, 57, 74 colour settings in your software default colour settings 122 feathering 167 145 depth of field (DOF) 58-9 file formats 124 CYMK 144 close-up 59 fill layers 163 RGB colours 144 deep DOF 58 film scanners 40-1 screen colour, 144 F-stops 59-60 filters 179-81 sRGB 145 shallow DOF 58 fixed lenses 26 compact flash (CF) memory card desktop 30-1 flash 9, 44-5, 64-6 16.20 digital single lens reflex camera 13, animals 110 composition 52-5 23, 27, 29, 44 automatic 9, 64 balance 54 discs (extra storage),46-7 bounce head 45 bull's eye 52 display mode 122 close-ups 71 framing 52 quick masks 123 creative 64-6 golden mean 52, 92 distortion 28 dedicated 44 landscapes 52, 91-2, 93-4 barrel 28 extra 44-5 portraits 52 pin cushion 28 fill-in flash 64 rule of thirds 52, 92 document mode 72 flash fall off 66 still life 78 dodge and burn 158-9 flashguns 44-5 computer 21, 30-1 colour 159 flash off 65 desktop 30-1 dodge tool 123 flash sync port 48 laptop 30-1 downloading 47 flash synchro terminal 45 Mac 30-1 D-SLRs 13, 23, 27, 29, 44 guide numbers (GN) 45 Windows 30-1 dust removal 174 hotshoe 44 connections 21, 34-5 DVD 37 low light 68 contrast 129 back-up 19 power 45 controls, camera 10-11, 21 dye sublimation printers 39 redeye reduction 66 converters 28 ring 44 telephoto 28 slave flash 45 wide-angle 28 slow sync 65, 96 copyright 211-2 still life 79-80 how to get copyrighted 212 studio flash 45

		7.0
flatbed scanners 40	inkjet printers 38	M
Flickr 204-5	interchangeable lenses 29	
flowers 102-5	ISO sensitivity 45, 67, 69	Mac (Apple computer) 30-1, 36-8
F-numbers 59-60	J	macro shots 57, 70-1
focal lengths 24-5 action/sports 97	J	magic gate cards 17
portraits 74, 76	jog buttons 11	magic wand tool 123
shutter speed 42	IPEG or IPG format 125	magnetic fields 23
focus 20, 56-7	Ji no or ji o tormac rno	magnification 71 maintenance, of camera 22-3
auto focus (AF) 57	L	marks, removal 156-7
landscapes 56	_	marquee tools 122
macro shots 57	landscapes 20, 52, 56, 86, 91-4	masks 164-7
portraits 56	correct settings 92	add and subtract a mask 167
shutter button 56	framing 92	feathering 167
small groups 57	rule of thirds 92	masking tips 167
framing (composition) 52, 76	laptops 30-1	painting onto layers 166
gardens and flowers 103	lasso tools 122	selections and masks 167
landscapes 92	layers 160-3	megabytes 16
F-stops 59-60	adding text with layers 162-3	megapixels 14-15, 18-9
full RGB 145	adjustment layers 163	memory (PCs) 30-1
_	basic adjustment layer 161	memory (storage) 46-7
G	fill layers 163	memory cards 11, 16-17, 20
	fundamental changes 161	card reader 32
gamut 144	modes 181	care/case 23
gardens 102-5	ordinary layers 163	compact flash (CF) 16, 20
close-ups 102	type/shape layers 163	covers 11
lighting 102	LCD 11	memory card slots (printers) 39
GIF format 125-6	lenses 24-9	memory stick (MS) 17
gigabytes 16, 31	adapters 27-9	securedigital (SD) 16
golden mean 52, 92	changing lenses 27-9	smartmedia (SM) 17
gradients tool 123	filters 28	xD picturecards (xD) 17
graphics pads 32	interchangeable 27, 29 zoom 9-11, 24-5, 29	menu bar (PC) 121
group shots 98, 101	lens flare filter 180	meters 48
guide numbers (GN) 45	levels 148-9	Microsoft Windows XP 190-2
н	controlling colour and brightness	midtone contrast 138-9
	149	mirror-less compact 29 mode dial 20
hand tool 122	histograms 148-9	Monet, Claude 185-7
hard discs 31-3, 46-7	using levels controls 148	money, making 209-10
hard drive 31-3, 46-7	lightening 158-9	monochrome 72
HDMI port 34	lighting 48	channels 154-5
healing 156-7	flowers 102	creating black and white 142-3
healing brush/patch 122	portraits 76	document mode 72
highlight control 138-9	still life 79-81	sepia 72
histograms 148-9	light meters 48	monopods 43
hotshoe (flash) 44	buying guide 48	motion blur 170-1
housings (waterproof) 22-3	flash sync port 48	mouse 32
HTML 202-3	sliding globe 48	movement, adding 170-1
hue/saturation tool 147	lopsided images, 132-3	move tools 123
-	lossless formats 125	movies 21
I	lossy formats 125	
	low contrast 129	N
image editing 120-3, 128-87	low light 67-9	8.1
image libraries 210	image noise 67, 69	negatives (scanning) 40-1
impressionist-style 187	low light and flash 68	night 67-8, 97
indoor photography 68	night portraits 68 party pictures 68	night portraits 20, 69
infra-red (IR) light 9	party pictures oo	noise (image) 67, 69

0	podcast 216 portable CD burner 33	Roxio Toast Titanium 37 royalty-free images 212
old photos/prints 174-5	portfolios 207-8	rubber stamp tool 122
restoring 174-5	copyright 208	rule of thirds 52, 92
scanners 40-1	date and location 208	-
on-line photo gallery 202-4	image dimensions 208	S
on/off button 10	image technical data 208	
operating systems (OS) 30-1, 190	including image information 208	save/save as 125
optical viewfinder 9, 29	online and on-disc 208	saving photos 124-7
optical zoom lenses 24-9	portraits 208	backing-up 190-2
optics, adapter 28	portraits 74-7	file formats 124
options bar 121	amputation 74	GIF format 125, 126
output 190-212	animals 110-3 candid portraits 74-6	JPEG or JPG format 124, 126, 127
P	children 106-9	lossless formats 124
•	formal portraits 74, 77	lossy formats 124 PDF format 126
paint bucket tool 123	lighting 76	Photoshop file format (PSD) 125,
painted effects 185-7	poster effects 182-4	126
painting onto layers 166	power 49	PICT format 125
panning 95	pre-focusing 96	PNG format 126
panoramas 172-3	preview screen 128	RAW format 125, 126
paper 194	printers 38-1	TIFF format 125, 126, 127
party pictures 68	buyer's guide 38-1	scanners 40-1, 196-7
children's parties 106	dye sublimation printers 39	all-in-ones 41
patch/healing brush 122	inkjet printers 38	film scanners 40-1
path selection tool/pen tool 122	printing without a PC 39	flatbed scanners 40
patterns (abstracts) 114-7	printing 193-5	reflective scanners 40
PC (personal computer) 30-1	at home 193	scanning 196-7
buying 30-1	in shops 194	for email and Internet use 197
cables 21	online 194	for inkjet photo printing 197
Mac 30-1, 36-8	paper 194	how to 197
memory 46-7	processors 31	scanner settings 196
storage (extra) 46-7	PSD (Photoshop file) 125, 126	scene modes 20
Windows 30-1	0	scratches, removal 174
PC/AV socket 11 PDF format 126	*	screen display modes 123 secure digital (SD) 16
PEN cameras 29	quick fix 128-9	selection brush tool 123
pencil tool 123	quotem 1200	selections 167
pendrives 33	R	selling photographs 209-10
pentaprism 13		sensitivity (ISO) 69
pen tools 122	RAM 31, 41	sepia mode 72, 99
people pictures 74-7	rangefinder 29	shadow control 136
personal computers (PC) 30-1	RAW format 125, 126	shape tools 123
pets 110-3	redeye	shape/type layers 163
flash 110	prevention 66, 140	sharpening 136-7
timing 110	removal 140-1	shooting controls 20
zoos and safaris 110	reflective scanners 40	shutter button 10, 20, 56
photomerge 172-3	remote release 43	shutter speed
photoshop file format (PSD) 125, 126	reportage 82-3	action 96-7
Picassa 37	resampling 134	camera shake 42
Picnik 205	resizing 134-5	exposure 60
PICT format 125	resolution 12, 14, 15, 134-5 ppi 41	lag 96
pin cushion (distortion) 28	restoring old prints 174-5	silica gel 23 skintones 146-7
pixels 14-15, 17, 18, 19	RGB 144	slave (flash) 45
ppi (pixels per inch) 41 planes (shooting from) 84, 116	ring flash 44	slide shows 198-9
PNG format 126	Roxio Creator 37	adding photo files 199

Apple's iMovie/ iDVD 198 background colour 122 building a slide show 198 blur 122 brush 123 saving the show to disc 199 video socket 34. sliding globe 48 burn 123 viewfinders 9, 11 sloping images 132-3 clone 122 electronic (EVF) 9 slow sync flash 96 colour samplers 123 optical 9, 11 SLR 13 colour variations 147 vignetting 28 smart fix 128-9 crop 122 smudge/blur tools 122 default colour settings 122 W softness 136-7 display mode 122 software 36-7, 120-3 dodge 123 Warhol, Andv 182-4 eraser 122 Adobe Photoshop Album 37 watercolour 186 Adobe Photoshop CS 36 exchange colours 122 waterproof housings, 23 Adobe Photoshop Elements 36 foreground colour 122 WB mode 62-3 gradients 123 ArcSoft Photostudies 37 web gallery 202-4 IASC PaintShop Pro 37 hand 122 web site, creation of 202-4 healing brush 122 Roxio PhotoSuite 37 web site, software 204 hue/saturation 147 Roxio Toast Titanium 37 weddings 98-9 ULEAD DVD PictureShow 37 lasso 122 checklist 101 ULEAD Photo Impact XL 37 magic wand 123 church/venue 99 special effects 176-81 marquee 122 group shots 98, 101 move 123 speciality inks 194 white balance (WB) 62-3 speciality media 194 paint bucket 123 wide-angle shots 28, 111 speed, connections 46, 47 patch 122 adapter lens 28 sports 95-7 path selection 122 converters 28 focal length 97 pen 122 setting 111 mode 20 pencil 123 WiFi 34-5 panning 95 rubber stamp 122 wind filter 181 pre-focusing 96 screen display modes 123 Windows 30-1 selection brush 123 shutter lag 96 Windows XP Home Edition 190-2 shape 123 shutter speed 96-7 wireless fidelity 34-5 slow sync flash 96 smudge 122 wizards 120, 191-2 type 123 timing 97 sRGB 145 zoom 123 X TPU (scanners) 41 stained glass filter 180 travel 84-7 still life 78-9 xD picture cards 17, 23 checklist 87 composition 78, 80, 81 x-ray machines 23, 87 landscapes 86 lighting 79,81 storage (camera) 23 planes (shooting from) 84, 116 7. sunset shots 86 storage (images) 46-7, 190-2 tripods/tripod heads 42-3 portable storage 47 zoom compact 24 TV, display on 21 speed and connections 46-7 zoom lenses 9-10, 24-5, 26 type/shape layers 163 straightening 132-3 zoom tool 123 studio flash 45 type tools 123 sunset shots 86 U ULEAD Photo Impact XL 37 telephoto (converters) 28 unsharp mask 136-7

USB (universal serial bus)

connections 34-5

text, adding (layers) 160-3 textures 72, 70

tools (editing software) 120-3

threshold control 136 TIFF format 125,126 timing 110 toddlers 106 tones 150-1

Index 221

Photography Credits

The publishers are grateful to the following for permission to use their photographs:

All photographs **David Jones** except:

Doug Harman pages 63, 68, 71, 72, 73 (right), 103, 104, 105, 112, 139, 140, 141, 149, 174, 175, 196, 198, 199, 212

Special thanks to all the manufacturers who granted permission to use their product shots:

Apacer, Apple, ArcSoft, Blogger, Canon, CCS, Corel, Elio, Epson, Facebook, Flickr, Fujifilm, HP, Intro 2020, Konica, Minolta, Lexar, Lexmark, LG, Maxtor, Nikon, Nixvue, Olympus, Panasonic, Pentax, Pioneer, Plextor, Ricoh, SanDisk, Sansa, Sigma, Slik, Sony, Velbon, Wacom

The publishers would like to extend particular thanks to Adobe for permission to use the image on page 111 and all Photoshop screen shots.

Special thanks also to Sony for permission to use the Sony DMC-TX7 image on the front cover; front cover hummingbird image: iStockphoto.

Quercus Publishing Plc 21 Bloomsbury Square London WC1A 2NS

First published in 2005 This revised edition published 2010 Copyright © Quercus Publishing Ltd 2005, 2010

The picture credits constitute an extension to this copyright notice.

All rights reserved. No part of this publication may be reproduced, stored in a retrieval system, or transmitted in any form or by any means, electronic, mechanical, photocopying, recording, or otherwise, without the prior permission in writing of the copyright owner and publisher.

Quercus Publishing Plc hereby exclude all to the extent permitted by law for any errors or omissions in this book and for any loss, damage or expense (whether direct or indirect) suffered by a third party relying on any information contained in this book.

Every effort has been made to contact copyright holders. However, the publishers will be glad to rectify in future editions any inadvertent omissions brought to their attention.

A catalogue record of this book is available from the British Library

UK and associated territories ISBN 978 1 84916 525 9 Other territories ISBN 978 1 84866 089 2

10987654321

The Author

Doug Harman has over 20 years' experience as a journalist, writer, photographer, and digital camera and technology tester. He has written extensively for a multitude of digital photography magazines and web sites, including *Amateur Photographer*, *What Digital Camera*, *Total Digital Photography*, *Digital Photographer*, Pocket-Lint.com and fourthirds-user.com, *Professional Photographer*, *Photography Monthly* and *Digital Camera Buyer*.

He's also the author of a pocket guide to better camera phone photography called *Snap It*, first published in January 2006.

Doug has his own web based photo gallery at www.dougharmanphotography.co.uk and a photography shop at www.photoboxgallery.com/dougharmanphotography. He has also written and presented a digital photography DVD show, *Doug Harman's Guide to Digital Photography*, and teaches clients on how to get more from their digital cameras, improve their photography and their photography technique.

In addition, he is also one of the founding directors of media and marketing company US3 Media Ltd (www.us3m.com) and is one of the founding editors of the technology, news, reviews and buyer's quide web site www.Best4Reviews.com.

The Photographer

David Jones is a professional photographer with an extensive commercial portfolio, particularly in the fashion and advertising industries. He has also been widely exhibited and contributed photographs to many magazines and books, including *Brunel, How to Keep Dinosaurs* and *Master Chef.*

grande agreement dage maken een gaar verke keer distriction meeting een de gewaten ver Die gewone de verke verke gewone die gewone gegen daar die gewone gegen daar die gewone gegen daar die gewone g